Seeing
Butterflies

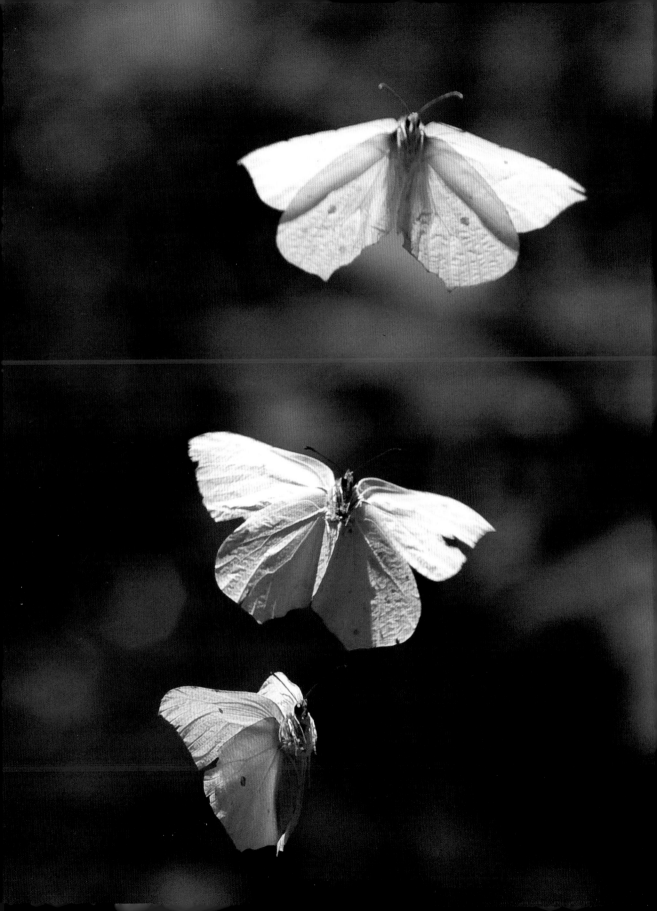

Seeing
Butterflies

New Perspectives on Colour, Pattern & Mimicry

Philip Howse

PAPADAKIS

To Clive Farrell, Honorary Fellow of the Royal Entomological Society, in recognition of his friendship, his generosity which has made the book possible, and of his enthusiastic efforts in presenting the splendour of Lepidoptera to the world at large.
– Philip Howse

First published in Great Britain in 2014 by Papadakis Publisher

 PAPADAKIS

An imprint of New Architecture Group Limited

Kimber Studio, Winterbourne, Berkshire, RG20 8AN, UK
info@papadakis.net | www.papadakis.net

 @papadakisbooks PapadakisPublisher

Publishing Director: Alexandra Papadakis
Designer: Alexandra Papadakis
Editor: Sheila de Vallée
Production: Dr Caroline Kuhtz

ISBN 978 1 906506 46 9

Published in collaboration with the Royal Entomological Society

Printed and bound in China

Front cover: Long-tailed blue (*Lampides boeticus*), male
Frontis: Brimstone butterflies (*Gonepteryx rhamni*) in flight

The Royal Entomological Society is a scientific society, aimed at the improvement and diffusion of entomological science.

The Society was founded in 1833 as the Entomological Society of London. In 1885, HRH Queen Victoria granted a Royal Charter to the Entomological Society, while HRH King George V granted the privilege of adding the word 'Royal' to the title in 1933 on the occasion of the Centenary of the Society's foundation.

In 2007, the Royal Entomological Society moved its Headquarters from the freehold it had held at 41 Queen's Gate, London, to The Mansion House, St Albans, Hertfordshire. This marked the first time the Society had left London since its foundation and first meetings, which were held in the Thatched House Tavern on St James's Street.

The Society plays a major national and international role in disseminating information about insects and improving communication between entomologists, for example through the organisation of specialist and generalist meetings. Supported by a large number of partner organisations, the Society also organises the biennial National Insect Week and Insect Festival (in York), both of which seek to engage the public with entomological science and encourage people of all ages to learn more about insects.

The Society publishes seven primary academic journals, as well as a series of handbooks for the identification of British insects suitable for both scientists and the general public. It also maintains a large entomological library, housed within Mansion House and including some 11,000 books and 750 journal titles. The Society also provides funding for outreach, expeditions and further study in the form of grants and scholarships, supporting activities that further the Society's aims and objectives.

Membership of the Society is international, open to all who contribute to entomological science. It comprises both Fellows and Members who are elected by the Council. Famous Fellows have included Charles Darwin and Alfred Russel Wallace. Fellows are permitted to use the suffix 'FRES', with MemRES being permitted for use by full Members.

Further information and contact details are available via the Society's website: www.royensoc.co.uk

Correspondence may also be addressed to the Headquarters: Royal Entomological Society, The Mansion House, Chiswell Green Lane, St Albans, AL2 3NS, United Kingdom

Tel: +44 (0)1727 899387 | Fax: +44 (0) 1727 894797

 @RoyEntSoc 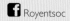 Royentsoc

CONTENTS

Look! The beauty – but that is nothing – look at the accuracy, the harmony. And so fragile! And so strong! And so exact! This is Nature – the balance of colossal forces. Every star is so – and every blade of grass stands so – and the mighty Kosmos in perfect equilibrium produces – this. This wonder; this masterpiece of Nature – the great artist.
– Joseph Conrad, *Lord Jim*

	Foreword Professor Jeremy Thomas, OBE – President, The Royal Entomological Society	6
Chapter 1	**SEEING: ILLUSION, DECEIT & SURVIVAL**	8
Chapter 2	**DEFENCE & ILLUSION**	34
Chapter 3	**DINOSAURS, BUTTERFLIES & COLOUR**	54
Chapter 4	**PEACOCKS & BIRD EYES**	66
Chapter 5	**TORTOISESHELLS. ADMIRALS, LADIES & PASHAS**	78
Chapter 6	**THE DANAID BUTTERFLIES**	96
Chapter 7	**BLUE MORPHOS & THE PURPLE EMPEROR**	106
Chapter 8	**WHITES & YELLOWS**	120
Chapter 9	**THE SWALLOWTAIL & BIRDWING BUTTERFLIES**	128
Chapter 10	**THE TROPICAL VINE & CLEARWING BUTTERFLIES**	140
Chapter 11	**THE HAWK MOTHS**	150
Chapter 12	**THE GIANT SILKMOTHS**	160
	Index	172
	Footnotes	174
	Further Reading	176
	Picture Credits & Acknowledgments	176

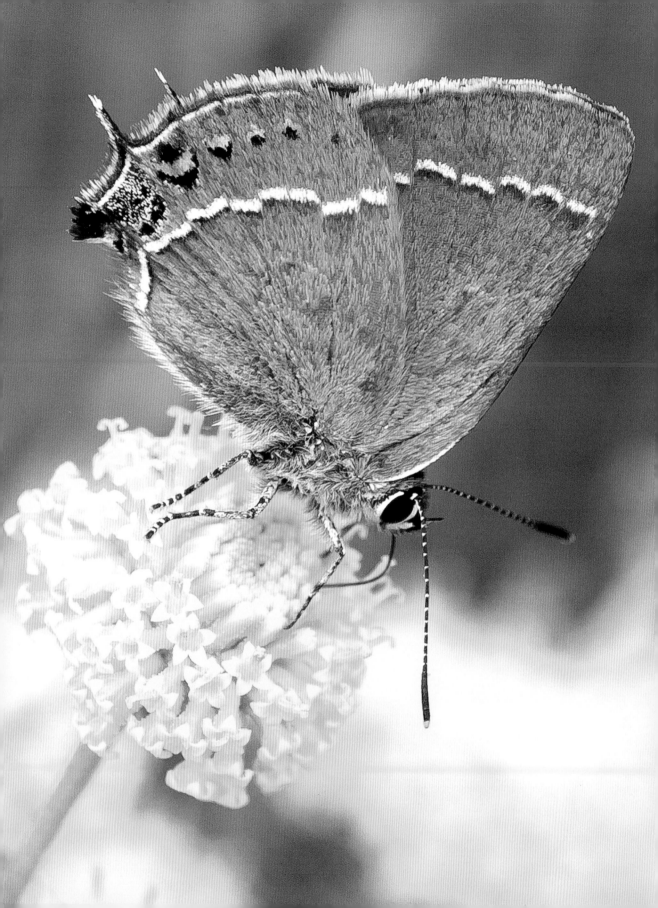

FOREWORD

Many hundreds of books about insects are published each year, but it is only once every decade or so that one arrives that takes the breath away, transforming our perception of an apparently familiar subject with fresh ideas, new insights, and unsuspected revelations of beauty. Bert Hölldobler and Ed Wilson famously achieved this in 1990 with their Pulitzer prize-winning book *The Ants*, and for me, Philip Howse's *Butterflies – Messages from Psyche* (2010) had no less an impact. It was here that Howse first propounded his intriguing idea that many of the bizarre colour patterns of insects could be explained by what he termed "satyric mimicry", whereby the hitherto inexplicable shapes seen, for example, on moth and butterfly wings, had evolved to deter a swathe of insect-eating enemies, whose perceptions of their miniature world were somewhat different from those seen by human eyes.

It is a great pleasure therefore to welcome an equally wonderful sequel, aptly named *Seeing Butterflies*. Here Philip Howse develops his intriguing ideas about insect appearances, supporting them with a diverse array of weird and wonderful new examples, each beautifully illustrated with astounding images. The reader is first taken through the reasons how and why butterflies and moths may have evolved this fantastic array of shapes, postures, colours and patterns, not only in the adult insect but also in caterpillars, pupae and even eggs. He then presents successive chapters describing the main groups of butterflies, and many moths, giving novel interpretations to their markings. Never again shall I look at a comma butterfly at rest and be content to admire its remarkable resemblance to bark or a dead leaf: nestling within this camouflage is a second, more sinister image – that of a rodent – subtly imprinted on the lower wings.

Some years ago, when discussing with the late Miriam Rothschild what defines a great natural history book – and why excellence was so rarely achieved – we agreed that to attain this accolade it should possess at least two out of three attributes: it should be a work of scholarship, providing fresh information and enlightenment of its subject; it should ideally also be a lovely illustrated work of art; and it should stand as a work of literature, elegantly written in prose that is a pleasure to read. Philip Howse clearly succeeds on all three fronts, with a book that will be read with fascination and delight by amateur naturalists, keen schoolchildren, and serious entomologists alike.

Professor Jeremy Thomas, OBE
President, The Royal Entomological Society

Blue-spot hairstreak (*Satyrium spini*), male, Spain

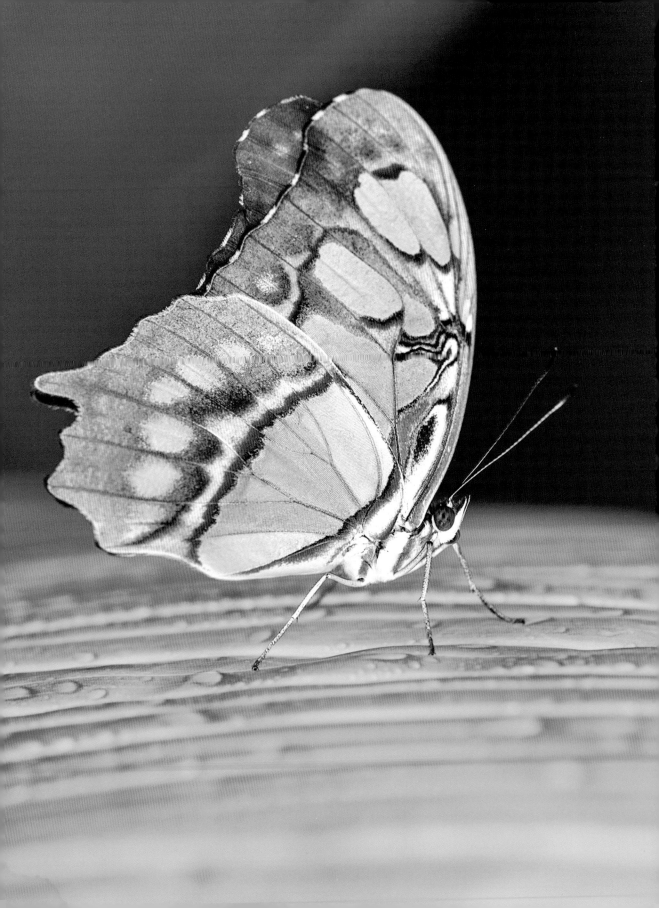

SEEING: ILLUSION, DECEIT & SURVIVAL

Principles for the Development of a Complete Mind: Study the science of art. Study the art of science. Develop your senses — especially learn how to see. Realise that everything connects to everything else.

— Leonardo da Vinci

Alfred Russel Wallace, the self-effacing genius who conceived the idea of evolution by natural selection, a theory that he announced to the Linnean Society in 1858 along with Charles Darwin, describes in his book *The Malay Archipelago* the capture of the magnificent butterfly that he named "Rajah Brooke's birdwing" after Sir James Brooke, then the Rajah of Sarawak. "*This beautiful creature… is deep velvety black, with a curved band of spots of a metallic green colour extending across the wing from tip to tip, each spot shaped exactly like a small triangular feather, and having very much the effect of a row of wing coverts of the Mexican trogon [the Quetzal bird] laid upon black velvet.*"

Of course the birdwings and the quetzal bird live on opposite sides of the globe, but there are many birds in East Asia with iridescent green wing feathers. Nevertheless the similarity that Wallace saw has always been taken to be a curious coincidence. But is it something more than that? This may be the first recorded observation of bird mimicry. But then again possibly

The malachite butterfly (*Siproeta stelenes*) — colours that blend in with vegetation

not: in the great creation masterpiece of Hieronymus Bosch *The Garden of Earthly Delights*, painted between 1490 and 1510, there sits, among the other symbolic phantasmagoria, a meadow brown butterfly with the head and beak of a bird, thus priming us to see the bird-like eye-spot on the butterfly's wings.

You may find it very surprising to learn that, engraved on the wings of many butterflies and moths, among the rainbow colours and the opalescence, are images which closely resemble, among other things, millipedes, salamanders, frogs, snakes, falcons, spiders, hornets, bats, large canine teeth, claws, caterpillars, wolves, and owls. These have been overlooked in the past because even the most patient observer has failed to be convinced that the illusory images are more than coincidences. But does this apply to birds that prey on insects? The visual acuity of birds is far greater than ours, isn't it? So there is little chance that they will be taken in by any superficial resemblance of a butterfly to another creature. The chasmal flaw in this argument stems from the fact that, while birds may have excellent vision, they do not *perceive* things as we do and they identify objects from a minimum number of clues while remaining seemingly oblivious to the rest of the picture.

The conventional explanation for the colour patterns on butterfly wings is that they enable one individual to recognise others of the same species and so prevent interbreeding. I have always wondered, if that is so, why wing patterns should be so intricate, complex and unique in butterflies such as tortoiseshells and peacocks, and yet in the chequered brown European fritillary butterflies, for example, the patterns remain remarkably similar in around fifty different species (not to mention sub-species) found in Britain and western Europe, with approximately thirty that can be added in North America. There are also numerous species of blue butterfly in the western world, some of which are extremely difficult to identify without resort to minor anatomical details.[1] The answer, as we shall see, is that the wing patterns of many butterflies and moths do not solely help them to find the right mate (in which pheromones are also of great importance), but also create illusions. These illusory features are very difficult for *us* to perceive, but they have evolved, not because they deceive humans but because they tend to deceive insect-eating predators, whose visual world is very different from ours and who see many features to which we pay no attention, or to which we are effectively blind. Conversely, we see many patterns, shapes and designs that most animal species almost certainly do not.

Rajah Brooke's birdwing butterfly (*Trogonoptera brookiana*)

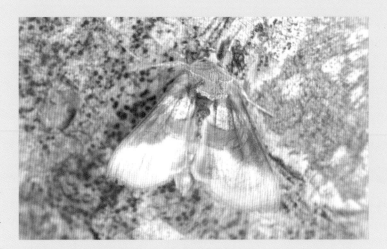

Visual illusions are part of everyday life. Unlike Narcissus who believed his reflection was a real person, with whom he fell in love, you know your reflection in the mirror is an illusion. But it is even less "real" than you may think. An anorexic person may see a seriously overweight person in the mirror and refuse to believe that this is not the reality. A mirror image is reversed from left to right, and is also smaller: try breathing on a mirror and tracing the outlines of your head with your finger if you doubt this. And if you have a computer with a web-cam, try to trace the outlines of your image on the screen; you will probably find this perplexing.

Distortion and illusion, though, are not uniquely features of human visual perception. Birds, for example, see things differently and some features are not seen at all: their "reality" is quite different from ours. We know this from experiments which have shown that they can be very easily deceived by simple models or crude copies of other creatures. I will now try to show how the wing patterns of insects exploit this susceptibility and so help them to survive.

How to Catch a Butterfly (or Moth)

Butterflies and moths are "cold-blooded", meaning that they must warm up before they can fly properly. One way they do this is by basking in the sun in the early morning sitting on flowers or walls and opening their wings towards the sun. On hot days they may risk overheating, but they are then able to cool their bodies by closing their wings, changing the angle of their wings to the sun, or flying into the shade.

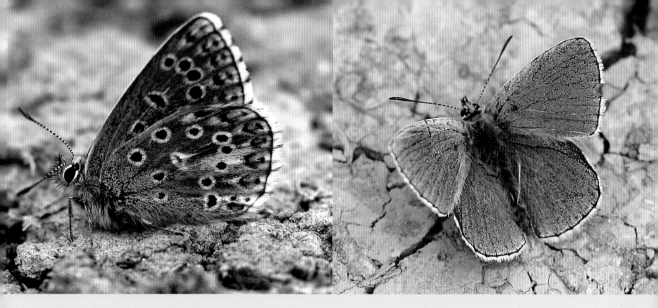

Most moths, on the other hand, fly at night, and to do this they need to generate their own body heat. If you disturb a moth in the early morning you will notice that it has difficulty flying away immediately. Some species can manage a quick emergency burst of energy and fly a short distance, but most must first beat their wings rapidly while staying on the spot – this is termed, appropriately, "shivering". The rapid, almost isometric, muscle activity raises their temperature, and when the body temperature starts to rise above 30°C (our body temperature is always about 37°C), their muscles begin to work effectively and they can fly away. Moths with large bodies can spend several minutes shivering when ambient temperatures are low. For example, the robin moth of North America (*Hyalophora cecropia*) which is very large-bodied, has been found to take eight minutes to warm up from 15°C.[2] During the warm-up period, of course, moths are tremendously vulnerable to predators.

The best time to catch or photograph a butterfly is therefore when it is basking in the sun in the early morning or at the approach of sunset; in the heat of the day it is off the mark too quickly. And the best time to catch a moth is when it has been concealed in the shadows and the temperature is low. Insectivorous birds tend to hunt at dawn and dusk for the same reasons.

Butterflies and moths protect themselves in many different ways, such as simply concealing themselves in crevices or choosing resting places where they are well camouflaged. Some are able to protect themselves still further by suddenly displaying bright colours when disturbed. Many butterflies open and close their wings so that colours and patterns on the upper surface of the wings alternate with contrasting ones on the under surfaces. In a great many instances the differences are radical and create a shock, such as happens when a conjuror appears to turn his silk handkerchief into a live dove. This is one of the fundamental strategies that butterflies use to confuse predators. In some species, the bright colours of the upper wing surfaces appear to flash like a warning light – which can be startling. But there are other intriguing ways in which insects defend themselves, which have been largely overlooked. Imagine you are hunting in tropical forest. You are potential prey as well as predator. Suddenly something leaps out from behind a bush in front of you. You need to find out extremely quickly whether it is a deer or a leopard; get it wrong and you might be dead within a few seconds (and your offspring might die from starvation as well). You may have to rely on easily recognised features that are fleetingly glimpsed, like black spots on the body or a set of sharp teeth. You may not have time to take a close look.

A bird hunting for moths in a bush is in a rather similar position: what could be a tasty caterpillar or moth might be the head of a venomous tree snake, or a partially concealed bird of prey. Again, an instant decision is needed, based on easily recognisable clues. The bird could be taking a big risk if it pecked at the object right away, but if it hesitates for even a fraction of a second, the insect, if that is what it is, has had a chance to escape.

Avoiding capture by predators depends not just on how fast an animal can swim or fly, but on the time it takes to detect a threat and react. We can take up to a second to focus on something that has caught our eye and work out whether or not it has triggered a false alarm. The delay in changing the direction of gaze and re-focusing also affects us in our ability to cope with many things in life, including, incidentally, the highly controversial offside rule in football in which the position of the ball, the goal keeper and three other players must be determined at exactly the same moment.

When you first see an object coming into your visual field it takes your eyes an average of just over a quarter of a second (270 milliseconds) to move in line with it. It then takes another 120ms for both eyes to centre on the object so that the brain can compute the distance the

Eye-spots are a magnet for the gaze: a peacock butterfly (*Inachis io*) among flowers

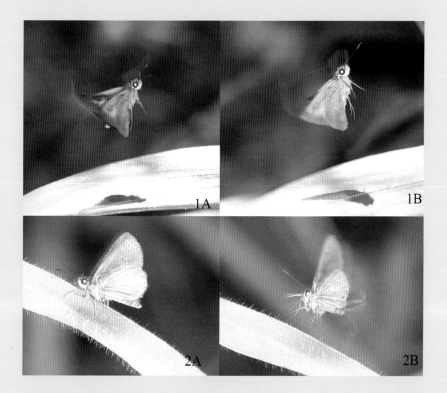

object is away from you; until you can do that you don't know exactly where it is relative to everything else you can see. The eye focuses on an object by changing the curvature of the lens – a process that takes 640ms when you change from looking at something in the distance to something close to you. And if you blink, that takes 400ms – a period of blindness of which we are completely unaware. Experiments have shown that monkeys and budgerigars can distinguish between different kinds of object in about half the time it would take you or me, but this still means that insects that detect a bird in front of them (and are already warmed up for flight) have a good margin of time to escape before the bird can focus accurately on them.

This explains why it is so difficult to catch a butterfly. Unless you can get very close to it and bring a large net down in a fraction of a second, it will have escaped you, so you have to guess where it will be within the next second to have a chance of capturing it.

Take-off times calculated from high-speed video recordings of several butterfly species show that it takes them around 3ms to lift off and a further 4ms to move one wingspan away.[3] Using a timed flash

Skipper butterflies: images of the South American species *Anthoptus epictetus* (1A and B) and an unidentified skipper captured within 17ms of exposure to a photographic flash

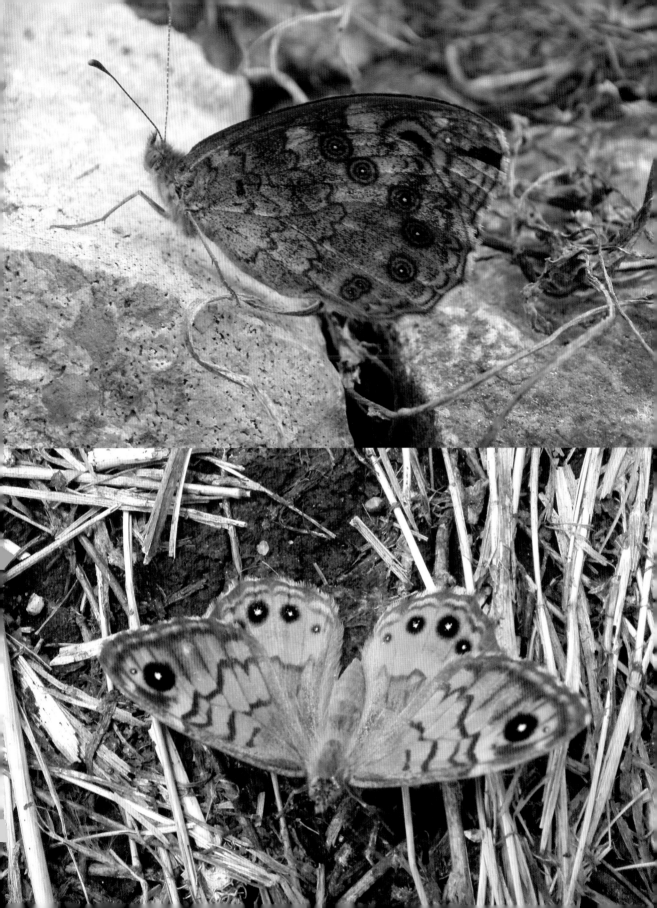

to photograph four species of South American skipper butterfly (Hesperiidae), Andrei Sourakov[4] found that they could detect the flash and leap into the air in less than 17ms, one of the fastest recorded responses in the animal kingdom. He also found that the iridescent blue nymphalid *Myscelia cyaniris* closes its initially open wings presenting its cryptic undersides in the same period of time.

Now imagine you are a bird and you have spotted a butterfly sitting in the sun on a flower. The next thing is to get within pecking distance. This is extremely difficult because the butterfly will detect the slightest movement and be off in a flash. The fastest peck recorded is that of a woodpecker, which takes 40ms, but that gives the butterfly ample time to escape if it has seen your beak begin to move; if you hesitate, confused, for example, by the weird patterns in front of you, and have to refocus from the "eyes" to the body, you will almost certainly miss and the butterfly will already be out of reach.

In general, then, the best option for insectivores is to search for butterflies that have not warmed up to flight temperature, and it is then that the illusory images on their wings come into play, as they do in moths. Ironically, most experimental work on mimicry has been done with models or static "prey" in which birds have all the time they need to approach and inspect before striking at a "sitting target", with the result that the survival value of images on wings is not put to the same tests as in nature.

Even if a bird tries to catch a butterfly in flight it has a very difficult task. Stephen Dalton, one of the pioneers of high-speed nature photography, had to overcome the formidable problem posed by the speed of movement of insects past the camera. In the one twentieth of a second (50ms) that it takes a camera shutter to open, the average insect will have moved about 25cm past the point of focus. In that time, a hoverfly could complete 5-6 wing-beat cycles. The small tortoiseshell butterfly (*Aglais urticae*) has a take-off velocity of approximately 1.1-1.4 metres per second[5] so 50ms after lift-off it will have moved over 50cm.

Of course, some butterflies, such as many of the blues and whites, are slow fliers, and tend to fly for long periods in and out of vegetation or make so many frequent twists and turns that birds have difficulty in predicting where they will be in the next fraction of a second, as Robert Graves described in his poem *Flying crooked*: "...a cabbage-white, (His honest idiocy of flight) / Will never now, it is too late, / Master the art of flying straight."

The Sardinian wall brown butterfly (*Lasiommata megera paramegaera*) is well-camouflaged with closed wings, but when disturbed or sun-bathing displays multiple eye-spots, each with light-reflecting centres that draw the observer's attention away from the body

Distracting the Gaze

Reaction times are relevant in a subtle way to the evolution of eye-spots on the wings of butterflies. The eye is always drawn towards images of eyes, a tendency that has been exploited by surrealist artists such as Miró and Salvador Dalí, and we can safely assume that this tendency applies also to birds and other vertebrate predators. Butterflies with eye-spots tend to half open and close their wings rhythmically while feeding, so that the eye-spots move relative to the body. Our eyes tend to remain fixated on them. When the wings are more than half-closed, the eye-spots in the peacock butterfly, for example, are about 2cm above the body. In order to capture a butterfly, a bird must change the focus of its eyes from the eye-spots to the head or body. Remember also that the outlines of the body are obscured in most butterflies by black areas on the wings (which also help, incidentally, in temperature regulation) or by stripe patterns that break up the outline.

Pecking at the eye-spots may be a defensive, pre-emptive strike against a perceived bird with an open beak. The possession of a series of eye-spots on a dark background, which we find again and again in the brown (satyrid) butterflies, may confuse a bird still further because it will make the true head more difficult to locate. The focus change will take longer in the shade or in poor light. Lifting the wing as part of the opening and closing cycle will bring the eye-spots towards the observer, which may also be threatening and could offer an explanation for the peck marks that are frequently found around butterfly eye-spots (a point we will come to again later).

Try this simple experiment. Place an ink spot on the edge of your thumb (which is normally about 2cm wide) and place the outer edge on the surface of a watch with a second hand. Now, getting as close as you can, focus on the spot and then shift your focus to the second hand

of the watch. You will find that it will have moved on by almost a second by the time you accomplish this — ample time for a butterfly to become airborne.

The eye is often deceived, or the mind briefly confused, when the outlines of an object are blurred or interlaced with other outlines. A major movement in art was Post-Impressionism, an art form developed by Paul Cézanne and others in which paintings of great clarity in the form used by the European great masters were superseded by forms and colours in which sharp borders were replaced by broad diffuse brush strokes. The brain slowly crystallises forms from the rough impressions, creating an emotional effect that is curiously more satisfying than looking at a painting accomplished with photographic precision.

Leonardo da Vinci made many drawings that are at first sight undecipherable, and which you have to interpret by going from one detail to another until you realise what the drawing represents. Then the drawing comes to life. You have seen through the enigma and it is easier to resolve the image the next time you look at the picture. The essential point is that it takes time to solve the conundrum, because, unlike animals, we generally see the big picture and not the details.

Yet another impediment to "seeing" is the presence of an object in a completely alien setting. Advertisements of various tobacco companies in the 1980s and 1990s used this device in order to perplex the observer and hold his or her attention while the brand image was subconsciously registered in the mind. This confusion effect had been anticipated by the Surrealists, who used the clash of images to question the nature of reality (see Chapter 2).

We can imagine that a predator might also briefly be confused, as we are, by the unfamiliar juxtaposition of symbols (such as eye-spots) on the wings of a butterfly,

and the moments of uncertainty will give valuable time for the insect to get away or defend itself. We get an indication that this trickery works also against other animals: budgerigars take twice as long to recognise a "scrambled" picture of another budgerigar with the features of the head in the wrong place: for example, if the eye is on the neck. Macaque monkeys also take longer to recognise a human face if the features are jumbled although still symmetrically placed.[6] The interpolation of images of parts of another creature on insect wings can be seen as a form of mimicry, called "satyric mimicry" which will be discussed in the next chapter.

Expectation

Psychologists have confirmed that much of the time we see what we expect to see, and hence two people may have quite different perceptions of the same object. The renowned French writer Antoine de Saint-Exupéry elegantly expressed this when he wrote "*A rock pile ceases to be a rock pile the moment a single man contemplates it, bearing within him the image of a cathedral.*"

The small tortoiseshell butterfly (*Aglais urticae*). The body is obscured by dark pigment and a covering of hairs

The brain stores images of what the eye sees in a sort of unimaginably complex reference library, and, as in Post-impressionism and Leonardo's drawings, it needs only a few cues to call up the picture that fits – to see the cathedral rather than the stones.[7] Thus we first see the whole picture. A tree is a tree: a normal person doesn't start with the leaves and see to what they are connected, and to what the twigs are connected, before they realise that it's a tree. Some people, however, have to do just that, for example many people who are autistic, or suffering, sometimes as the result of a stroke, from the condition known as *visual agnosia* in which objects are seen but can be identified only with much prompting. Such people have to assemble and connect the details, as a normal person might need to read all the words in a message before grasping the meaning.

A patient of the psychiatrist Oliver Sacks,[8] Virgil, who was re-sighted in an operation at the age of fifty after losing his sight in early childhood, could see only parts of a cat – a paw, nose, and tail – but could not integrate the details into a whole. A month later, Virgil was able to put a tree together and realised that the trunk and leaves formed a complete unit. Because he relied upon simple features, Virgil had difficulty in distinguishing a black cat from a black dog. He recognised a giraffe because of its height, not its shape, and a zebra by its stripes.

There is good evidence that birds see detail rather than the whole picture, and if they do have the same constraints as a newly sighted person who has a tremendous amount to learn before he or she can see complete objects, it explains why birds can be deceived by simple details or patches of colour.

Seeing Parts of an Object

In my first excursion into tropical forest in Uganda, I had an experienced ornithologist as a guide. He saw and identified for me birds which were apparently all around me but which I rarely saw except for the occasional flicker of a wing tip. I can occasionally impress people in the same way with butterflies: this is possible because of a process known as "priming", which is also used by conjurers and magicians. After repeated exposure to a part of something – an idea or an object – the brain gradually anticipates what is there more and more readily. It was more of a shock when my companion in Uganda asked if I had noticed that we were being followed by a leopard. He had picked up the subtle cues.

Very occasionally, people who suffer a stroke lose part of the visual field. Eventually, vision may be restored by the brain "guessing" what is there and completing the picture. A friend, who suffered a stroke that left a gap in his visual field, initially saw his dog walking in front of him slowly disappear into the visual void and re-emerge the other side. After some months a ghostly transparent dog appeared walking across this gap to reappear the other side, and eventually he saw the whole dog spliced into the scene – a dog that was real and unreal at the same time – his brain's "expectation" of what was there.

The downside of priming is that the brain is so eager to find a match for stored images that, as in the case of the Emperor with his new clothes, it can easily be deceived or impose it's own interpretation on what the eye sees. This is evident in written language. It is usually quite easy to read the following (and much easier a second time), although it means making big assumptions.

Get the frist and lsat lttrees rgiht.
The mnid fllis in the rset.

And how long does it take you to interpret the following, when you first see it?

econdisalongtimeas.

In the latter case, the brain searches for matches that are obscured.

Birds See Things Differently:

Animals have sensory capacities that are different from ours, and birds, especially, have brains that are constructed differently, so we can't assume that they see a butterfly as we do. We all tend to assume that what we see is the only reality, and it rarely occurs to us that someone else's reality might be different. It seems that the "mind's eye" of birds and other animals contains very simple schematic pictures of part of an object or another animal (or plant) that are templates for recognition. But these supposed templates are simpler that the ones that we have, allowing animals to see diagnostic details rather than a complete figure or object.

Stripes and Flicker

Stripes across an animal obscure the outline of the body and wings and make it difficult to distinguish the head, body and legs (as in the obvious example of the zebra). Stripe patterns used in camouflaging clothing and military vehicles were also used on warships during the second world war. These ships were covered with black and white irregular or jagged stripes, in what is known as "dazzle painting". This made it very difficult to see the outlines of structures such as the funnels, bridge or deck by which observers normally recognise a ship.[9] Some butterflies have evolved stripe patterns that have the same effect, concealing or obliterating the outlines of the body, a phenomenon which is seen, for example, in the *Idea* (tree nymph) butterflies of South-East Asia and Australasia (see Chapter 6).

The malachite butterfly from South and Central America is a different example in which the body is obscured by green leaf patterns and by distracting reflective patches (see illustration on page 8).

A television or film picture is shown at 60-100 frames per second. We are not aware of the separate images because the rate is above what is called the "flicker fusion frequency" (FFF). Birds, though, and insects as well, have an FFF two to three times higher than ours and would still be able to resolve the flickering images. Butterflies have a high FFF, which helps in detecting other butterflies and approaching birds. Silver-washed fritillary males are attracted by the flickering patterns of the female wings in flight: the higher the flicker rate the greater the effect, up to about 140 per second.[10]

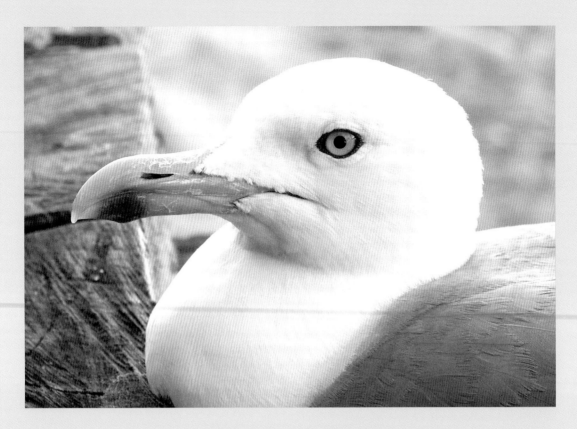

Hummingbirds have the fastest wing-beat frequency of all birds at 40-80 beats per second, and the hummingbird hawk moth's wings reach 85 per second. While we see just the wings as a blur in both cases, birds may be able to see the details of colour and shape in both.

Colour Vision

Between 12 and 20 per cent of white men and less than 1 per cent of women have some form of colour blindness, usually failing to distinguish red and green or yellow. A very small percentage of the population has synaesthesia, and many may not even realise they have this condition. Synaesthesia is the blending of sensory impressions, which was only recently accepted as a phenomenon worthy of scientific study.[11] To some people, music evokes colour sensations, in others, the letters of the alphabet and even whole words may take on different colours.[12] There is evidence that young babies are synaesthetic, unable to separate out information fed to the brain by the various senses. It may be that animals, including birds, also have synaesthesia, although we tend to assume that they do not and research into animal behaviour is generally based on the flawed view that their visual perception is similar to ours.

Herring gull (*Larus argentatus*)

It is only by experiment that we can begin to learn how far apart we are from birds in our perception. To take an extreme case, it has recently been found that homing pigeons have a magnetic sense located in the inner ear, so they may hear features of magnetic fields. There is also some evidence that other birds detect magnetic fields through their eyes, and so may see them.

Our understanding of the way birds see things changed radically when Niko Tinbergen, a Nobel Prize winner, published his work on the behaviour of gulls. The herring gull has a bright red spot on its yellow beak. When a gull chick pecks at this the parent regurgitates partly-digested fish for the chick. By using various card models of a gull's head, Tinbergen showed that a model of the parent without the spot is of very little interest, but a red rod with white bands on it is even better at attracting pecks than a faithful model of the adult. It constitutes a "supernormal stimulus".

Redness, good colour contrast, and an elongated beak-like outline are the details which the chick sees and to which it responds: it appears that it sees neither the whole head, at least in the way we do, nor the parent bird; just a few selective details are sufficient for it to recognise the dispenser of food. As far as the young chick is concerned, the bill with its red spot *is* the parent gull (this changes, of course, as the chick develops and gains more experience). This dependence on simple cues brings to mind the psychiatrist Oliver Sacks' account of "The Man who mistook his Wife for a Hat". Sacks' unfortunate patient had suffered brain damage and was able to recognise his wife only by the hat she wore.

Konrad Lorenz in his charming book *King Solomon's Ring* described how his tame hand-reared jackdaws attacked him when he was carrying a black bathing costume: they apparently "saw" a dead jackdaw. The founders of the modern science of ethology (animal behaviour), Niko Tinbergen and Konrad Lorenz, found similar examples of this unrefined form of perception wherever they looked in the animal kingdom, and called the detailed images (or sounds or smells) "sign stimuli" or "releasers" of behaviour. They are often seen as the simple keys that one animal uses to unlock particular behaviour patterns in another.

Following on from this, the neural mechanism of a sign stimulus was located by the neurophysiologist Jerome Lettvin and his colleagues who published a paper entitled "What the frog's eye tells the frog's brain"[13] in which their results reinforced the idea that the visual system of many animals is designed

to detect only certain features of the picture that falls on the retina. They found "bug detectors", for example, that respond to small black spots the size of flies moving rapidly across the visual field, but not to static spots. To frogs, a fly is simply a small moving black thing.

Uses of Colour

Nocturnal animals are generally colour-blind: we assume they see only black, white, and shades of grey because they lack the colour-sensitive cones in the retina. The rods in the retina, however, are 100 times more sensitive to light than cones. Colour contrasts are therefore difficult to make out in dim light. This is one reason for the dull colours of most moths, but it also helps to make them well-camouflaged when at rest. Brightly coloured hind-wings, though, may be concealed by the fore-wings and unveiled when the curtaining fore-wings are moved forwards in response to a touch or vibration. The coloured hind-wings appear to have evolved, in the main, as a defence against day-active predators (with colour vision): a defence that works by startling them.[14]

Butterflies and moths are at most risk, obviously, in sunlight, when colours are perceived clearly through the eyes of day-active vertebrate predators. This explains why visual mimicry (see below) is so widespread in butterflies, and why many mimics have evolved as almost perfect copies.

Many of the most brightly coloured butterflies and moths are poisonous. We know this from observing the reaction of birds to them, and because some biologists have tasted them to satisfy their curiosity and we know it also from chemical analyses of the organic compounds in such insects. The late Miriam Rothschild, who contributed so much to the understanding of warning colours, once unwittingly took a near-lethal dose of cyanide when chewing on a burnet moth to test its palatability. These brightly coloured day-flying moths ooze cyanides from the joints of the legs and thorax when squeezed.

There are many species of moth with dull-coloured fore-wings that stay camouflaged when they are at rest during the day, but show hind-wings with dazzling colours if they are disturbed. Some of the tiger moths have white stripes or spots on the dull-coloured fore-wings that can be opened to reveal bright red hind-wings with blue spots. Biologists call these startling colours "aposematic", which roughly translated (from the Greek roots) means "warning signalling". Often the insect displays its colours suddenly,

The "shock and awe" effect for predators: display of warning colours of the garden tiger moth (Arctia caja)

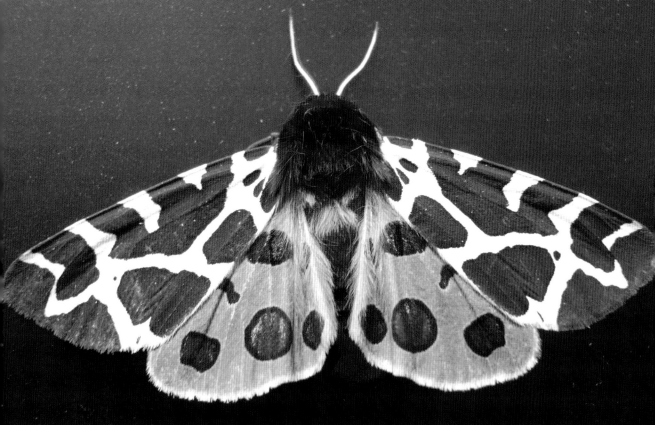

explosively almost, accompanied in some species (the peacock butterfly, for example) by clicking noises, or by noxious secretions from special glands (as in many tiger moth species). The fore-wing patterns stand out at night or in dim light when animals cannot see colours. Those of the garden tiger moth vaguely represent the outlines of a goliath beetle, the white border stripes disrupting the moth shape and concealing the body.

Very bright colours may also confuse predators. This is an area that has been very little explored scientifically. We humans often dislike flashing lights, which at certain repetition rates can trigger epileptic fits in susceptible people (as do stripe patterns), and have been used as instruments of torture. Temple Grandin in her pioneering book *Animals in Translation* explains that cattle can be very fearful of bright colours and shiny objects, which sometimes provoke them to panic.

Blue and red together, which occur in the peacock butterfly and many of the poisonous tiger moths, produce chromatic aberrations, especially where the boundaries are made by colour alone. The reason is that red light comes to a focus on the retina at a slightly greater distance from the lens than blue light (even greater in the case of ultraviolet). Blue on red is very rarely used in advertisements because the effect of parts of the image going in and out of focus is disturbing. It is a reasonable assumption that it can be a discomforting experience for animals also, and suggests why the patterns on the wings of some of the tiger moths may have evolved with these contrasting colours.

Iridescence produces colours that change, like the light reflected from a soap bubble. These colours can be seen only when an insect is viewed from certain angles, and then the reflected light may be intense: there can be more light reflected back from an iridescent wing than from a pure white surface and almost as much as is reflected from a mirror. The wings of a morpho butterfly reflect light (mainly blue and ultraviolet to which birds are particularly sensitive) that can be seen from a long distance, but as the wings close together in flight the light ceases to be reflected. This flashing in itself may be disconcerting to a predator.

Iridescent colours are often seen in day-flying moths, especially the tiger and burnet moths. Burnets are common on chalk grassland in mid-summer, and the colours you see depend on the angle at which you view the reflections from their wings.

The six-spot burnet moth (*Zygaena filipendulae*) showing colour variation due to the angle of the incident light

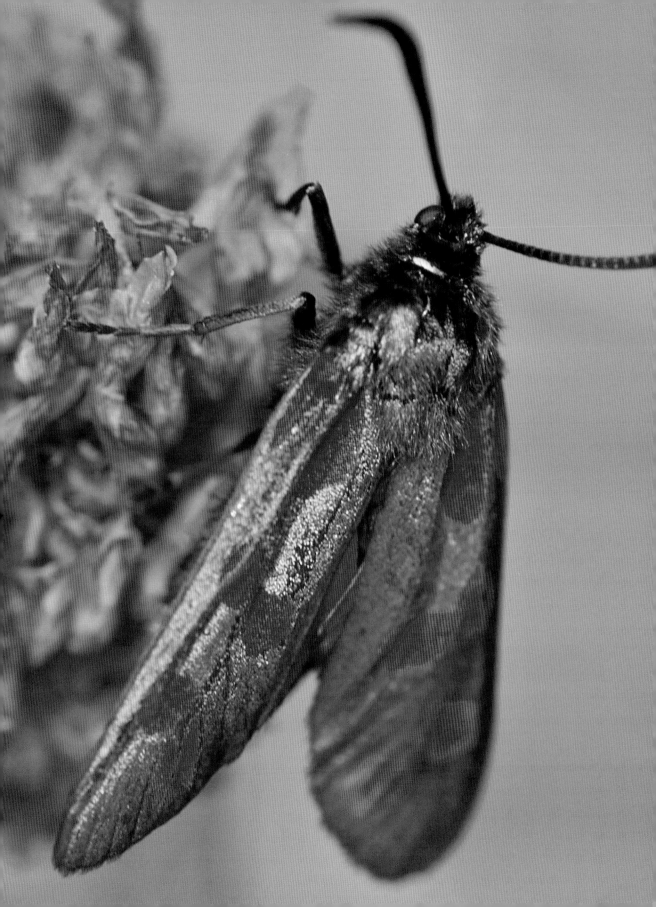

Seeing in the Ultraviolet

Some people are partially colour-blind, usually unable to distinguish red and green. The colour-sensitive cones in our eyes are tuned to wavelengths of light that we know as red, green and blue, but birds have four types of cone, (with evidence for a fifth in pigeons) including cones sensitive to light in the near part of the ultraviolet. The illustrations below show the colours of a rainbow seen by people with two-cone vision (lacking red) and with the normal three-cone vision.

It is impossible to imagine how colours are perceived by a bird with a fourth and fifth type of cone, and thus what additional colours it sees on a butterfly's wing, but it is certain that most birds see more colour bands than we do.

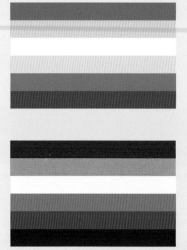

top: Rainbow of a person with dichromatic colour vision, lacking red-sensitive cones

above: Rainbow of a person with trichromatic colour vision

opposite: The Indian leaf butterfly (*Kallima inachus*), (*left*) with sunlit background, (*right*) with sun obscured capturing the blue-ultraviolet reflection

According to Jay Neitz of Washington University, each individual cone in the retina can detect about 100 different gradations of colour.[15] However, two types of cone make it possible to see 100 times more hues because of the mixtures that are now detected, so the average human trichromat can distinguish about one million different hues. It follows that a dichromat may see 10,000, a trichromat at least 1,000,000, a tetrachromat 100,000,000, and a pentachromat 10,000,000,000 different hues. Theoretically birds may be able to detect some 10,000 more hues than we can, making it possible for them to see designs and colour patterns that are not visible to us. Bear in mind also that the peak sensitivity of red, blue and green cones in a bird are not at exactly the same wavelengths as in the human eye. Colour photography is also based on the human trichromatic system, so even the most high-resolution photographs will not reveal the subtleties that a bird could see.

Colour sensitivity in the bird retina is uniformly high between 370-445nm where the blue-violet and ultraviolet sensitivities overlap. The sensitivity of the human eye peaks sharply in blue at about 440nm and then falls steeply at about 420nm and is gone altogether in the violet at about 390nm. So although we are ultraviolet blind[16] in contrast to most birds (and also bees and butterflies), there are a few people who can see ultraviolet. One of them is Alan Bradley, a Canadian.[17] He found he had ultraviolet vision after an operation in which his surgeon had implanted a plastic replacement lens – that was transparent to UV – in his left eye. When he arrived in a market, he was stunned by a brilliant mauve light. "It was almost as though I had been hit in the nose," he said. "I had to look away." The light came from ultraviolet scanners that were used in the market to test for forged credit cards. This arresting anecdote suggests to us that birds and reptiles may be thrown into

confusion by strong ultraviolet reflections, such as those many of the blue and morpho butterflies are capable of producing from their wings.

Because the colour spectrum of birds is different from ours, some colours and patterns no doubt stand out more brightly on a butterfly's wing than they do for us. One study[18] has shown that over 90 per cent of 139 bird species tested had colour patterns on their wings that we cannot see (for example, small birds of the type that birdwatchers lump together and like to call LBJs (little brown jobs) may appear multicoloured to another bird. This is not simply because of the extra ultraviolet sensitivity but is due to the way colours of the spectrum divide into different colour bands in birds. It is likely that some animals can see colour patterns in butterflies and moths that we are unaware of and cannot even imagine.

Fluorescent materials strongly reflect light and fluoresce when ultraviolet light falls on them: the ultraviolet light is changed to a different spectral colour which we can see, and a message written in invisible ink will show up if you shine an ultraviolet light on the paper. Just as credit cards have hidden security marks that you can see only under ultraviolet light, we find that many white and yellow butterflies have markings on their wings resulting

from the reflection of ultraviolet. These "messages" are patterns that are produced by ultraviolet reflecting scales on various parts of the wing. To a bird, a male white butterfly may then look different from a female, and if you had ultraviolet sensitive eyes, one species could look strikingly different from another (see Chapter 9). These patterns are important in helping butterflies to select the right mate, although male scents (sex pheromones) usually play a role in this as well.

The wings of many brown butterflies have violet-UV reflecting scales, which are concealed in the main by the brown pigment, especially in bright sunlight. However, in the shade, where the proportion of scattered light in the near UV is very much higher, these patterns will be more easily seen. The two photographs of the Indian leaf butterfly were taken with a digital camera capable of detecting near UV, in a sunlit environment, and then in the same position with the sun obscured, increasing the proportion of scattered UV.

Sometimes, illumination with near UV will reveal hidden designs, as for example in the African eggfly (*Hypolimnas misippus*); and remarkable images of birds with spread wings can be found in some giant silkmoths (see Chapter 12).

Among the blue butterflies (Lycaenidae), it is often only the males that are bright blue and conspicuous. It is the general belief amongst biologists that the colour is important in courtship rituals and mate selection, and most believe colour patterns have evolved to that end. However, it could have other functions, which we will examine in Chapter 7. Few butterflies produce blue pigment; the colours are generated by reflection and refraction of light from the surface of the scales, a little as in a soap bubble, producing an all-blue rainbow effect. This iridescence is also common in the plumage of birds. In some birds and butterflies it is masked by pigment and we may see only a surface that is shinier than usual.[19] Other butterflies have a sheen on their wings seen only when light strikes them at a certain angle. Opening and closing the wings in the sunlight, as the insects often do, results in subtle changes of colour and brightness.

In some butterflies black and orange pigments can shield the presence of blue or yellow colours or reflections. As birds have a greater sensitivity than the human eye to light at the blue end of the spectrum as well as more colour boundaries, these colours may be more apparent to them by virtue of the UV-sensitive retinal cone that most have.

The white admiral (*Ladoga camilla*) is a butterfly that has, to the human eye, white markings on a dense black background. Filtering the light from the red end of the spectrum, however, reveals what most people would take to be a different species, which is pale brown with larger white markings. In the lower photograph on page 31 the underlying patterns and colours similar to those of the European and N. American white admiral species are made visible. Note the two images of hairy caterpillars with eyes on the hind-wing borders and the more extensive white markings that are visible. The "caterpillars" resemble those of a (poisonous) burnet moth. It is reasonable to suppose that birds see these designs. This is only one example of patterns and colours "hidden" from us by the lesser sensitivity of our eyes to light at the blue-UV end of the spectrum. There are certainly many more butterflies and moths that

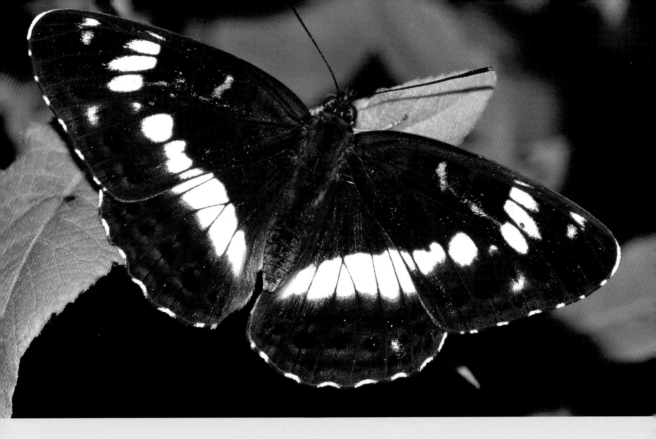

will look different when seen through the eyes of a bird, or a digital camera with suitably chosen sensors.

Binocular Vision: Judging Size

A common objection to the suggestion that a diminutive "thumbnail" image is sufficient to deceive a bird, is that bird vision is known to be so good that birds are less likely to be deceived than we are. I shall now explain why, in spite of the high visual acuity of birds, this is not the case.

In relation to the size of the body, birds' eyes are much larger than ours. On average, the eyes take up about 15 per cent of a bird's head against 1 per cent of a human head. Birds can see much more detail than we can. A sparrow has twice as many cones per square millimetre as humans in the fovea of the eye (where light is focused); a hawk has five times as many. With hawk eyes you could read the number-plate of a car 100-150m away, while we just manage to see it at 20m. Experiments have shown that an American kestrel can detect an insect 2mm long (about the size of a pin head) from the top of a tree 18m high.

opposite: The African eggfly (*Hypolimnas misippus*) photographed in normal light (*left*) and near ultraviolet light (*right*)

top: White admiral butterfly (*Ladoga camilla*)

above: The same photograph as top but with the reflectance of shorter wavelengths enhanced, as the butterfly may be perceived by a bird

Owls have huge eyes which compensate for the low light levels at night. Most birds are short-sighted, but the eyes of owls are slightly telescopic with a long distance between the lens and the retina so they can overcome short-sightedness. Most insectivorous small birds have to feed during the day, because not enough light enters their eyes at night. Normally, such birds have to get very close to objects to find out if they are insects or not, and so not only the insects themselves, but any designs on their wings or bodies will appear very large to birds, although they appear small and insignificant to us. As already mentioned, birds (with the exception of raptors), and amphibians, are myopic in the lower field of vision enabling them to focus on the ground below them – which is also of course the pecking or striking distance.

The uncertainties of monocular vision: how far away are the figure and butterfly?

The artist René Magritte demonstrated the problem of judging the size and distance of an object without binocular vision when he painted, for example, an apple apparently filling a room (small apple close-to in a miniature room, or giant apple in a room of normal size?). The butterfly on the left may not be familiar, but illustrates the problem of determining size without binocular vision. Binocular vision implies that two eyes can focus on the same object and the brain combines the two images, without you realising it, to create a three-dimensional one and you then become aware of how close the object is. Monocular vision does not allow this, and motion parallax (in which, as you move, near objects appear to move a greater distance across your visual field than distant ones) provides clues to the distance between the eye and an object.

Most birds have eyes at the side of the head and look at you, or photographers, with only one eye, so they too will have difficulty is judging size and distance. Watch a bird looking for crumbs on the garden table or worms on the lawn. It constantly tips its head one way and the next. One reason for this is that many birds have eyes that are fixed in their sockets, and they cannot turn them without moving the head. They use a simple trick to find the size and distance of an object: they move their heads in a jerky fashion putting one eye in two places in quick succession, so it takes two "snapshots", from different positions, which is the next best thing to having two eyes. If a bird sees something interesting with one eye it will then turn its head towards it and then has the object in its small zone of binocular vision where it can get more information about its size and location.

We have about 140° of binocular vision in the horizontal plane, while an owl has 50°-70° and most other birds that have been studied, including

pigeons and sparrows have only 20°-30°. Binocular vision is obviously very important for predators like owls and hawks, but having the two eyes facing forwards means an animal has a large area blind to approaching predators, which is obviously disadvantageous for animals down the food chain.

Although it seems that foraging birds in general can detect prey in the lateral field (i.e., using only one eye), the binocular field of view can be of great importance in identification of that prey. The American rock pigeon (*Columba livia*), a typical grain-feeding bird, is short-sighted with the greatest visual acuity at 10cm from the eye in the main axis of vision.[20] This is ideal for objects within pecking distance, but either side of that the bird has increasing difficulty in focusing on an object, and at 35cm the resolution falls by 50 per cent. Smaller birds have smaller eyes giving them an even shorter focal length, so the peak of visual acuity is likely to be even closer to the eye.

It's not only the depth of focus that is important in recognition of prey; the field of vision is generally very restricted so that a bird may see only a piece of a butterfly. The field of vision of house sparrows and house finches in the horizontal plane is limited to 46° when foraging, but when the eyes converge on a close object, this is reduced to a cigar-shaped binocular field of 3°-4° horizontally and around 180° in the vertical field.[21]

Knowing this about the vision of small birds that feed on seeds and insects, we can now begin to see why some butterflies and moths have an eye-spot on each wing. For example, a bird with a very narrow cigar-shaped field of binocular vision seeing a peacock butterfly with spread wings at less than 10cm from its beak will not be able to focus clearly on all four wings. Like a digital camera on a macro close-up setting, the zone outside the focus area will appear blurred, and it is likely that a small bird will see only two eye-spots, which can easily be mistaken for a bird's eyes.

Inattention Blindness

We can "see" things, but not "notice" them or be aware of them afterwards. It often happens that we do not see something right in front of us, even if it is conspicuous, because it is not what we are looking for or expecting to see. You may suddenly "see" electricity pylons across a familiar landscape, or someone may point out a scratch on your car and you wonder why you have not noticed it before. There was a notorious experiment set up by psychologists in which people were asked to watch a one-minute video of a basket-ball game and record the number of passes. Halfway through this specially prepared video, a person in a gorilla suit walked slowly across the pitch between the players and thumped his chest. Half the observers didn't notice this "detail"! When they were then shown the video again and told what to expect, they refused to believe the gorilla was there before. This kind of "non-seeing" is known as "inattention blindness" and is one reason, incidentally, for the British government banning the use of mobile phones in cars.

This "blindness" is also found in animals and is not unlike the phenomenon we saw in herring gull chicks. People have always wondered why a blue tit will carry on putting food into the open mouth of a cuckoo nestling, even though it may be several times the size of its own babies. The explanation, only arrived at recently, is that the parent responds only to the begging calls of the cuckoo nestling and does not "see" it – the parent responds to one detail and ignores the other details that make up the big picture. You find this incomprehensible, but you are not a bird – take careful note of this fact from now on!

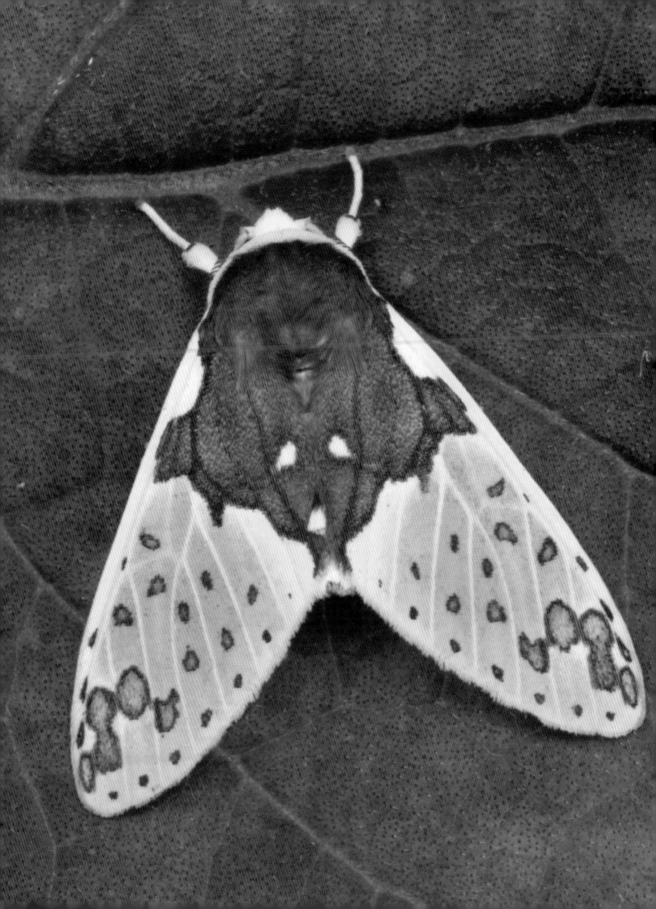

DEFENCE & ILLUSION

The lepidopterist, with happy cries
Devotes his days to hunting butterflies.
The leopard, through some feline mental twist
Would rather hunt the lepidopterist.
That's why I never adopted lepidoptery I do not wish to live in jeopardoptery
– Ogden Nash

In 1848, two keen amateur entomologists – Alfred Russel Wallace and Henry Walter Bates – sailed from Liverpool with few financial resources on a boat bound for the mouth of the Amazon. This was at a time when there were no telecommunications, no long-haul flights, no portable cameras. They were inspired in part by Darwin's *Naturalist's Voyage around the World*, first published some years earlier, but little was known about the Amazon at that time. What knowledge there was came from the Portuguese colonisers of Brazil and a few early explorers. However, the two naturalists had enough information to realise that there was a plethora of exotic birds, insects, other animals and plants waiting to be discovered, classified, and shown to an eager public in museums in Britain and Europe.

opposite: The arctiid moth (*Amaxia apyga*) from Costa Rica, marked with the mask of a bird's head

page 37: A lunar hornet moth (*Sesia bembeciformis*)

Wallace spent four years in the Amazon and Rio Negro and after his return travelled through Malaysia and Indonesia before coming to the conclusion, in a "Eureka moment" while confined to his bed with malaria on an Indonesian island, that animals and plants evolved over time, changing as a result of

survival of the fittest. His draft paper on this was a shock to Charles Darwin and prompted a meeting of the Linnean Society in London where the near identical theories of the two great men were simultaneously presented to the world. Since then it has been Darwin who has achieved immense fame while few non-biologists have even heard of Wallace.

Bates spent eleven years exploring the Amazon and its tributaries, and collected a staggering total of 14,712 insect species, 8,000 of them new to science. When his claims were challenged at the Natural History Museum, Darwin's great friend, the highly esteemed botanist J.D. Hooker wrote: *"Above all things, remember that entomologists are a poor set, and it behoves you to remember this in dealing with them. It is their misfortune not their fault; deal kindly with them."*

Of butterfly wings Bates wrote *"on these expanded membranes, nature writes, as on a tablet, the story of the modification of the species, so truly do all the changes … register themselves thereon."* He was fascinated by the brightly coloured passion vine butterflies that hover around lazily in the Amazonian forest. In spite of their dalliance which, incidentally, makes them popular and easy to observe in butterfly houses, insect-eating birds leave them alone. Henry Bates realised that they were poisonous and surmised that birds rapidly learned by experience to avoid them. He also found some butterflies that had almost identical colour patterns although they belonged to completely different families of butterfly. For example, some of the whites and sulphurs, which birds normally find edible, were found to be mimics of the passion vine butterflies: effectively sheep in wolves' clothing.

This kind of mimicry, which is a wonderful defence, is now known, fittingly, as Batesian mimicry. Everyone has encountered, knowingly or (more likely) unknowingly,

moths that look like wasps or hornets, or caterpillars that resemble snakes. The lunar hornet moth (*Sesia bembeciformis*), for example, is an amazing mimic and can end its days under someone's boot, so great is its resemblance to a hornet.

The African mocker swallowtail, once described as the most interesting butterfly in the world, is a Batesian virtuoso. The males are always yellow with black markings and are readily eaten by birds, but the females, in most races (except those in Madagascar and the Comoros) are quite unlike the males and until 1869 were thought to be quite distinct species. They appear in at least 14 different guises throughout the African continent, most of them tail-less and mimics of toxic species. In Ethiopia and Somalia the females resemble the evanescent yellow male (which has earned the popular name of the "flying handkerchief"), while others are mimics of poisonous danaid (milkweeds and their allies, see Chapter 6), and orange *Acraea* butterflies. The female mimics (known as *morphs*) have no tails, and most have either predominantly black and white wing colours, or orange and black (as, for example, in the morph that mimics the toxic African monarch or queen butterfly (*Danaus chrysippus*). Some female morphs, by a strange twist, resemble the males, which is believed may prevent them from being harassed by randy males, which could influence their chances of mating and so have an effect on populations comparable with that of predation.

Papilio dardanus is not unique among swallowtails for its complex sex-linked mimicry. This is also rife amongst the birdwings and swallowtails of South-East Asia and Australasia, and includes many examples that Wallace discovered in the mid-nineteenth century in his travels through Malaysia and Indonesia (see Chapter 4).

The German naturalist and explorer, Fritz Müller, a great admirer of Darwin, found that South American passion

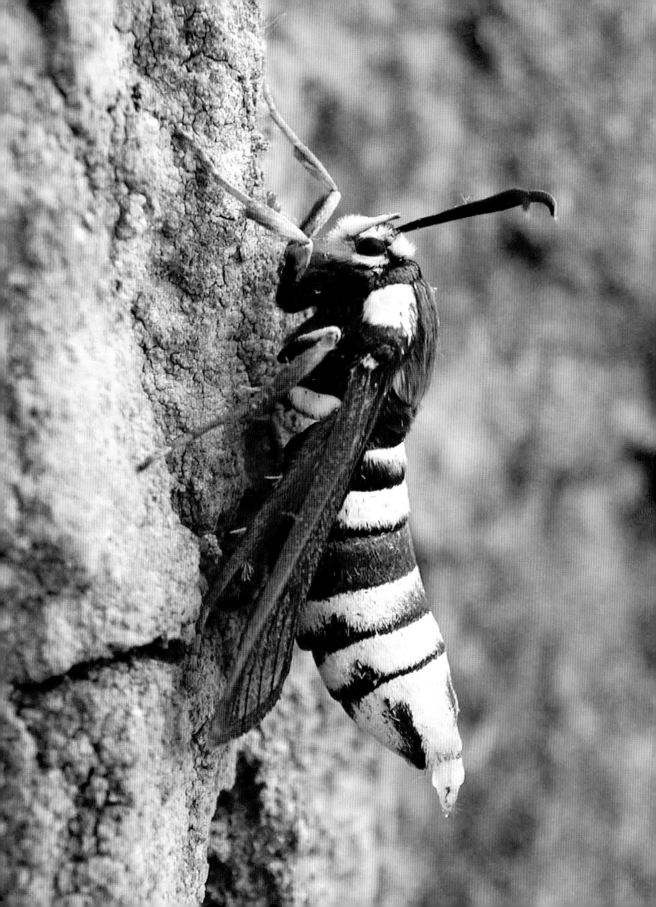

vine butterflies and some of their poisonous relatives often shared the same colour patterns. He suggested that this gave them all better protection because a bird that got a distasteful beakful would then avoid any butterfly with a similar colour pattern. He showed mathematically that this gave an advantage to the rarer of two species that occurred together.

An analogy of Batesian mimicry, then, is that of an unarmed merchantman flying the flag of a warship, and that of Müllerian mimicry is fleets of armed warships all flying the same colours. The most famous and well-studied examples of this latter form of mimicry occur among the passion vine and longwing butterflies of South and Central America (see Chapter 10). The two types of mimicry intergrade, however, and a Müllerian mimic of one species may be a Batesian mimic of another.

Bates, Müller and Wallace were interested in insects that mimic other insects, and biologists have focused on this aspect ever since, as can be seen in any biology textbook. Every year, hundreds of scientific papers on Batesian and Müllerian mimicry are published; with rare exceptions they are all concerned in some way with butterflies mimicking other butterflies. But does mimicry stop there?

Satyric Mimicry

It is common for artists to "hide" or embed images within their paintings – Salvador Dalí was a master at this; some of his famous paintings have a face or skull in which other images are inserted that we tend not to notice unless we are looking for them. The reason that we have difficulty in recognising such images is not just that we tend to see the whole picture and leave it at that, but that we need to focus on the detail to see them.

Some surrealist art with clashing images, such as that of Max Ernst, finds analogues painted by nature on the wing patterns of Lepidoptera, as can be seen, for example in Chapter 12. The main effect of mixing two normally unrelated images is to tangle the threads of perception that weave the picture in the mind, and it takes more than a few seconds to disentangle them and conquer the confusion.

One of the most terrifying monsters to the ancient Greeks was the mythical Gorgon Medusa, whose glance turned people or animals instantly to stone. Masks of her were carried by warriors in battle, notably by Alexander the

opposite top: Four forms of *Heliconus numata* (top two rows), two forms of *Heliconus melpomene* (row 3), and the two corresponding mimicking forms of *Heliconus erato* (bottom row)[1]

opposite below: Some of the remarkable mimetic forms of the African mocker swallowtail (*Papilio dardanus*). Above the line are the toxic models of other species (and the male far left), and below the line are female *P. dardanus* mimics. The yellow male is also mimicked by females (see text)

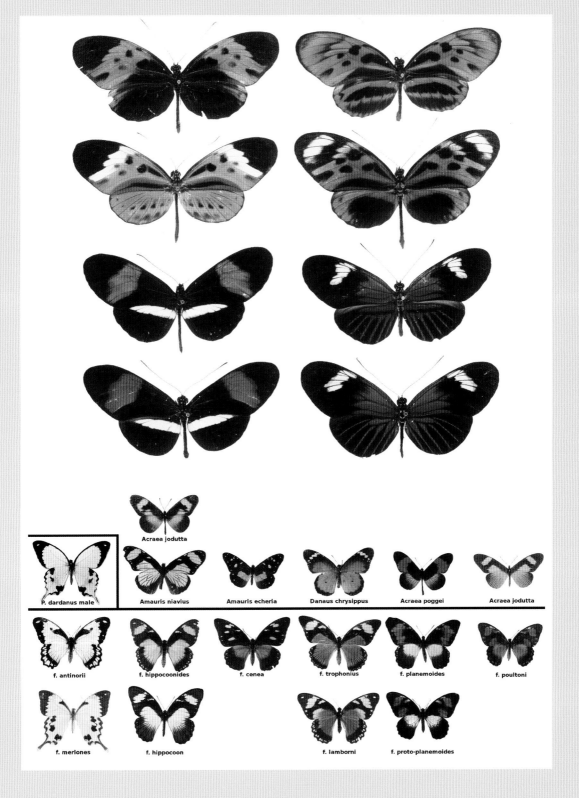

Acraea jodutta

P. dardanus male

Amauris niavius

Amauris echeria

Danaus chrysippus

Acraea poggei

Acraea jodutta

f. antinorii

f. hippocoonides

f. cenea

f. trophonius

f. planemoides

f. poultoni

f. merIones

f. hippocoon

f. lamborni

f. proto-planemoides

Great,[2] and by young women on a bag (the *aegis*) containing a snake as protection. Her portraits typically showed a yellow or orange face with staring eyes, a crocodile grin, long, pointed Dracula teeth, a blood-red tongue, the fat nose of a carnivore such as a dog or bear, coiled snakes for hair, the wings of a hawk, and claws on her feet. These are all features that we see in many mythical creatures such as dragons, features that derive from vicious and dangerous predators that can kill, creatures from which we instinctively flinch. The giant Atlas moths and many of the other giant silkmoths provide good examples in which a mix of embedded images creates monsters that are not too dissimilar.

We find on insects many images of animals that inspire fear in people, such as spiders, heads and eyes of various animals, poisonous toads, bats, feathers of hawks, poisonous millipedes and many other things. Why has no one noticed these? Firstly, we always tend to see what we are expecting to see and not look for anything we are not expecting. Secondly, we see the whole insect to start with, and don't need to look at all the parts to decide whether or not it is a butterfly or moth. Unlike birds, we are then more interested in looking at the detail to work out what species it is, rather than whether it would be dangerous to eat.

Butterflies and moths, it seems, are iconic in the original sense of the word; an icon was first and foremost a representation or likeness of a religious personage, but is also used in semiotics for a class of images that are likenesses, distinguishing them from other types of symbol. Animals that carry iconic images that make them ambiguous to an observer have been termed "satyric mimics",[4] in allusion to the half-man half-goat satyrs of Greek mythology. Iconic images of animals that are important predators of butterflies include frogs, toads, lizards, rodents, bats, monkeys, and birds.

Sigmund Freud used the German word *unheimlich* (unfamiliar or discomforting, but generally translated as "uncanny") to describe objects that have something weird or unexpected about them, arguing that they were usually emotionally charged. This concept was applied by Masahiro Mori to the way people react to human-like robots. As the similarity of a robot to a human increases, so does empathy with the image increase – but only up to a point, at which the image becomes strongly repellent. After this area of uncertainty, named the "Uncanny Valley", empathy increases again sharply.

The Atlas moth (*Attacus atlas*).
Embedded images include snakes, predator claws and a bat

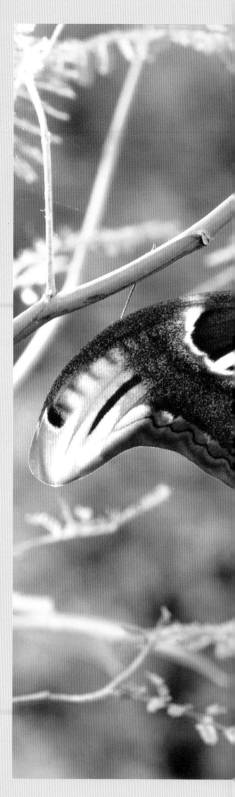

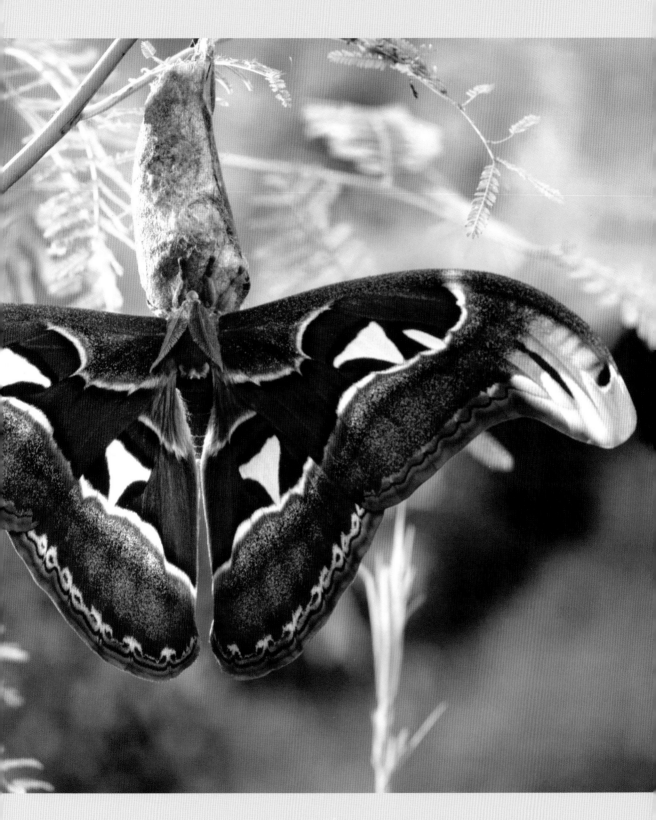

The same phenomenon is evoked in response to people with facial deformities, and to the aliens of science fiction.

The fact that obvious "imperfect mimics" are well protected from predation has been a perennial puzzle for biologists. Research has shown that pigeons are confused by hoverflies with features that are half fly-like and half-wasp-like.[3] This is where the gradient of generalisation from "fly" is roughly at the same level as the one from "wasp", suggesting that birds too have an "uncanny valley". If this is so they should not really be called mimics: they are aliens, which to us would be represented by mythical animals with unknown powers, or, at the least, appear ambiguous.

The survival value of ambiguity was explained in the previous chapter. One of the greatest dangers facing a small insect-eating bird is a larger bird, for example a hawk, eagle or owl, and any bird searching for insects may get an unpleasant surprise if it pecks at such a predator or another bird of *any* kind. Any insect that has the mask of a bird's head, beak, feathers, wing or tail profile may just be able to avoid attention for the split second it needs to escape. The mask or icon does not have to be a complete image but may contain only sufficient features – for example eye-spots – to suggest the presence of another creature. A striking example of a bird icon is found in the arctiid (Tiger) moth (*Amaxia apyga*) from Costa Rica (see page 34). Were it not that bird icons can be seen again and again in Lepidoptera if you look for them, this might be dismissed as illusory; the kind of image you may think you see in an ink-blot. But note that there are many features of a bird head in *A. apyga* that are listed in bird identification guides: crown, forehead, eyes, orbit, ear coverts, lores, chin, throat, and wing mantles. We should also bear in mind that the parent birds are virtually all that a nestling sees, along with its siblings, so birds are primed to see similar images when they leave the nest.

You may succeed in finding images of all kinds of animals in the photographs of butterflies and moths in this book. Some will be difficult to see at first, but once you have seen them they will look even more convincing every time you look. Notice that some are visible only when the insect is viewed from a particular angle. When you look at the wings of a butterfly or moth, you very often find that embedded images lie on the edges of the wings. It appears that different families of butterflies evolved a basic wing shape and colour pattern, and species diversified during the course of many millions of years, evolving crude images of poisonous caterpillars, wasps, bees, bird beaks, etc. in ways that made use of the wing margins to delineate outlines of the bodies of such creatures.[6]

Butterflies, Art and Illusion

Before reading on, put this book briefly aside and draw a butterfly from memory.

My guess is that you will have drawn a butterfly with the wings neatly splayed out horizontally (I do this myself when doodling in boring meetings, perhaps fuelled by a subconscious hope that I could escape on silent wings). That is how butterflies appear in almost all identification guides, museum displays and in advertisements for "natural" luxury products. In museum collections, butterflies and moths are always "set": displayed with the wings dried in a horizontal position, with all four wings pushed forwards so that as much of the surfaces as possible can be seen (as in the illustrations on page 39). This enables taxonomists to detect small differences between similar species that may be difficult or impossible to see in a live insect or in one that has died and dried with its wings folded.

Your image of a butterfly probably has the head up and the body down. That's the way we see most things; we read a page and keep our heads in the vertical plane so

that we see everything "the right way up". Many things look completely different upside-down and we are very uncomfortable with writing or a picture which is the "wrong" way up. This does not necessarily apply to very young children who have *form constancy*, that is they recognise an object equally well from any angle; it is only as they mature that they adapt to seeing things more easily in a conventional orientation.

One easily recognisable image can even turn itself into another on inversion. The surrealist artist Salvador Dalí experimented with this in a number of his paintings. One of the most striking is the almost incredible transmutation, achieved by skilful painting of the reflection, of elephants drinking at the water's edge into long-necked swans when each trunk becomes a swan's neck. Another illusion depending on inversion is an anti-Papal coin from the sixteenth century in which the Pope's head becomes that of his antithesis, the devil, on inversion.

One of the most striking examples of the creation of a new image by inversion is found in the eyed hawk moth (see Chapter 11) in which, when the insect is viewed face down we see the caricature of a fox, but there are many other examples which you will discover as you read on. Many moth species, such as the oak eggar, also come to resemble small rodents when seen in the head-down position, as a bird might see them.

I'm watching a blue tit hunting for insects in trees and bushes. It goes up and down, swings around branches inspecting all the surfaces, constantly changing the position of its head in space, second by second. Its chances of seeing an insect "the right way up" are pretty low. It is obvious that, in order to recognise something very quickly, the bird has to rely on special cues of characteristic details of colour, pattern and shape. Birds hunt in different ways for insects in vegetation: treecreepers and nuthatches run up and down the

Oak eggar moth (*Lasiocampa quercus*) in leaf litter, resembles a mouse when seen in the head down position

trunk, flycatchers and yellowhammers hover up and down the tree trunks close to the bark, robins and great tits survey from a vantage point and then make a detailed search at close range where they are able to detect moths by their profile close to the bark. Thus, for most animals that forage in vegetation, form constancy extending to all planes of perspective is a necessity, and has been demonstrated in Japanese tomtits,[5] while in ground-dwellers, including ourselves, it is gradually lost when the perspective is changed by rotation of the object to the left or right. This is easy to test for by rotating a printed illustration in front of you. The artist Paul Cézanne's letter to his son on interpreting nature strikes a chord here:

"Here, on the riverbank, there are more and more motifs. The same subject seen from a different angle offers a subject for study of the very greatest interest, and so varied that I think I could occupy myself for months, without leaving the spot, by leaning somewhat more to the right, somewhat more to the left."

An easily recognisable object placed in an unusual setting can take a few seconds to interpret – a

phenomenon that has often been exploited in surrealist art. Many insects have images of dead leaves, grass, lichen and so forth on their wings. The wing outlines may say "moth" to you, while the wing patterns say "lichen" or "dead leaf". This was once known as protective resemblance, and is now called camouflage or *crypsis*. Vladimir Nabokov, the celebrated author (and impassioned entomologist) wrote:

"When a butterfly has to look like a leaf, not only are all the details of the leaf perfectly rendered but markings mimicking grub-bored holes are generously thrown in."

He was so overwhelmed by the "*mimetic subtlety, exuberance and luxury*" of mimicry that he refused to believe that it could have been achieved by natural selection. For some strange reason, though, we are all willing to accept that some butterflies and moths are good copies, not just of the patterns and colours of lichens and dead leaves, but also of objects such as moss, twigs, flowers, flower-buds, grass, bird droppings, fungi, stones and the ground itself to a high degree of perfection, but most people remain highly sceptical of any suggestion that insects mimic birds and other animals with which they share their environment.

Ambiguity: Facing Two Ways at Once

"Ambiguity" occurs when there are two possible meanings to something or two possible interpretations of something. For example, "They're cooking apples" is an ambiguous statement. Puns such as "Time flies like an arrow; butter flies like a flower" surprise us and usually make us laugh – at least when we hear them for the first time.[7]

A well-known and simple visual illusion is the figure of a Greek vase in silhouette. If you start looking for the outlines of two faces you will suddenly see them, but it is impossible to see the vase and the faces at the same time, and once you have seen both images your brain keeps switching between the two. There are many such illusions, but what is important is that they make you hesitate while you try and decide what it is that you are really looking at.

Ambiguity is at the root of many forms of camouflage or *crypsis*. The peppered moth (*Biston betularia*) is usually white, resembling lichen, but a black form can be common in some places, and the variation is often used to illustrate the process of evolution by natural selection. In the middle of the last

The light form of the peppered moth (*Biston betularia*) is difficult to spot on a tree trunk where lichens grow

century the blackish, so-called "melanic" form was found to be common in the industrial Midlands of England, where there is more soot on the trees, making it difficult to detect against a black background. This gives the melanics a much better chance than the white moths of escaping the eye of birds, but the black form blends in better on tree trunks where there are no lichens. Lichens, however, need clean air, and industrial pollution tends to kill them.

Many butterflies, especially with their wings closed, tend to melt into the background. White and yellow butterflies sometimes appear to reflect the colour of the surrounding leaves, although their colour can also change with the angle at which light is reflected from the wings. This is so in the Cleopatra butterfly, for example, which appears bright yellow in sunlight, but yellow-green, like a decaying leaf among vegetation (the male fore-wings also reflect ultraviolet very strongly). The green-veined white also appears greener when resting among plant leaves, and the holly blue reflects the colours of flowers on which it feeds. The phenomenon of *colour constancy*, whereby colours of an object appear not to change for us in different lights means that we notice these reflected colours only in photographs. The camera does not have colour constancy but most photographs are taken in good illumination, and the reflection of coloured light from flowers and leaves is detected only in photographs of shaded objects. There is some evidence that birds have only limited colour constancy[8] in which case they might have difficulty in seeing butterflies coloured with reflected light when they come to rest on flowers and vegetation, but few species have been studied in this respect and the question remains open.

Ambiguity is confusing to us and can also lead to life or death decisions. In his book *The Decisive Moment* Jonah Lehrer describes the dilemma of a radar operator on an Allied warship during the 1991 liberation of Kuwait. On one occasion a blip on the radar screen appeared identical with those from US fighter aircraft using the same airspace, but the operator sensed something suspicious. He had seconds to decide on whether to destroy the target which might have been an Iraqi missile heading for the ship, but if his hunch was wrong he would down an Allied fighter plane with its crew. He pressed the button to destroy the target. That turned out to have been the correct decision. It took months of analysis before the subtle feature that made the radar trace ambiguous was detected: an eight-second delay in the target appearing on the radar screen as it climbed to the same height at which aircraft were flying.

above: A remarkable example of ambiguity, this Brazilian moth (unidentified) mimics a red-legged tree frog. It is impossible to see both images at the same time, confusing identification

opposite: A fragment of bark? The comma butterfly (*Polygonia c-album*). But note the rodent-like face in which the mysterious "comma" becomes an eye

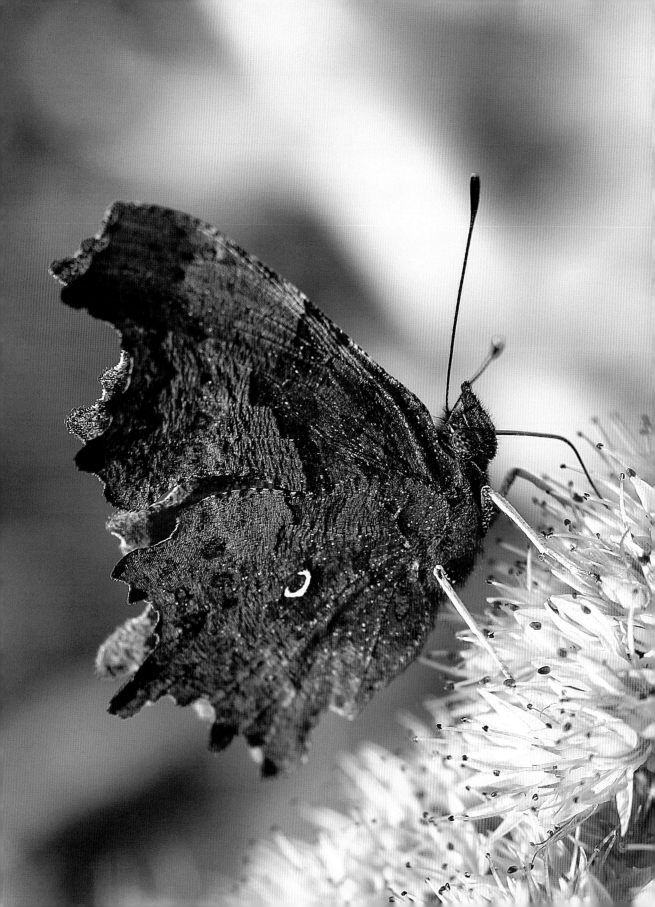

The muslin moth (*Diaphora mendica*): (*left*) resting among red flowers; (*right*) among green leaves

Birds hunting insects face not dissimilar dilemmas. What may appear to be an insect may have some aberrant features, for example, details on its wings that resemble, say, canine teeth or animal claws. Again, there is something suspicious and an instant decision is needed. Just as a wrong note mars the experience of a piano recital, a bird might treat an unexpected distortion in a visual image as something alarming.

Many insects have some ambiguous aspect to them that may confuse vertebrate predators. False heads are found in some butterflies and moths at the tail end; these usually take the form of eye-spots on the tips of the hind-wings coupled with fine projections that look like antennae. Some tropical species of blue butterfly have long filamentous false antennae on the hind-wings and make them appear to move by slowly moving the hind-wings. The hairstreak butterfly (*Calycopis cecrops*) which is preyed upon by jumping spiders has a different means of distraction: it turns its false head towards the perceived attacker.[9] In this butterfly and also many others, including the tiger swallowtails and the Jersey tiger moth, the illusion of a "false" head is strengthened by lines on the fore-wings which converge on the eye-spots at the end of the hind-wings so that the eye is led towards them. There

are two advantages to the false heads. First, a confused bird may peck at the false head rather than the true one: this is known as the deflection hypothesis. Second, the ambiguity – the confusion over which is the true head – may delay a strike long enough for a butterfly to fly off. These hypotheses are by no means mutually exclusive. Indeed butterflies can often be found with their eye-spots pecked out (see opposite and page 131).

Alice's Blue Caterpillar and Other Mimics

Many caterpillars present visual ambiguities. One of the famous illustrations by Sir John Tenniel for Lewis Carroll's *Alice's Adventures in Wonderland* is that of the pipe-smoking blue caterpillar that Alice found sitting on a mushroom. The head of the caterpillar looks almost human. Tenniel has used the outlines of the three pairs of jointed front legs of a caterpillar to create the illusion of a face in profile. This is an illusion similar to that of the Greek vase: you see either a caterpillar or a hooded pipe-smoker.

The elephant hawk moth caterpillar is often mistaken for a snake because of its habit of lifting and inflating the front part of its body, thus enlarging the two eye-spots there so that the front segments appear

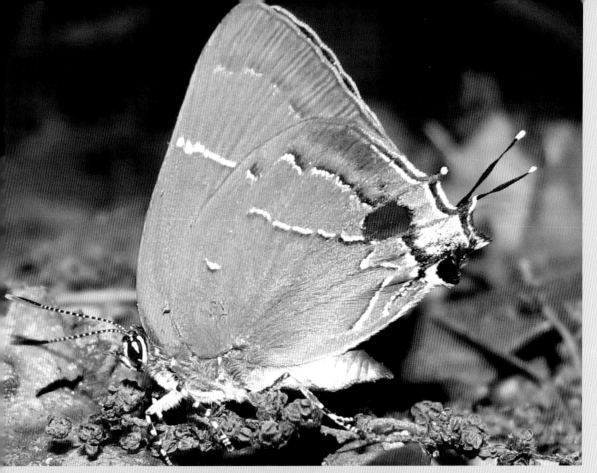

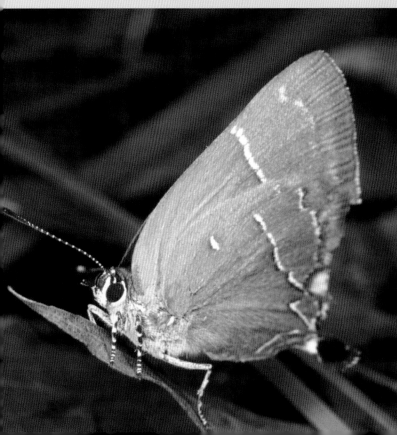

above: Predator distraction: false head in the red-banded hairstreak butterfly (*Calycopis cecrops*)

left: With the false head missing after an attack by a jumping spider

Tenniel's illustration of the caterpillar smoking a hookah in *Alice's Adventures in Wonderland*

to turn into a snake's head, which scares the unwary. The forelegs, unlike those in Tenniel's cartoon, suggest a snake's fangs rather than a nose and chin. The caterpillar may also make striking movements when threatened, completing the masquerade.

One of the most spectacular illusionists is the lobster moth caterpillar, which has multiple ambiguities associated with it. Look at different parts of the body, masking them off and rotating the page, and you may find a snake's head with forked tongue, a spider with folded legs, and perhaps even a scorpion's sting. It has also been said to closely resemble a curled-up dead beech leaf.

Caterpillars of some hawk moths, called "hornworms" in America, have false heads, like Dr. Doolittle's "Pushmi-pullyu". In the well-known children's book this was an antelope with a head at each end of its body (later a llama in the film), which faces both ways at once. In the caterpillars, of course, one head (with the horn) is a dummy, but possibly a good enough one to confuse a predator – you will probably not immediately be able to identify the real head of the convolvulus hawk moth caterpillar on page 52. This caterpillar is possibly a mimic of the three-lined salamander, which has exactly the same colouring with black bands running the length of the body and white markings on the abdomen and legs. Some salamanders, like many frogs and toads, secrete powerful venom from glands in their skin. The poisonous salamanders are generally brightly coloured, and some of the other fat, smooth hawk moth caterpillars, including the yellow-spotted one of the Madder hawk moth (*Deilephila gallii*) may also be salamander mimics.

Birds are able to learn which insects are best avoided. The caterpillar of the monarch butterfly (*Danaus plexippus*) has yellow and black bands around its body – the familiar wasp insignia – and feeds on milkweeds (Asclepiadaceae), which are highly poisonous plants, containing substances (cardiac glycosides) that can cause violent illness and stop the action of the heart. The passion vine butterflies (Chapter 10), amongst others, feed on poisonous plants of the family Solanaceae, which includes the nightshades. The poisons persist in the caterpillar's body until it becomes as adult butterfly.

Some caterpillars are covered in stinging hairs. Generally, only a few birds, including cuckoos, are able to cope with hairy caterpillars. The hairs typically contain histamines and other toxic chemicals which can produce painful

opposite above: Caterpillar of the lobster moth (*Stauropus fagi*)

opposite below: Elephant hawk moth caterpillar (*Deilephila elpenor*)

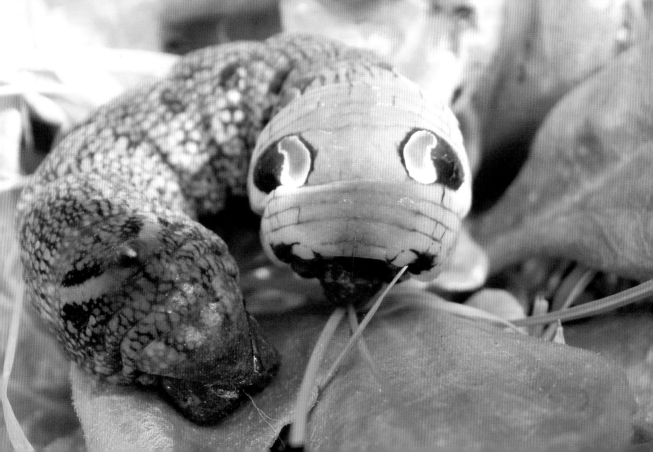

Caterpillar of the convolvulus hawk moth (*Agrius convolvuli*)

allergic rashes in most mammals, including ourselves. The caterpillars of the brown-tail moth (*Euproctis chrysorrhoea*), for example, live together in silken tents on trees and bushes; it is dangerous to get too close to these tents because the hairs from the cast skins of the caterpillars can blow around in the wind and get in the eyes and lungs, producing asthma and painful irritation, which sometimes needs hospital treatment. The caterpillars of the giant silkmoth of the American tropics, *Lonomia*, can kill.[10] The hairs contain a powerful venom and the caterpillars group together, so that contact with the cluster can produce multiple lesions and injection of a lethal dose.

Many butterflies have colour bands on their wings, which are caterpillar-shaped, with darker coloured "heads" and a row of black dots which resemble the spiracles (breathing holes) that caterpillars have on each segment of the body. The red admiral provides a good example (Chapter 5). Usually the caterpillar is a different colour from the adult butterfly or moth, but there are exceptions to this, in which the moth mimics the caterpillar. Another example is the magpie moth, which birds and other animals avoid. The caterpillar is also rejected by most birds, so this is a case of the adult moth becoming a mimic of its former self, or possibly of both being Müllerian mimics of each other. There may be many more such examples waiting to be found. Perhaps Linnaeus knew of the warning colours when he called it "Abraxas" – the word for a kind of talisman that the Ancient Greeks used to keep evil spirits away.

opposite above: The magpie moth (*Abraxas grossularia*) with images of its "looper" caterpillar on each fore-wing

opposite below: Caterpillar of the magpie moth

Let us now reconsider the concepts of Batesian and Müllerian mimicry. Butterflies and moths mimic many diverse features of their surroundings and Batesian and Müllerian mimicry and crypsis can be viewed as special cases. The concepts of Batesian and Müllerian mimicry have been developed from the study of mimicry of Lepidoptera by other Lepidoptera. The boundary between the two types of mimicry, which are based on the relative toxicities of model and mimic, has been notoriously difficult to define and is obviously artificial. The concept of crypsis, in contrast, does not include chemical toxicity or distastefulness but is effectively mimicry of the background on which an animal rests: usually rock, twig, fungus or other vegetation. However, as you read on you will find on butterfly and moth wings many images of animals that are not chemically toxic. They include mammalian, reptilian and bird heads, bird plumage, etc. This form of mimicry, which I have called "satyric mimicry" forms a bridge between crypsis and other forms of mimicry, encompassing a continuous spectrum of predator-prey relationships.[11]

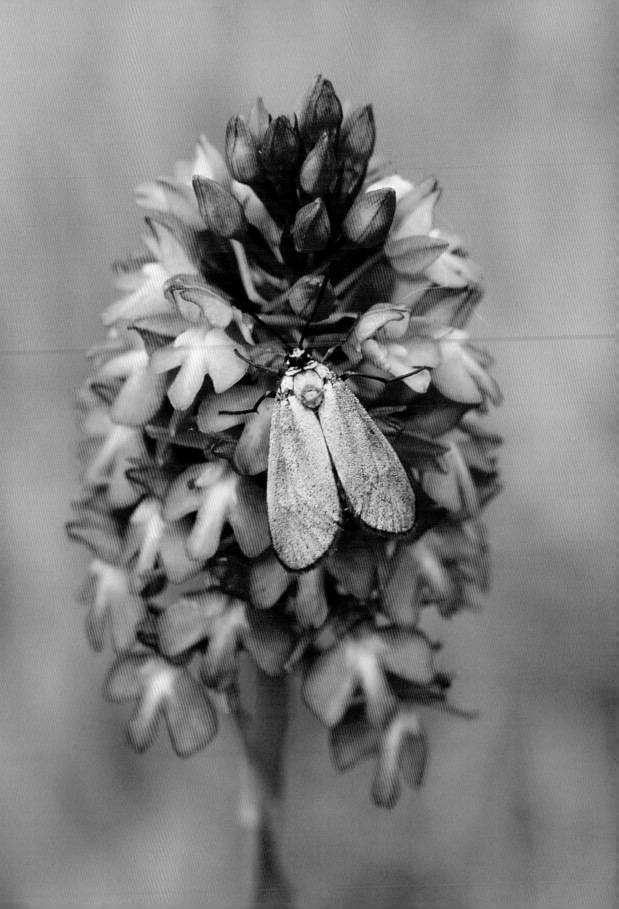

DINOSAURS, BUTTERFLIES & COLOUR

Not half so many sundry Colours are
In Iris' Bow, ne Heaven doth shine so bright,
Distinguished with many a twinkling Star;
Nor Juno's Bird, in her Eye-spotted Train,
So many goodly Colours doth contain.
— Edmund Spenser, *The Fate of the Butterflie*, 1591

Many butterfly species including the brush-footed butterflies (Nymphalidae) – some of those most familiar to us today including the tortoiseshells, painted ladies, commas, fritillaries, admirals, purple emperors etc. – have wings which are mainly orange, brown or black. In other families, white or yellow, or iridescent blue colours tend to predominate. To understand why these colours have evolved, we have to look back to the age of the dinosaurs.

In the course of evolution, it seems that patterns gradually evolved on an orange-brown wing canvas, particularly on the borders where the sinuous outline, which appears to flex as the wings fold and unfold, forms a template for crude images of such creatures as salamanders, lizards, caterpillars or millipedes. Orange is the colour of old red sandstone, which formed mainly in the Devonian when the evolution of land vertebrates began. It was the ideal camouflage colour then for animals living in riverbeds and semi-deserts. They manufactured their own pigment – melanin – from

A forester moth (Zygaenidae) –
Monti Sibillini, Italy

tyrosine, which is present in animal cells and is one of the amino-acids used to make proteins.

We may never know how the scaly dinosaurs were coloured, because the thin skin covering their scales and containing the pigment is destroyed during fossilisation. However, the dinosaur *Sinosauropteryx*, which lived in China 125 million years ago, had primitive feathers which housed pigment cells (melanophores) containing melanin (which may be orange, brown or black). Melanin in our skin and that of other animals protects against damage to DNA resulting from exposure to ultraviolet light from the sun. It has the interesting property of absorbing ultraviolet light and converting it to heat. It is not surprising, then, that many living mammals, birds, and cold-blooded reptiles and amphibians (as well as humans exposed to high intensity sunlight) have melanin in their skin, hair or feathers, and in the iris of the eye.

We can immediately see the advantages of orange and brown pigmentation in butterflies. It serves the purpose of camouflage in areas with ferruginous soils and rocks, helps warming of the body in the sun, and protects against damage to the soft tissues of the body. The fossil butterflies, *Praepapilio* and *Riodinella*, from the Eocene period (around 40 million years ago), have predominantly orange, brown, yellow and white pigments as did the 34-million-year-old *Prodryas persephone* from North America. White or yellowish pigments are mostly substances known as pteridines. These are essentially nitrogenous waste products that are shunted into the hollow microscopic wing scales which appear to us as "dust". The scales serve then not just as a thin layer of micro-dustbins but also as arrays of transparent envelopes for wing pigments – one of nature's amazing economies.

As we saw in the first chapter, adding a new cone type to the retina results in a hundredfold increase in the number of colour hues that can be seen. This must have been an important driver in the evolution of butterflies and moths, because as vertebrate predators developed more cones, they could more easily distinguish cryptic insects from their background, putting the latter at a disadvantage and encouraging the evolution of brighter colours that could have a shock effect or advertise distastefulness.

Iridescent colours, on the other hand, are not usually produced by pigments but by reflections from the ultra-thin layers present in scales, feathers, etc. Scientists at Yale University have found iridescent colours in the feathers of a 40-million-year-old bird fossil, *Confuciusornis*, from China.[1] These colours, like those of kingfishers, are produced by light reflected from the feather surface and from the surface of melanophores. Some scientists believe that predatory dinosaurs, such as *Sinosauropteryx*, which fed on small lizards and insects, also had iridescent colours.

Lepidoptera generate iridescent colours on a carpet of melanin. The iridescent surface of melanophores becomes transparent when viewed at certain angles, so that the blue, green or silvery colours suddenly give way to the dull brown underlay. These varying scintillating and evanescent rainbow colours provided both birds and butterflies with a means of self-advertisement, which is useful for courting males, but a liability for egg-laying females that need to conceal themselves from predators.

Recently, a 47-million-year-old fossil moth was found preserved in oil shale in Germany[2] and is thought to belong to the family of day-flying moths known as burnets and foresters. Advanced imaging techniques revealed that the colours of the wings in life were yellowish-green, produced by iridescence, and the researchers concluded that the colours helped to camouflage the moth in vegetation and also acted as warning colouration in sunlight.

The forester and burnet moths are found today throughout the world in temperate zones and are all capable of secreting cyanides to defend themselves. Some extant forester moths are remarkably similar to the fossil species, little changed, it seems, after 47 million years (see page 54). It is sometimes asked why evolution should have produced the dazzling colours of peacocks, kingfishers and blue butterflies, when they are seemingly more beautiful than they need to be. But this is the way iridescence works, in soap bubbles as well as birds and butterflies. A better question is, "Why do these colours provoke in us such awe and delight?" And how many millions of years, one wonders, did it take to evolve scales with the fine, precisely patterned sculpturing that selectively reflects light of yellow-green and blue-cyan wavelengths, the amount varying with the angle of incidence of the sun's rays?

Land Bridges

Some of the common European nymphalid butterflies are also found in North America; for example, the small tortoiseshell, Camberwell beauty (known as the mourning cloak in America), the red admiral and the painted lady. Others, including tortoiseshells and commas, exist as species which differ only slightly between the continents. A possible explanation for this distribution comes from an unexpected source: the discovery of a minute fossil tooth, only millimetres long, at Maastricht in the Netherlands.

The tooth is that of an opossum-like mammal that lived alongside the dinosaurs 66 million years ago, about a million years before the latter became extinct. Palaeontologists[3] have concluded that this marsupial must have come from North America over a land bridge incorporating Newfoundland, Baffin Island, Greenland, the Faroes and Great Britain, at a time when Arctic temperatures were much higher than they are today. Now, clearly, if marsupials were able to use this land bridge so were insects, especially those that were strong

fliers and, above all, that were able to feed upon plants such as nettles and thistles that are pioneers on newly cleared land in temperate zones. This land bridge, like the one along the Bering Strait, through which humans migrated into North America from Asia, may have been open also during the last Ice Age 10-15 million years ago.

It seems likely, then, that butterflies followed their food plants as they colonised new continents over land bridges in the northern hemisphere. Of the approximately fifty species of fritillary butterfly found in Britain and Europe today, a few are found right through to Siberia and northern Norway. More significantly, the Arctic fritillary (*Clossiana chariclea*) and its relative the Polar fritillary each have a circumpolar distribution extending from north-east Siberia to Greenland, Labrador and the North American Arctic. Many fritillaries feed on members of the violet family, which are widely distributed in sub-Arctic regions. Most people are surprised to learn that the same small tortoiseshell, Camberwell beauty, red admiral, painted lady and comma, all species that we think of as uniquely British and North European, are found in North America, where similar species of white admiral, purple emperor, fritillary and comma are also found.

Being among rare butterflies and their food plants was ecstasy – a spiritual experience – for the famous author Vladimir Nabokov. He carried out research for five years in Harvard Museum of Comparative Anatomy on the classification of blue butterflies (Polyommatini) and came to the conclusion that there have been at least five invasions of blue butterflies from Asia into North America across the Bering Strait, and in the reverse direction, over the last eleven million years. To add to his outstanding reputation as a writer, he achieved posthumous fame amongst the previously sceptical scientific community when his hypotheses were confirmed in 2011 after the application of DNA "finger-printing" of populations from the Old and New Worlds.[4] It is not unreasonable to suggest that

the nymphalids (fritillaries, admirals, tortoiseshells, etc.) mentioned above made similar journeys.

Many nymphalids share similar wing patterns: a background of fiery orange marked with black designs. Some of them, however, have evolved additional iconic devices in the form of crude images of wasps, bees, poisonous caterpillars and even bird beaks on the borders of their wings (see Chapter 4).

The caterpillars of some species have the ability to feed on toxic plants, and while they are feeding they have the toxins in the gut. It is then intuitively obvious that they will benefit by evolving conspicuous colour patterns that will enable predators to learn to distinguish them more easily from palatable ones. This also applies to caterpillars that are able to sequester food-plant toxins in their body tissues where they are retained and persist in the tissues of the adult insect.

The Camberwell beauty (*Nymphalis antiopa*) is very common in much of North America up to the Arctic Circle,

in Canada and across Europe and Asia to Japan. It is one of a number of butterfly species that does not mimic another toxic adult butterfly, but appears to be a Batesian mimic of a toxic caterpillar, in this case figured by the black-speckled white or cream wing borders. These resemble the humped caterpillars of the common silkworm (*Bombyx mori*), and its wild ancestor from central Asia (*Bombyx mandarina*). Their food plants – mulberry trees – contain toxins in the sap and leaves. This caterpillar image would have been an advantage when the butterfly colonised the New World. The gulf fritillary (*Dione vanillae*) and the passion vine butterfly (*Heliconius melpomene*), which are common in parts of the American tropics and sub-tropics, have black-speckled white caterpillars that feed on poisonous passion vines.

Members of the great family of brown butterflies, the Satyridae, are common everywhere, particularly on grassland. Not surprisingly the grass-feeders have colonised most regions of the globe except the Arctic and Antarctic. The gatekeeper or small meadow brown butterfly (*Pyronia tithonus*) commonly seen on brambles in mid-summer in Europe has even been

found in the hostile environment of southern Chile although it does not occur in North America.[5]

The satyrids or brown butterflies generally have a darker ground colour than the nymphalids, matching the colour of earth or bark. With their wings closed they can be almost invisible amongst leaf litter, but the embroidery on their wings is in the form of eye-spots – portraits of eyes of small insectivorous birds that search amongst the leaf litter and at the bases of grass stems in the early morning and evening. The graylings and meadow browns often bear the patterns of dead leaves or bark on their undersides, but if possible danger approaches the fore-wings are raised slightly to show the copy of a bird or reptilian eye.

The ancient Romans kept dice in brown wooden boxes latticed with holes in the sides so that the dice could be heard rattling and seen when they were shaken. This was called a *fritillus*, and gave its name to fritillary flowers and fritillary butterflies. The fritillary butterflies have orange wings strewn with black spots and lines on the upper surfaces, although sometimes the orange is suffused with green and silvery colours. There are over forty species in the European fauna, and considerably more in North America, where they can be found from Mexico to Arctic America and Greenland.

opposite: The Camberwell beauty
(*Nymphalis antiopa*)

above and top: The southern grayling butterfly
(*Hipparchia aristeus*), Sardinia

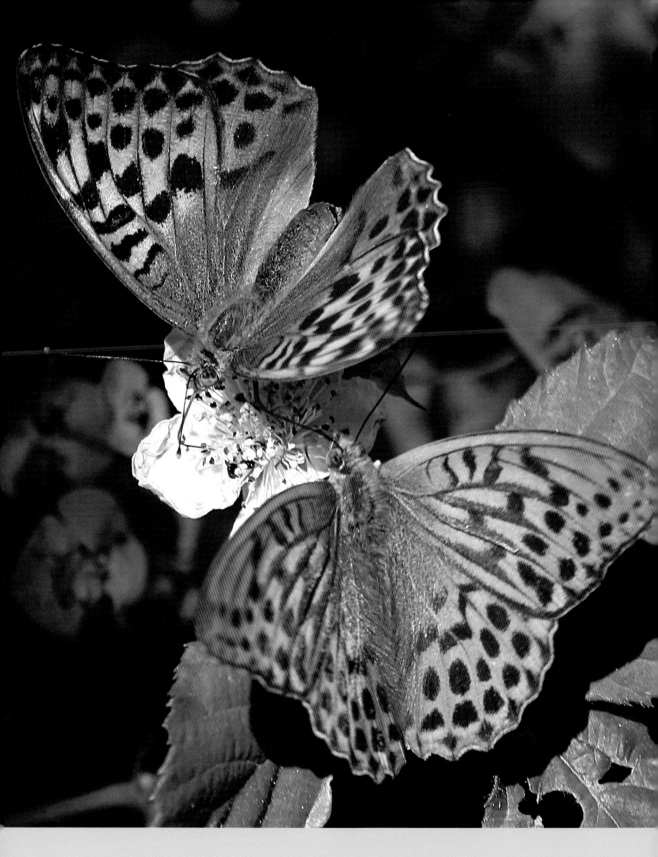

Why might this orange and black pattern, which is found in so many species in the Western world, help the survival of fritillaries? The likely answer to this question will become clear if you look at the breast feathers of many birds: a flick through a bird identification guide will show that the fritillary pattern, which also helps to obscure body outlines, is found repeatedly, and in some birds, for example kestrels, it extends to the wings.

The kestrel is the most common bird of prey in Britain. Small birds such as larks and finches are among its prey; they face a constant threat and one bird will alert all its neighbours (including birds of other species) with mobbing calls when it spots a kestrel or similar bird of prey. The kestrel and its relative the lesser kestrel,

which has the same distinctive markings, are found all over Europe, in fact in the same areas in which fritillary butterflies occur. The American kestrel (*Falco sparverius*) also has similar plumage and North America is the only other zone in which fritillaries are common.

It seems likely that small insectivorous birds have learnt or instinctively recognise the signs of a kestrel – it has been known for many years that they respond to the shape of falcons hovering above them. Experiments with pigeons have shown that they focus their attention first on parts of an image – although they may be able to see the whole, they may ignore the contours. Autistic people may do the same: there is one report of an autistic boy who recognised a

opposite: Silver-washed fritillaries (*Argynnis paphia*) (female above, male below) with the typical chequer pattern on the wings. The black streaks on the male are scent glands used in courtship

below: A mating couple of silver-washed fritillaries displaying the reflective underside of the wings

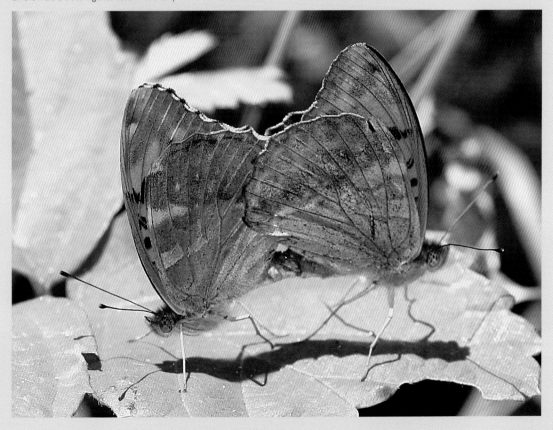

leopard solely from the colour pattern and as a result identified a giraffe as a leopard.[6]

Stuffed kestrels and sparrow hawks placed alongside feeders have been found to deter four species of tit.[7] Even "occluded" models, with part of the kestrel body covered, and truncated ones with only part of the bird visible had a deterrent effect. Evidently tits identified just the pattern of the plumage as a warning signal.

When smaller birds see the kestrel pattern one imagines that they may get a shock a little like the driver of a speeding car might have on seeing the blue and yellow chequered pattern on a police car. Kestrels search for prey either while hovering or, less conspicuously, by sitting on posts or in bushes and trees on the ground. Here they are in the same living space as fritillary butterflies, most species of which frequent woodland glades or the forest fringes.

Looking closely at living fritillaries sunning themselves and feeding on flowers you may sometimes see subtle colour changes that you do not see in museum specimens. This is very easy to see in the silver-washed fritillary (*Argynnis paphia*), which gets its name from the silvery patches on the underside of the wings. The variety *valesina*, which is found in certain areas of Britain and continental Europe, normally presents as orange-brown in colour but in reflected light iridescent patterns are revealed on the wings and these are likely to be much more apparent to birds.

These are not the only forms of protection that some fritillaries have. Look for the face in the pearl-bordered fritillary on the page opposite. It is not difficult to make out two eyes and a nose or beak. The tail feathers of female common kestrels are orange with black bars across them. There is also a copy of a kestrel's tail feather in this picture.

The "kestrel" pattern is found not only in the fritillaries, but also in a few other species found in Europe. The most obvious ones are the painted lady and the comma butterfly, but the large tortoiseshell and the map butterfly of southern Europe are other possible candidates. You can research this yourself with a good identification guide.

Some fritillaries, for example the Queen of Spain fritillary (*Argynnis lathonia*), have silvery blotches on the under-wings. This type of marking is startlingly similar to that of the Central and South American silverspot butterflies (*Dione*). These latter butterflies belong to the family Heliconiidae, which feed on passion vines and hence are very poisonous (see Chapter 10). It is possible that the fritillaries with silver spots evolved millions of years ago as Batesian mimics of silverspots, and after colonisation of Britain and Europe over the millennia the spots have remained because they carry no disadvantage that would lead to natural selection weeding them out.

If we look right back to their early ancestry, it is generally accepted that the birdwings and swallowtails were at the base of the evolutionary tree of butterflies. The birdwings are confined to South-East Asia and Australasia

opposite: The common European kestrel (*Falco tinnunculus*)

top: The small pearl-bordered fritillary (*Bolonia selene*)

above: The silver-washed fritillary (*Argynnis paphia*) from Crete. At certain angles of light reflection iridescent patterns become visible

above: The comma butterfly (*Polygonia c-album*) has colours that resemble kestrel plumage

opposite: The Queen of Spain fritillary (*Argynnis lathonia*) showing silver wing spots

today, while Asia in general has a plethora of swallowtail species. Butterflies were well established at the time of the dinosaurs – the swallowtails and the nymphalids were around about 90 million years ago,[8] but it is believed that during the massive extinction of the Cretaceous-Tertiary period about 65 million years ago (the so-called K-T boundary that led to the demise of the dinosaurs) many butterfly species and their food plants were wiped out. After that event, perhaps 20-45 million years ago, there seems to have been a period of accelerated speciation among insects, particularly in the lower humid slopes of the Himalayas and the Tibetan plain. This zone today harbours a rich fauna of birdwings, swallowtails, and nymphalid butterflies, and, significantly, it is here that bumblebees[9] with their yellow, orange, black and white striped bodies evolved – patterns that we find on the wings of many butterflies. The main predators could have

been members of the crow family (Corvidae), which also underwent a rapid increase in diversity in that epoch, and which were mimicked by many butterfly species.

Many of the ancestral swallowtails, which were toxic as a result of feeding on Aristolochia vines, radiated out and became colonisers of other continents. As they did so, the mimetic patterns on their wings changed to make them safer in the new habitats. Some of them found alternative poisonous food plants, and their mimics, including admirals, tortoiseshells, commas, painted ladies and emperors evolved into new species that changed to mimic features of the animals and plants of their new habitats. They were like ships of one nation flying under false colours, changing their flag to that of each new country in which they sought safe harbourage, in order to find protection.

PEACOCKS &
BIRD EYES

"…they cast about them sparks of the colour of the Rainbow; by these marks is it so known that it would be needless to describe the rest of the body though painted with a variety of colours."

So wrote Sir Théodore de Mayerne, the most famous doctor in Europe in the early seventeenth century who ministered to Charles I among others, about the eye-spots on the peacock butterfly, then known as the "peacock eye". De Mayerne also contributed to the publication of the first butterfly book, the *Theatrum Insectorum* by Thomas Moffatt, written in 1589 but published posthumously.

Images of eyes are powerful symbols for us. They are magnets for the gaze, used in advertisements to attract attention and in social interactions to convey attitudes and feelings. The concept of the Evil Eye pervades mythology and beliefs in many countries from the Mediterranean to the Far East.[1] Eye images also play a huge role as part of the defences of butterflies and moths against predation.

The eye-spots on the wings of the peacock bird are one of the marvels of the animal kingdom, so intricately and precisely constructed at the microscopic level and so accurately positioned and spaced apart on a hypothetical mathematically defined array that the peacock's tail is commonly cited as evidence of the miraculous work of a divine Creator. Each "eye" is mainly blue and violet with a dark centre and an orange surround that provides good colour contrast. Most of these colours are iridescent and change according to the angle at which the

Peacock butterfly (*Inachis io*) displaying its eye-spots

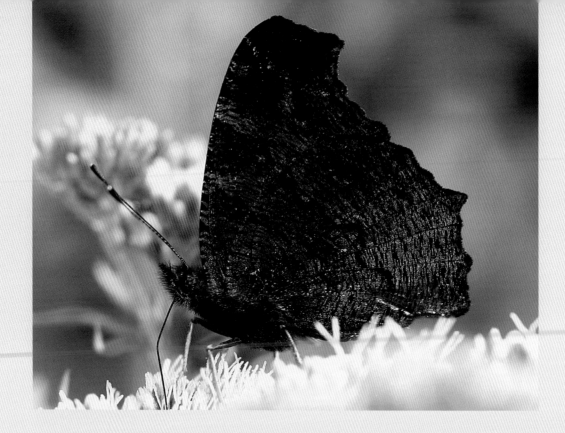

feathers are viewed. Similar iridescence is found in the eye-spots of the peacock butterfly, here based upon reflection from the finely sculptured wing scales.

The peacock butterfly is a magician – at least that is what you might think if you had the eyes and vision of a bird. By closing its wings it becomes part of shaded bark in the hollow of a tree, or a sun-darkened dead leaf, its yellow legs looking like the tips of grass stems.

It hibernates during the winter in hollow trees and similar places, such as the eaves of houses, woodpiles and so forth. With its wings closed it is almost invisible against a dark background, but if it is disturbed then it flashes open its wings to reveal, first, two false eyes and then two more. This sudden apparition has been shown to startle birds, probably by the suddenness and also by the crude animal face that appears. When the insect pushes its fore-wings forwards to expose the hind-wing eyes, the small white spots draw the eyes to them, shifting the focus of the observer and making the display yet more startling. Not only that, but it makes a grasshopper-like sound as its wings open.

Opening its wings to the sun, which it needs to do from time to time to absorb heat, it seems more like a bird of prey with large forward-facing

above: Peacock butterfly with the bark-coloured under-wings that camouflage it at rest

opposite: With the fore-wing eye-spots in focus the body is obscured, and two more eye-spots are in waiting for the insect to suddenly expose them

overleaf: Peacock pansy (*Junonia almana*)

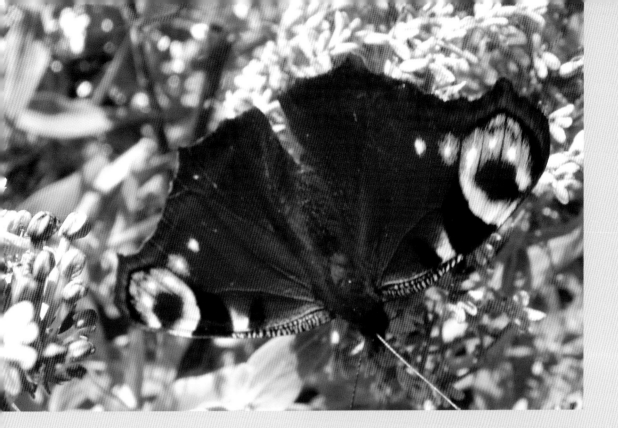

eyes. Each eye-spot on the fore-wings is asymmetrical, but appears to glow in the sun, like those of the bird, but from a ring of iridescent blue scales rather than from the ultra-thin feather membranes in the peacock bird. The asymmetry gives rise to the illusion known as *anamorphism* (i.e., change of form according to the way in which an object is viewed).[2]

When feeding or basking in the sun, the butterfly opens its wings towards the sun, with the result that anything approaching casts a warning shadow over its eyes, so that the sun's rays become part of a biological intruder alarm. A bird approaching from the side can evade detection, but is confronted by two-dimensional non-circular "eyes" — anamorphic images that appear circular when viewed at a narrow angle to the wings. As if to strengthen the illusion, the butterfly fans its wings rapidly, seeming to repeatedly grasp at the air above it, giving the eye-spot the further illusion of a 3-D image.

Imagine you are a (myopic) bird a few centimetres away, and your eyes will focus on the moving eye-like images on the wing tips, which are about 3cm above the body. To capture the insect you need to focus on the body, but that is shrouded in dark scales, and to refocus takes precious microseconds during which time the insect has an opportunity to begin its escape. To convince yourself of this, try looking down from a computer screen to find a key — let's say the letter "z" — while listening to a clock ticking: even if you know approximately where the key is you have to be very familiar with its location to do this in less than half a second.

I cannot leave this insect without further speculation. The yellow-black-yellow coding of the fore-wing barring is suggestive of bumblebees, as in the small tortoiseshell (Chapter 1). There are a number of European (and North American) bumblebee species which have the thorax bordered with white hairs. Look again at the fore-wing eye-spots and you see this border with a

putative head and mandibles in blue, and an antenna-like line of white spots. Fanciful? Don't forget that confusing one bird for half a second is the coinage of survival.

When peacock butterflies are hibernating they are usually unable to fly immediately if they are disturbed because their bodies are too cold, but then they do something quite rare for a butterfly. They produce clicking noises by rubbing the bases of the wings together, so that one part buckles inwards making a noise like that made by a tin lid when pressed in the middle. Although we can hear some of this sound energy, most is ultrasonic, way above our range of hearing. But small rodents, such as mice and rats, and especially bats, have very sensitive hearing in this range and their ears will collect most of the sound energy. The clicks will sound very loud indeed to them when they are close to the source.

Bats themselves emit ultrasonic clicks through their mouths or nostrils and pick up the echoes, getting a sonar picture of objects around them. The noises the butterfly makes are in the same frequency range as those of the bats, so that insectivorous bats, which have very poor vision, may get the impression that there is another bat in front of them rather than a butterfly. They sometimes make little screams or jump back when they hear a butterfly clicking, and move away. The small tortoiseshell butterfly, which also hibernates, is bat-proofed in a similar way.

Butterflies like the peacock pansy (*Junonia almana*) of Africa and Southern Asia, and the buckeye of North America (*Precis lavinia*) have, like the peacock butterfly, quite large eye-spots. They can open the wings and slide back the fore-wings, creating the image of a bird focusing with both eyes as it would before pecking. The leading edge of the fore-wing of the peacock pansy carries two small black eye-spots and orange and black banding that creates an image of a burying beetle (*Necrophorus* spp.). These beetles are bumblebee mimics and have a pungent, possibly toxic, defensive secretion.

The presence of relatively large eye-spots on the fore-wings as well as on the hind-wings may also cause confusion to predators. It takes longer for us, and other animals, to recognise a drawing of a face if any of the features -- nose, mouth, eyes -- are in the wrong place. Budgerigars can recognise the face of another budgie in a fraction of a second, but one set of experiments showed that a budgerigar took about three times as long to recognise a photo of another budgerigar when the image was altered so that the bird's eye was in the wrong place. As we saw in the first chapter, anything that delays identification of an insect by a bird, gives the insect valuable time to respond and escape.

The "owl butterflies" (*Caligo* spp.) of the tropical and sub-tropical Americas are huge insects; the males generally have a beautiful blue sheen to their wings. They can often be seen in butterfly houses feeding on the juices of over-ripe fruit.

The owl-like image is very clear on the underside of a set specimen: the two large round eye-spots seem to stare at you and the colours of the wings are those of typical owl plumage. Various authors have used this image of set butterflies to illustrate owl mimicry.

There is, however, a real difficulty in interpreting these butterflies as owl mimics; they have their wings folded most of the time when they are resting or feeding, so that you see only one eye-spot at a time. In fact, they are misnamed and they are not owl mimics at all. The give-away is the second smaller eye-spot on each wing. No vertebrate animal has two eyes on each side, but lizards, frogs and toads, which lack an outer ear, have a circular tympanum (ear-drum) on the surface of the body behind the eye. In many frogs and toads the eye and ear each side are obscured by what looks like a broad, black brush-mark.

Compare the "eyes" on the underside of the wing of an owl butterfly with the head of a cane toad. Are

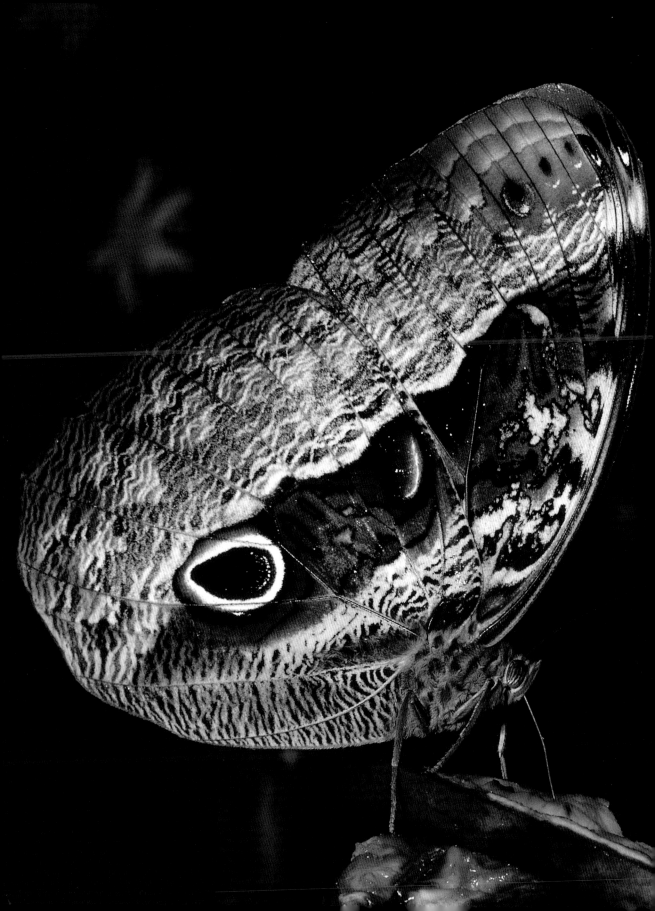

you looking at an owl butterfly or a toad butterfly? After I had plumped firmly for toads, a year later I came across a paper by Dave Stradling[3] and found that he had come to more or less the same conclusion several years previously, that *Hyla* butterflies were mimics of hyla tree frogs and that another kind of owl butterfly (*Eryphanis*) mimics anolis lizards.

Some of the most dangerous poisons known to man come from amphibians, the best-known examples being those of the poison arrow frogs of South America. The skin secretions of these frogs smeared on arrow tips can cause monkeys to fall out of the trees within seconds. The cane toad, which is found in the forests of South and Central America, also produces, from glands in its skin, toxins which can cause hallucinations and death. At least one tribe in the Amazon is known to use the toad secretions as a substitute for those of the poison arrow frog. Cane toads were introduced into Australia in 1935 to control sugar cane pests. They are now found in large areas of western Australia where they are a threat to man and wildlife. Crocodiles, snakes and dogs are among those killed every year by their venom. Of course, there are many other frogs and toads similar to the cane toad in tropical America, so we

opposite: An owl butterfly (*Caligo eurilochus*)

above: The poisonous South American cane toad (*Bufo marinus*)

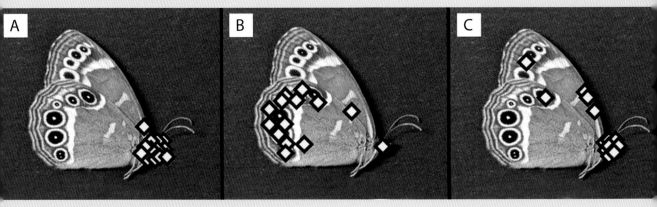

Sites of pecks on the woodland brown butterfly (*Lopinga achine*) by blue tits in good light (A); in low intensity light (B and C), but with UV filtered out in (C). (see footnote 5)

cannot say for certain that any owl butterfly is a mimic of that creature, but it has the key features (large round "eye", circular "ear-drum", with a black band linking the two, and general brown colouring) of many toad species.

Small Eyespots

You may have noticed that the reptilian-like eyes on the edge of the wings of the *Caligos* are surrounded by markings that look like reptile scales. Small eye-spots are also very common among brown butterflies (see Chapter 3). Most brown butterflies are well-camouflaged when sitting with their wings folded, but at the slightest disturbance the tip of the fore-wing is pushed upwards to show a small eye-spot with a highlight in it: the image of the eye of a small bird. These butterflies rarely rest in an exposed position, but prefer long grass, bushes and sheltered places like ditches. They open their wings when alert to possible danger, exposing the small eye-spots on both the upper and undersides of the wings.

Mysteriously, butterflies with small eye-spots usually have lots of them.[4] A good example is the speckled wood. The dappled markings on its soft brown wings, at one moment seeming like spots of sunlight filtering through the leaves, remind one also of the breast of a thrush and call to mind lines of Gerard Manley Hopkins, *"Glory be to God for dappled things ... Fresh fire-coal chestnut-falls and finches' wings."* Crude images of bird heads with white beaks can be discerned if you isolate the tips of the fore-wings. But perhaps the pansy butterfly (*Precis atlites*) holds the record for spots with a row of ten on each side.

The blue morpho butterflies from South America also have rows of eye-spots on the undersides of the wings. To try and understand the reasons for this, we have to remember that a butterfly's wings are usually in motion except when it is basking or resting, and then if it is disturbed it moves very quickly so a row of eye-spots looks like a single flickering eye, opening and closing.

Butterflies are sometimes found with small eye-spots missing or bearing tell-tale beak marks. This is usually explained by the deflection hypothesis: the spots are decoys for the true head. Mystery is attached to this, however, because experiments to demonstrate deflection of pecks have often given ambiguous results, but the issue has recently been clarified by Olofsson[5] and his colleagues from Sweden who studied the woodland brown butterfly (*Lopinga achine*). They realised that insectivorous birds forage

The speckled wood butterfly (*Pararge aegeria*)

most actively at dawn and dusk when the light intensity is low but contains a higher proportion of ultraviolet light. Resting butterflies are then dependent upon colour patterns for defence, and the multiple eye-spots on the wings of the woodland brown have centres which strongly reflect the ultraviolvet. In high light intensity, blue tits directed their pecks towards the head region, but in low light (containing UV) most pecks were aimed at the eye-spots; but with UV filtered out the pecks were somewhat haphazard. During the daytime butterflies are less vulnerable because they can escape by flight manoeuvres, making the small eye-spots largely redundant.

Apart from the explanation for small eye-spots offered by the deflection hypothesis there is also the possibility that the sudden appearance of an "eye" provokes a pecking response in defence. Birds direct pecks at the eyes of other birds when they fight or defend themselves. When humans approach birds too closely this can lead to loss of an eye. While training crows for their role in Alfred Hitchcock's film masterpiece *The Birds*, the bird-handlers were terrified of possible damage to their eyes, at which the birds tended to direct their attacks. One handler got pecked in the eye region three times.[6]

Precis atlites. Note the barred feather markings

opposite: The morpho butterfly (*Morpho peleides*)

Another possible explanation for rows of eye-spots, mentioned in the introduction, is that the repetition makes a supernormal stimulus that has greater impact, like a repeated sound. It is tempting to make a comparison with Andy Warhol's famous paintings of stacks of identical Coca Cola bottles and cans of beans.

It may seem bizarre to refer to the Bible in relation to eye-spots, but *Revelations*, which contains vivid descriptions of visions of deadly beasts, personifying evil, includes some with eyes all over their bodies, while the devil, in the form of a dragon, has seven heads, each with eyes.

This is the stuff of science fiction today and it would seem that a creature with multiple eyes has a seismic effect on the human mind: illusions that the mind creates can be more terrifying than anything in nature. Perhaps this is true of animals also.

While these possibilities remain, the eye-spots may have evolved in the first place from spots on the wing. We find these on the "caterpillar" images on the edges of wings of butterflies such as the red admiral, where they simulate the spiracular openings. The next stage could have been enlargement of these spots with a reflective centre leading to a row of "eyes".

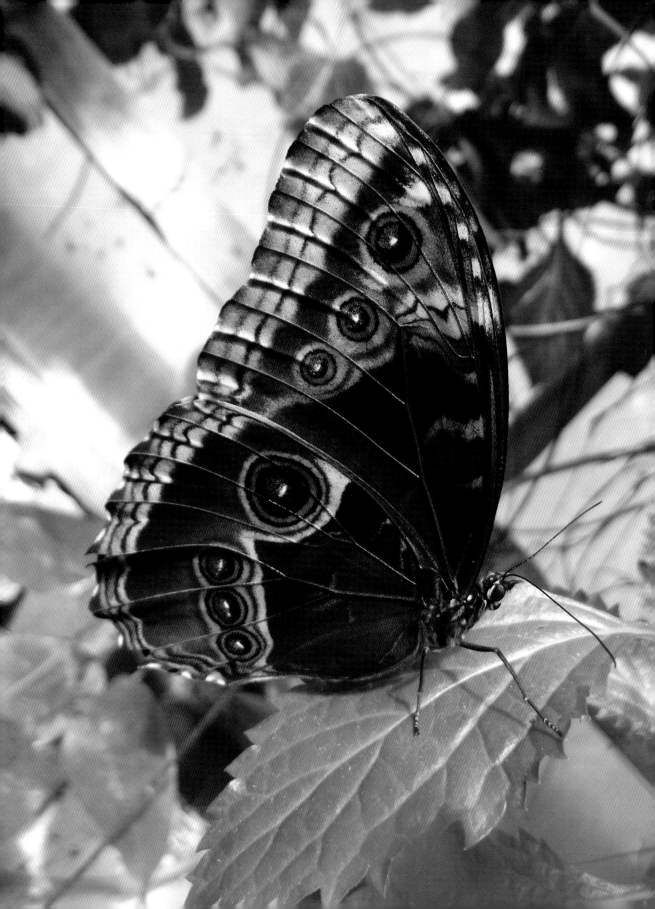

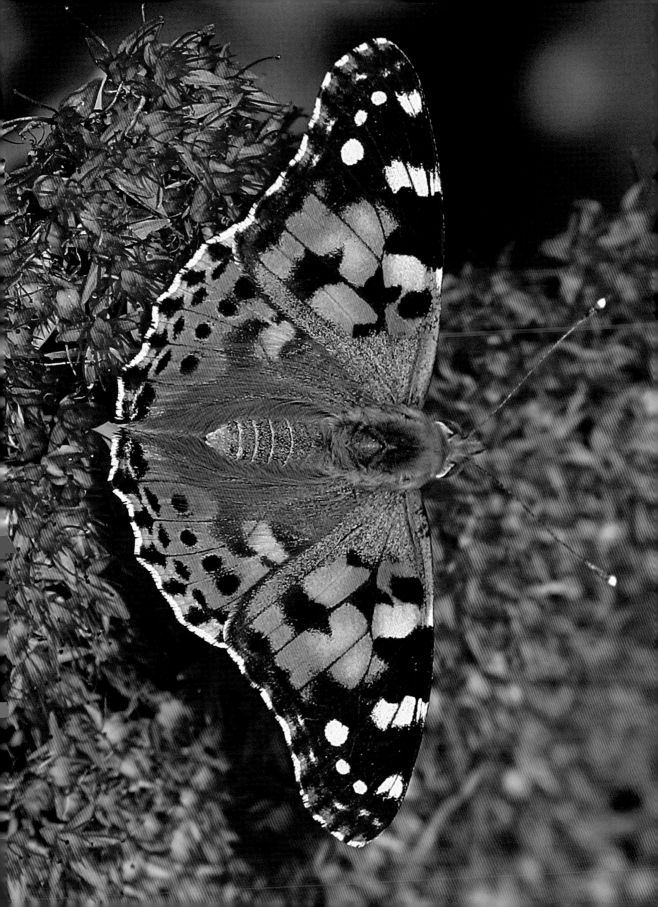

TORTOISESHELLS, ADMIRALS, LADIES & PASHAS

Much converse do I find in thee,
Historian of my infancy!
Float near me; do not yet depart!
Dead times revive in thee.

– William Wordsworth, *To a Butterfly*

The small tortoiseshell (*Aglais urticae*) is one of the butterflies you are most likely to see in gardens in northern Europe in summer, and one of the most beautiful, although for some obscure reason it was once known as the "devil butterfly" in Scotland – possibly because in spring it comes out of the darkness of winter and hibernation marked in red and black. Its cousin, the large tortoiseshell, unlike many of its other relatives, including the red admiral, which has caterpillars that feed on nettles, feeds on elms and is now quite rare in Britain although fairly common in continental Europe.

My first sight of a small tortoiseshell as a young boy is permanently etched into my memory, and even now in later life, it evokes everything connected with those few moments of discovery and surprise, as in Marcel Proust's familiar account of the taste of fresh madeleines that reconstituted lost time from his youth.

Painted lady (*Cynthia cardui*). Note the spider image on its wings and body

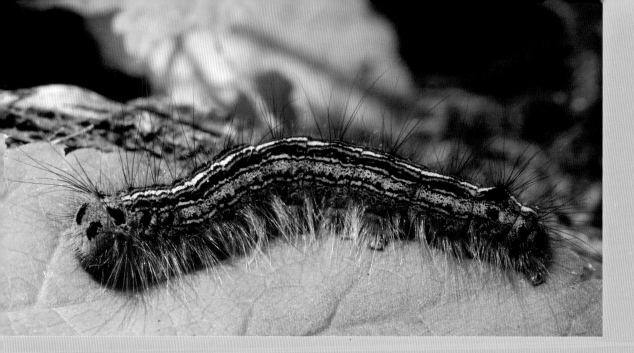

Look at the bands on the edges of the fore-wings of these butterflies. You will see feather-shaped markings with black bands separated by yellow and white bands. Banding like this is typical of the black and yellow combination of wasps and hornets. The addition of a white band at the tip of the fore-wing of the small tortoiseshell produces exactly the same banding as many European bees, including the buff-tailed bumblebee, one of our commonest bees. This narrow strip of the fore-wings is rather like a striped road barrier or cordon warning of possible unpleasant consequences if it is ignored: for a small bird those consequences might be a painful sting followed by a shock reaction. Watch a tortoiseshell nectaring on flowers with multiple florets and you will see it moving its wings slowly up and down, which simulates the movement of a bumblebee abdomen as the bee moves from one floret to another.

Ever since I first looked closely at a small tortoiseshell butterfly I have wondered why the borders of the wings have beautiful half-moon shaped blue marks. Surely these cannot be just recognition marks used in courtship? But could they be caterpillar images? My reasoning is as follows: if the wing borders are representations of poisonous caterpillars, then there must be a caterpillar with blue crescent marks. I was pleased to find that there is a particularly good fit with the lackey moth (*Malacosoma neustria*), which occurs in Britain and Europe. These caterpillars even have a black background with a white borderline like the tortoiseshell wing border.

The epicentre of bumblebee evolution is believed to have been in North India and China, on the slopes of the Himalayas, beginning about 40 million

top: The lackey moth caterpillar (*Malacosoma neustria*), which has irritant hairs that only a few birds can cope with

above: The buff-tailed bumblebee (*Bombus terrestris*). Compare the colour band sequence with that on the front wing of the small tortoiseshell

opposite: Small tortoiseshells (*Aglais urticae*). Note that the eye tends to fixate on the coloured bars of the fore-wing

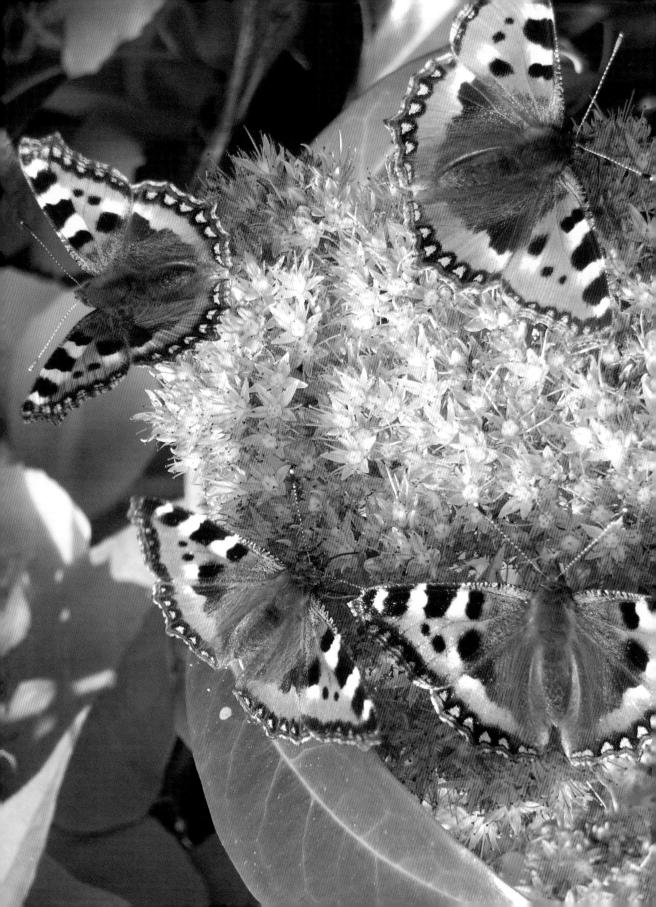

years ago. Subspecies of the small and large tortoiseshell are still found there – perhaps the ancestors of the European *Aglais urticae* and several similar tortoiseshell species found in North America. The Indian tortoiseshell (*Aglais kaschmirensis*) is almost identical with our *Aglais urticae,* as is the Californian *Nymphalis californica.* The wing borders of American tortoiseshells appear to resemble slightly more the tent caterpillars (*Malacosoma americanum*).

The tent and lackey moth caterpillars are found in large numbers in silken tents, which they construct themselves. Nowadays they often become serious pests as they can kill trees by defoliating them. Although they are easily available to birds, only a few bird species (notably cuckoos) will eat the larger caterpillars. One reason is that most birds cannot cope with the stinging hairs, and another is that the caterpillar has poisons in its tissues – *M. neustria* has been listed as one of the world's ten most toxic caterpillars.

The Red Admiral

The red admiral butterfly might easily have been named after an admiral's uniform. Uniforms of military officers often have white gold or red shoulder flashes and sometimes a red sash diagonally across the body, epitomised, for example, in Lord Nelson's uniform. However, another explanation[1] is that the name is a reference to the naval flag. Moses Harris, author of the famous illustrated folio *The Aurelian*, published in 1766, called the butterfly the "red admirable" and this name has been used from time to time. Indeed the Russian author, Vladimir Nabokov, who was an ardent butterfly collector, insisted on this name. In France the red admiral is known as *le vulcain* (the vulcan) after the ancient Greek god of fire, perhaps in reference to its flickering fiery colour when flying.

Whether the red admiral is basking in the sun with its wings open or in flight, it is flying a red warning flag. Red, suggesting blood on clothes, is one of the most powerful and emotionally charged signalling devices used by man. It has been used to signal defiance and a fight to the death since the Middle Ages when ships flew a long red streamer, called the *Baucans*. In the insect world, red markings are commonly bordered with black, which increases the apparency of the red. The day-flying, poisonous cinnabar moth is a particularly striking example.

From time to time great numbers of red admirals migrate from Africa to northern Russia, and Nabokov explained that country people there referred

Red admiral butterfly (*Vanessa atalanta*), basking in sunlight

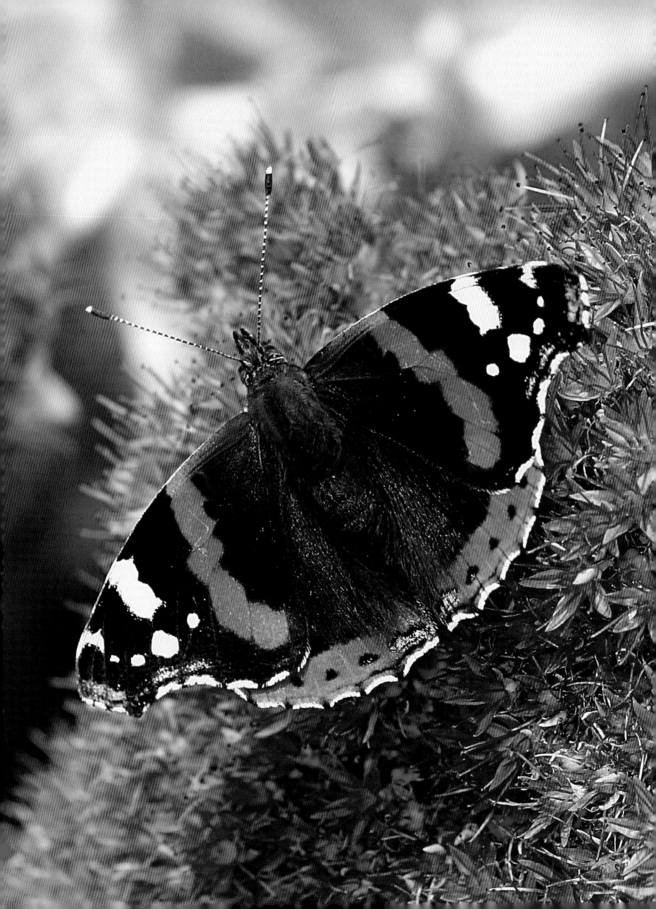

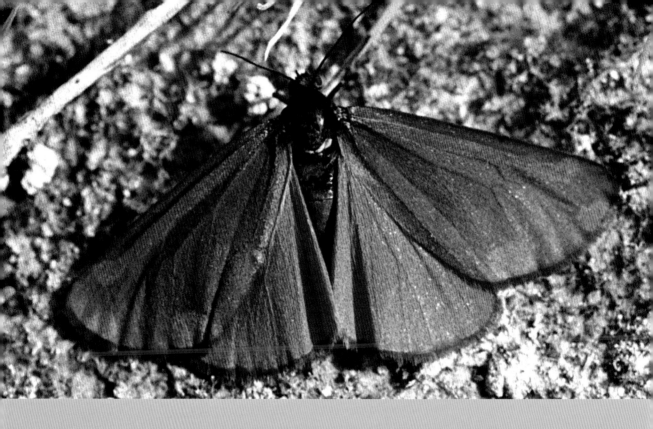

to them as "Butterflies of Doom". This was because there was a huge migration into Russia in 1881 when Tsar Alexander II was assassinated, and the markings on the underside of the two hind-wings seem to read "1881". You can see this date in the photo opposite.

The 1881 image is obviously a fanciful coincidence, although superstitious people may always see mystical significance in it. Nevertheless, the patterns on the under-wings of butterflies, including the camouflage, are almost certainly meaningful to birds and other insectivores, but it is always difficult to imagine what the patterns represent to such animals. After hours of puzzling over this one summer, I suddenly saw something in this butterfly that I would never have expected.

When the red admiral rests after flying around, it folds its wings together so you cannot see the red bands, and then it is very difficult to see in bushes and trees, especially against dark-coloured bark. Now if something disturbs it, it will either fly off quickly or push up the tips of the fore-wings showing red, white and blue patterns. At a certain orientation these patterns reassemble themselves and you can see the image of a bird, or at least its head. It's very like a goldfinch, so look at the picture of a goldfinch on the opposite page first and then look for it on the butterfly. Start by finding the beak, which is a white triangle in the centre of the wings.

The goldfinch image is also slightly anamorphic.[2] To see the effect of the angle at which you view the butterfly, turn the page so that the head of the butterfly on page 85 is positioned away from you and then slowly turn the page away from you so that it is inclined at about 20°-30° to your eye. The goldfinch "head" then becomes more convincing. The live butterfly, of course, can exploit this by slowly opening its wings. Imagine that you are a small bird searching among the bushes for insects to feed on. Suddenly you see this image in front of you, which is nearly your size and has a big blue eye and a beak. Any bird confronted with what at first appeared to be an edible morsel might be at least a little taken-aback when

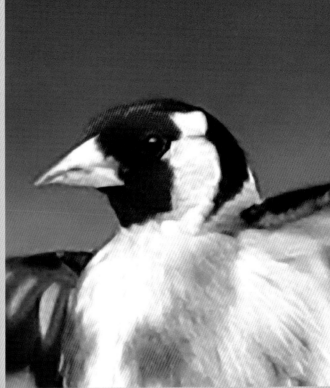

it suddenly found itself looking at what could be another bird. The white-spotted tips to the wings are also similar to the white-spotted tail feathers of many birds (including the goldfinch).

Goldfinches are fond of feeding on thistle heads. In earlier centuries large flocks were found everywhere in Britain, northern Europe and Asia. They were so common that they were trapped for food in the nineteenth century: it is recorded that 1300 were once trapped in one place in Sussex in a single day. It is very likely that red admirals, thistles and goldfinches have co-existed for millions of years in Europe and Asia, and that the butterflies have evolved a defence against insect-eating birds, which depends on suddenly displaying the striking combination of colours that are the insignia of the goldfinch.

Birds may also see two red caterpillars with blue eyes on the wings of the red admiral. Look at the detail and you will see black dots on each segment, and feet showing as black points along the scalloped edge. We have seen that many toxic Lepidoptera are red and black. Similarly there are toxic caterpillars that carry red patches with black spines in the middle. The caterpillar of the bordered patch butterfly (Chlosyne lacinia) is a perfect model for the red admiral image and may contribute to the survival of the red admiral in North America.

opposite: The cinnabar moth (*Tyria jacobaeae*), a day-flying poisonous moth

above left: Red admiral butterfly when alert at rest, showing the goldfinch image with the beak as a pale triangle and the blue "eye" either side of the red band. The "1881" mark can also be made out

above right: European goldfinch (*Carduelis carduelis*)

This, however, is only touching the edge of a fascinating story. The red admirals found in Southern Africa (*Antanartia* species) have a simple red band on the upper surface of each wing. These butterflies are thought to be ancestral to the Indian species, *Vanessa indica*, which is very similar to *V. atalanta* but differs in having a less distinct goldfinch image and black bars intruding into the red fore-wing bands. To add a twist to the tale, *V. gonerilla*, found only in New Zealand and the Chatham islands, has eye-spots on the hind-wings and a remarkably clear finch-like head on the underside but one with a large beak in a different position from other red admirals.

Why goldfinches then, when, apart from recent introductions, there are none in Australasia? In what is now Asia the only birds with red head-bands were goldfinches. So it was a simple step to modify the red band on the underside of the butterfly and make it part of the image of a very common bird. This must have happened at least twice and when the continents drifted apart in the Cretaceous, one population in the Far East got stranded in New Zealand, while the main population spread westwards into Europe and the United States.[3] New Zealand has very few species of bird, and none remotely like a goldfinch. A really intriguing possibility is that the red admiral found there and also in the nearby Chatham Islands, in which the "head" image on the butterfly differs in a number of respects from that of the goldfinch image of other admirals, is a mimic of the extinct moas. There were about twenty

species of these ostrich-like birds, which although initially very common, were hunted to extinction over the last few centuries, but reconstructions of moas present a head with a large eye and a secateur-like beak. Analysis of DNA skin and feather fragments has revealed brown feathers with fine white tips. The head may have been coloured like that of an ostrich or a fowl, according to the folk memory of the Maoris. Is the butterfly telling us what these curious birds looked like?

As for the "caterpillar", I spent many hours searching for reports of a red caterpillar in Asia and Europe, until, in one of those "eureka moments", I realised that the model was not a caterpillar at all, but could be one of the red-bodied swallowtails of South-East Asia. These butterflies are highly distasteful to birds (see Chapter 4) and there is a complex of butterfly species that are Batesian mimics copying their wing patterns. The abdomen is red with black spots around the spiracles (breathing holes) and black bars on the dorsal surface. Thus *V. atalanta* may be another Batesian mimic of red-bodied swallowtails. The image may have persisted in red admirals in other geographical areas because it also resembles other caterpillars – that of the American bordered patch butterfly, for example.

Red caterpillars of various species have been recorded which have been turned red by entomopathogenic bacteria that make them first luminescent

opposite: The New Zealand red admiral (*Vanessa gonerilla*) with red stripes that differ from those of the Indian red admiral (see overleaf)

top: Underside of *Vanessa gonerilla* showing bird head images on the fore-wings

above: Caterpillar of the bordered patch butterfly (*Chlosyne lacinia*)

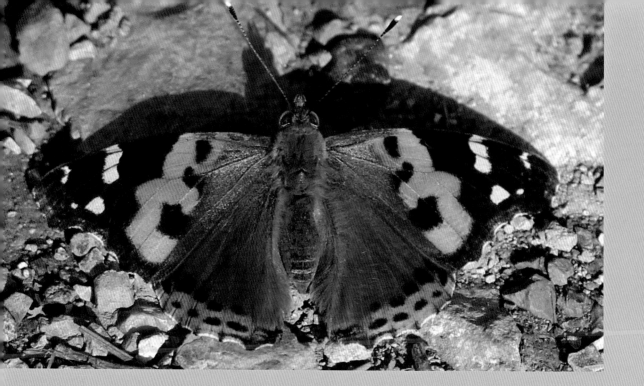

and then red. The bacteria breed and consume the internal tissue of the unfortunate caterpillar. One of the sources of infection is through the nematode *Heterorhabditis*, which is used as a biological control agent for soil-dwelling insects (on golf courses, for example). The nematode enters the body of the caterpillar and releases the bacteria, which turn the caterpillar into soup upon which the nematode multiplies, the young forms emerging into the soil when the caterpillar is empty. Robins reject the infected red caterpillars largely on the basis of their colour,[4] which actually ensures the survival of the nematode and bacteria. If birds eat the caterpillars that is the end of the trail for the bacteria.

It is interesting at this point to pause and think about the way we attach various meanings to the things in nature with which we are familiar. Because we (mostly) see the whole picture we build up connections between the picture, events, and feelings. Even a patch of colour may affect us (as in the red flag) but think, for example, of the expressions "seeing red", or "black despair". The colours red and black are particularly meaningful for us.

The French writer Stendhal entitled his most famous novel *Le Rouge et le Noir* (The Scarlet and the Black). In France, red symbolised the military and black the Church, but the same colours were also linked to passion (red) and evil (black). In the eighteenth and nineteenth centuries, artists often included a red admiral butterfly in their paintings not only for its beauty but as a reminder of unavoidable mortality.

above: The Indian red admiral (*Vanessa indica*)

opposite: The common rose swallowtail (*Atrophaneura* [= *Pachliopta*] *aristolochiae*)

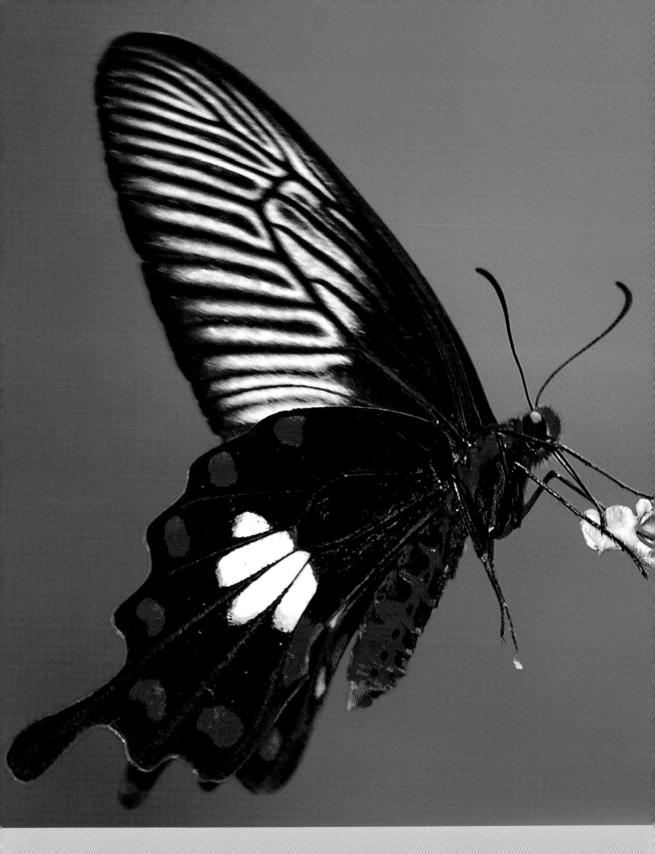

There is even a link in art between the red admiral and the European goldfinch, which in the Middle Ages was a symbol for Christ and his suffering. This arose because the bird was usually found where there are thorny plants and bushes, and because the red band around the head was the colour of blood. In 1505, Raphael, one of the Great Masters of the High Renaissance painted *The Madonna of the Goldfinch*. It shows Mary with two infants at her feet, Jesus and John the Baptist, who is passing a goldfinch to Jesus. Raphael was using the bird as a symbol: a warning of the Crucifixion. It is interesting to reflect, at this point, on how the human mind creates a myriad of associations from a simple pattern of two colours, a wonderful gift that distinguishes us from the rest of the animal kingdom.

The White Admiral

The white admiral, a woodland butterfly, has a semicircular band of white on its black wings. Various white admiral species are found from northern Asia through to Canada and the southern United States. The Asian species have white banding that closely resembles the swallow-like white marking on the tail fan of swallowtails such as *Papilio polytes*, which appears to be a swallow mimic (see Chapter 9). So we can see a connection between swallows, toxic aristolochia-feeding swallowtails and white admirals. As we go east from Asia, where there are no black and white swallowtails, the white markings coalesce and resemble the patterns on the spread tail and primary wing feathers of birds such as magpies (*Pica pica*), which are ruthless predators of small birds. This white band is the equivalent of a pirate flag from a small bird's perspective.

The European and North American white admirals, which greatly resemble the British species, have a caterpillar image on the hind-wing borders similar to that of the lackey moth. That is still there in *Ladoga camilla*, but obscured by black pigment (see Chapter 1). Once the white admiral pilgrim fathers reached North America they appear to have evolved mimetic patterns of other brightly coloured toxic caterpillars and adult butterflies. *Limenitis arthemis* has a beautiful iridescent blue morph (*L. arthemis astyanax*) that has lost the white band and is a Batesian mimic of the indigenous aristolochia-feeding pipe-vine swallowtail (*Battus philenor*). Another stock has given rise to a mimic of the monarch butterfly. This is the viceroy (*Basilarchia archippus*) long thought to be an edible Batesian mimic of the monarch.

White admiral butterfly (*Ladoga camilla*)

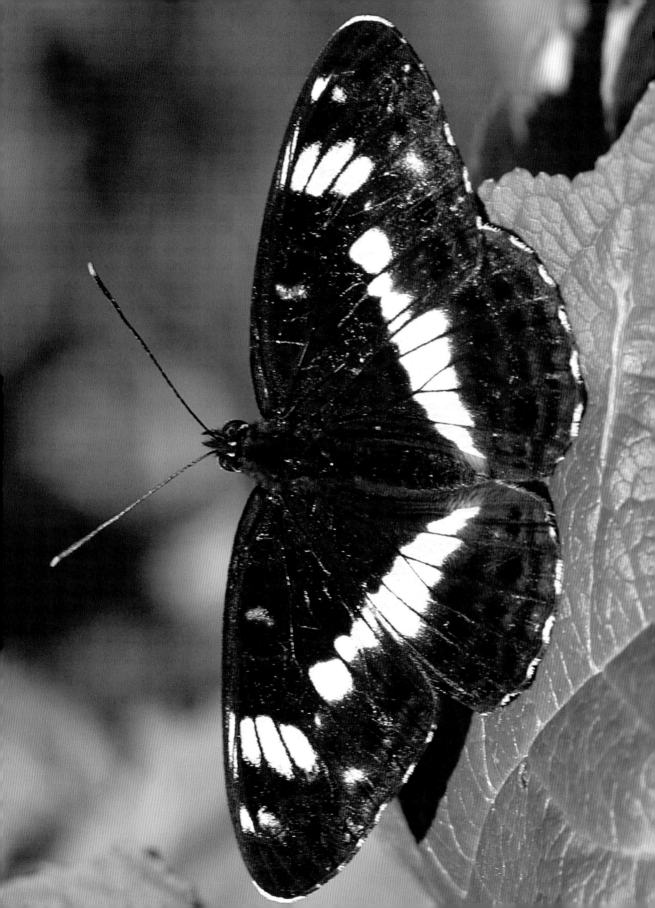

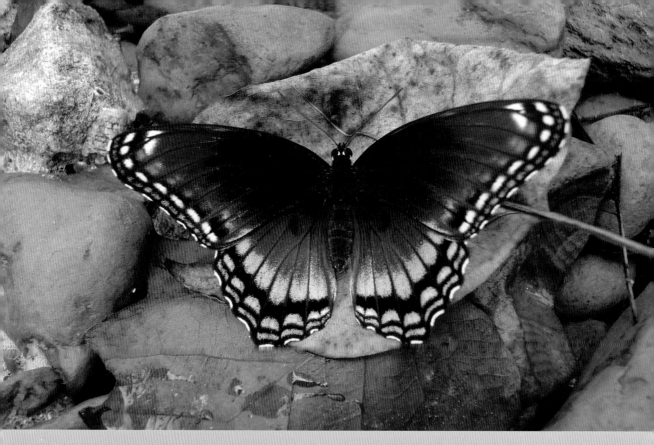

There are thus strong indications that mimicry of a bird by aristolochia-feeding Asian swallowtails about forty million years ago resulted in a nymphalid butterfly becoming a Batesian mimic of the swallowtails (the white admiral) and then spreading through the Palaearctic region into the New World, replacing its demonic model as it went with a local one, but achieving this in ways that demanded the minimum of change in the wing pattern.

The Painted Lady

The painted lady butterfly has a similar name in French: *la belle dame*. The name is said to be derived from a comparison with the once popular heavy cosmetics that gave the face a light orange colour.

This butterfly (see page 78) is very similar to the red admiral: the fore-wing red stripe can still be discerned, although it is converted to orange, and more orange has been added to the wings producing a fritillary-like pattern. Like some other members of the Nymphalidae, including the tortoiseshells and the comma butterfly, the painted lady has lines of iridescent scales and it is these that cover the body like a faintly glittering eye-shadow and map out the superimposed image of a large spider with the legs radiating out

above: The American white admiral (*Limenitis arthemis astyanax*)

opposite: The viceroy (*Basilarchia archippus*)

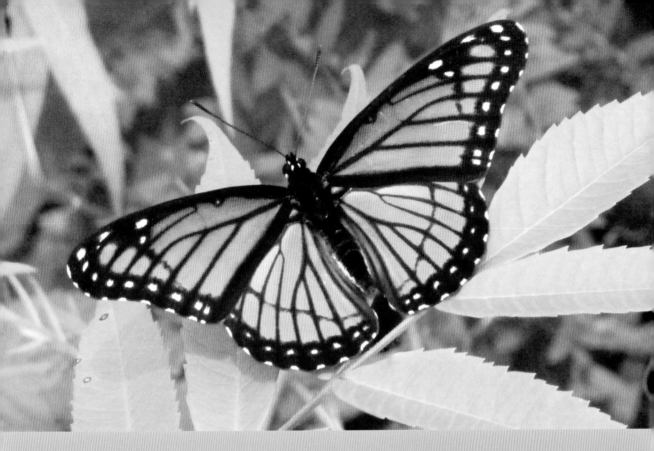

from the insect's body. You can't see this easily in a museum specimen but in the live insect it appears to be painted on the wings against a background of red earth. It is as if the butterfly has found that red caterpillar stripes are less effective in deterring predators than an image resembling a wolf spider.

The painted lady is attracted to blue and purple flowers, such as thistles, teasels and buddleia and is often quite common in the late summer in Europe. The numbers gradually increase in Britain during the spring and summer because they breed in large numbers in North Africa and southern France and Spain. They then migrate, flying northwards and swelling their numbers as they breed on the way helped along their one to two thousand mile trajectory by the southerly winds common in Britain in the summer. They are occasionally seen in Iceland (where they are the only butterfly recorded), a distance of some 3-4000 miles from North Africa. In the late summer they commute back to North Africa, gaining height until they hit the high altitude wind streams that help propel them along.[5]

Early in 2009 hundreds of thousands of painted ladies were observed in Morocco following good spring rains; 18,000 of these, or their descendants, were observed crossing the north Norfolk coast alone, with estimates of

up to a billion reaching British shores that year. In the autumn the migratory path takes the butterflies back again towards southern Europe. Butterfly Conservation recorded by radar 11 million arriving in Hampshire, and 26 million leaving in the late summer. However, in 2012 and 2013 hardly any painted ladies arrived in Britain. Unusual weather patterns took them westwards and huge numbers were found in the Canaries.

The painted lady is said to be the world's most widely distributed butterfly. It breeds on thistles and is well camouflaged with its wings folded; its colours and markings make it difficult to see amongst dead thistle heads. In America it has a cousin, *Cynthia virginiensis*, sometimes called the "cosmopolitan" because it is to be found everywhere in North America. It has been recorded in the spring on the Mexican border and in the summer as far north as Alberta and almost up to the Arctic circle, well over 2,000 miles away. Some butterflies fly back at the end of the summer, and it is thought that these help to maintain the migratory population.

The American painted lady has two large bird-like eye-spots on the under-surface of the hind-wing, but its Old World cousin has a frog face recognisable, to me at least, as two small eye-spots with nostril openings between them and a wide line that could represent the mouth.

The Mother-of-Pearl and the Pasha

Images of bird heads are found in many butterflies and moths (if you take the trouble to look for them). One good place to look is around the tips of the fore-wings, and beautiful examples are found in the mother-of-pearl butterflies (*Salamis* spp.), which have a beautiful translucent sheen on their wings, which gives them their common name. If you frame off the wing-tip image on the mother-of-pearl butterfly you can imagine the initial confusion of a small bird trying to decide whether or not it is looking at bird images on each wing.

Similar beaks are also found on many of the large African *Charaxes* butterflies. One of these, the two-tailed pasha can also be found in various places around the Mediterranean. The bird's eye and open beak can be seen with the butterfly upside-down.

A caterpillar image with a blue eye and two dorsal spines can also be seen if you rotate the page anticlockwise.

above: Mother-of-pearl butterfly (*Salamis duprei*)

opposite: The two-tailed pasha (*Charaxes jasius*)

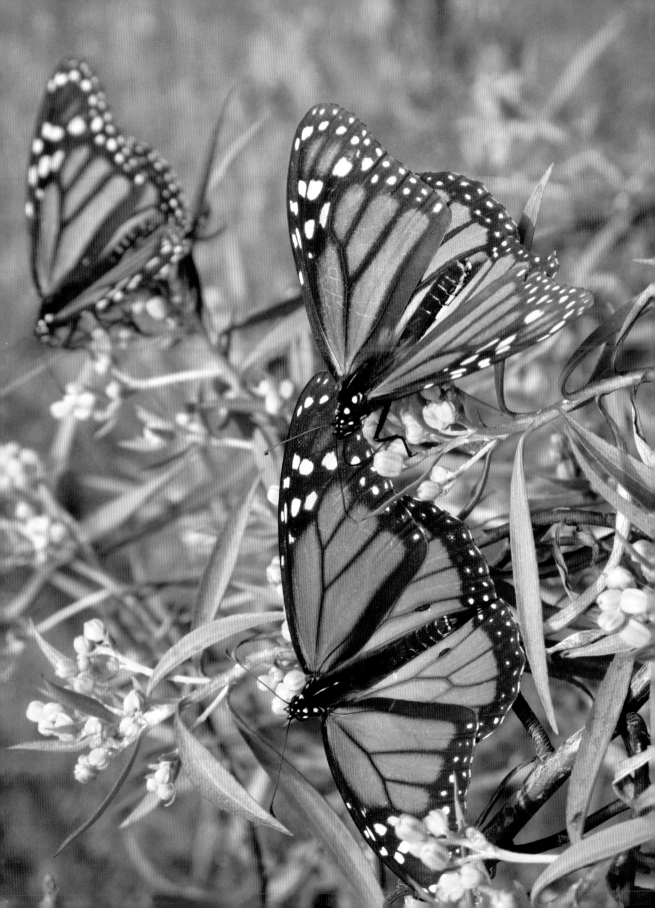

THE DANAID
BUTTERFLIES

The pedigree of Honey
Does not concern the Bee,
Nor lineage of Ecstasy
Delay the Butterfly
On spangled journeys to the peak
Of some perceiveless thing —
— Emily Dickinson

The danaids are represented in South-East Asia by the tree nymph (*Idea*) and crow butterflies (*Euploea* species). Like the New World danaids, many are toxic, and are models for Batesian mimics. They have a leisurely floating flight, which they can afford because most are protected by cardiac glycosides (properly known by the less evocative name of cardenolides).

Probably more is known about the biology of the monarch, or milkweed butterfly of North America than any other; for many its image epitomises the natural world. It is considered by some that the monarch butterfly derived its name as a result of its orange colour, in homage to King William III of England, by birth the sovereign Prince of Orange.

This magnificent butterfly occasionally turns up on south and west coasts of Britain and those which have been captured there have always been considered great prizes for collectors. In my early youth, I was captivated by

Monarch butterflies feeding

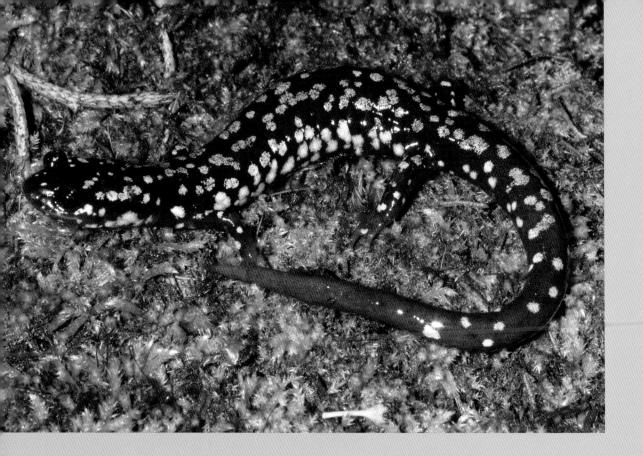

E.B. Ford's classic *Butterflies*, the first in the *New Naturalist* series, in which he wrote about the excitement of catching a monarch – one of the northern hemisphere's most beautiful butterflies – after tumbling over the rocks at Kynance Cove in Cornwall. It's tempting to think that such butterflies had struggled across the Atlantic, blown off course on their migration. However, during the nineteenth century this insect colonised the Canaries, Madeira and southern Spain. The main Spanish population is found between Gibraltar and Cádiz and in 2011, at its last peak, 2,573 individuals were recorded there. At least one monarch found in southern England has been found with the DNA typical of the European populations.

Every year, populations of monarchs in North America migrate southwards and over-winter in the warmer southern climates of the southern States and Mexico. In the Americas, the greatest numbers converge in the pine forests of Michoacán in central Mexico, where it is estimated that around a hundred million remain clustered on the pine branches until the following spring. As Simon Barnes put it, *"There is a sudden overwhelming beauty, as if the wild world wanted us all to believe in the brightness of the universe."*[1] In the spring they return to their original zones to the north breeding on the

above: The slimy salamander (*Plethodon glutinosus*)

opposite: Monarch butterfly (*Danaus plexippus*), with spotted wing borders

way, so the adults that arrive at their summer haunts are descendants of the ones that left. Nevertheless, they are able to find their way using the sun as a compass. The movements of the sun are compensated for by circadian clocks – neural structures found in the brain and in the antennae. One study has proposed that a pigment in the antennae (cryptochrome), when activated by the ultraviolet present in sunlight, becomes responsive to the earth's magnetic field and sends information to the vision-processing part of the brain. The butterflies can only detect the lines of force, so their ability to distinguish between north and south depends on the position of the sun. How these various sensors interact in navigation is still unclear, however, and the "beacon" that draws over-wintering monarchs to a small, defined area of forest in central Mexico is completely unknown.[2]

Sadly, it is now emerging that the migrations are facing two serious threats: deforestation of the over-wintering zones, and widespread destruction of food plants by herbicides used along with GM crops in the southern corn-belt of the United States.

The key to the survival of danaids is the immunity to predation that they pirate from the milkweed plants on which they feed. Even in the over-wintering populations that cover the trees like a fall of giant orange snowflakes, only a few species of bird are able take advantage of this vast food larder. Most birds that attempt to feed on monarchs suffer almost instantaneous violent sickness with associated unpleasant side-effects as a result of the toxic glycosides in the tissues of the butterflies. Ingesting the toxins could be fatal.

Mimicry in butterflies and moths can be understood at one level as a chain of theft, in which insects steal plant chemical defences, develop bright colours that advertise their toxicity, and then have their colours stolen by other species that have little or no chemical defences. Many complexities arise: for example, the monarch food plants have varying amounts of toxins, and some have none at all, resulting in undefended butterflies that have been termed "automimics" of their more toxic relatives. Then again, predators may differ enormously in their tastes: what is one man's meat is another man's poison: to give two examples, chocolate is toxic to dogs, and quail can tolerate doses of the cardenolide digitoxin (from foxgloves) that would kill fifty men.

The cardenolide toxins found in members of the plant families Apocyanaceae and Asclepiadaceae protect these plants from attack by insects and other animals. The asclepiads are known as "milkweeds" because of the toxic white sap that oozes from cut leaves. The monarch caterpillars are able to ingest the sap and remain unaffected by the toxins, which they store in their tissues. In the pupal stage, the toxins move from the soft tissues and lock into the hard external body skeleton and wings.

It has been shown that inexperienced blue jays (*Cyanocitta cristata*) learn, after just one encounter, that monarchs are distasteful to the point of provoking instant sickness. Birds find them difficult to kill because of the tough body wall, but a few birds, including the black-backed oriole (*Icterus abeillei*) have developed the habit, possibly carried over from eating fruit, of winkling out the soft edible body contents of the butterflies. They reject the hard external skeletons, which are loaded with toxins. This species, and the black-headed grosbeak (*Pheucticus melanocephalus*), which has some immunity to the poisons, take a heavy toll of the roosting butterflies in Mexico.

In the course of evolution it seems that the basic orange wings of the monarch ancestors acquired new designs on the wing borders. The three colours that contrast most strongly with orange are black, white and yellow, which have found their way onto the wings of the monarch – presumably to provide a strong signal. There is a striking white-spotted black border on the wings of the monarchs and also of the queen butterfly, a pattern which is repeated on the thorax. At pains to explain why this pattern is there on these danaiines, I hypothesised that there must be a poisonous reptile of some kind living in the same geographical zones. I quickly found the perfect candidate: it is not a reptile but a salamander, the slimy salamander (*Plethodon glutinosus*). This animal is generally black with rows of white spots, and sometimes yellow spots, around

opposite: A male African queen butterfly (*Danaus chrysippus*). The black spots near the abdomen tip are wing pockets containing pheromone

above: Male of the African queen with partially extruded hair pencils

page 103: The dark blue tiger butterfly (*Tirumala septentrionis*) of South East-Asia and Australia

the head region. The skin secretion that earns this animal its name is described as a sticky glue that you can wash off your skin only with the greatest difficulty and which can gum up the beaks and nostrils of birds and the mouths of other animals. This is one herpetologist's experience:

"*The first time you try to restrain one with your bare hands is a memorable experience. The salamander will coat your hand in a seemingly never-ending supply of thick, sticky mucous* [sic] *that is very difficult to remove by washing. My first attempt to catch one by hand resulted in my having to spend about ten minutes scrubbing the mucous off with sand in a nearby stream.*"

There are in fact three very similar species of *Danaus* in the New World – the monarch, the viceroy, and the queen butterfly. All three are toxic to some degree and avoided by birds, and all have a double row of white spots on the outer wing borders – a feature that is lacking in a close relative of the monarch, the African monarch or plain tiger butterfly (*Danaus chrysippus*), which has a much reduced spotted border. Significantly, perhaps, slimy salamanders are not found in the Old World.

It is possible that birds avoid monarchs not only because they learn that they are poisonous, but also because they associate the curved band of white spots with another highly toxic creature – a salamander.

This provides us with a new explanation for the colours of the viceroy butterfly (*Basilarchia archippus*), which is not a danaid but was long described in textbooks as a classic example of a Batesian mimic. That is, until it was found to be toxic as well, making it a Müllerian mimic, but it may have evolved as part of a mimicry ring which included salamanders.

In recent years an extremely rare white morph (*nivosus*) has been found on the island of O'ahu in Hawaii, forming ten per cent of the population in some areas in recent years. Although its colour is controlled by a recessive gene, this white monarch survives in the Hawaiian environment. In 1965 and 1966, two bulbul species from South-East Asia, *Pycnonotus cafer* and *Pycnonotus jocosus*, arrived in the Hawaiian islands and have since become the most common insect and fruit-eating birds. The puzzle is, that despite the presence of a great majority of toxic orange monarchs, the birds allow enough of the white monarchs to survive despite their lack of orange colour. This may be because the asclepiad food plant that is found in Hawaii is low in cardiac glycosides or because the "salamander" image is equally effective in both forms (or indeed for both reasons).

It is generally easy to separate male and female danaids. In the middle of the hind-wing in the male there is a prominent black spot that is not present in the female. This spot is actually a tiny pocket that contains the ingredients of the male sexual pheromone.

The queen butterfly (*Danaus gilippus*) has a ritual courtship dance during which the male hovers above the female, dusting her with microscopic particles coated in pheromone. The dust comes from the so-called hair pencils: thistledown-like brushes that are extruded from the tip of the male's abdomen. Before unfolding these brushes the male pushes them into the wing pockets to charge them with pheromone.

The chemicals that form the basis of sex pheromone, danaidone, do not come from the food plant but, as in the ithomiines, are stolen from plants such as heliotrope and *Calotropis* which the males visit. These compounds (pyrrolizidine alkaloids) are also toxic and add to the chemical armoury of the male. The male converts these alkaloids to slightly different ones and donates some of them to the female in mating, not only in the hair pencil dust but also in the spermatophores (sperm sacs) which it transfers in mating.

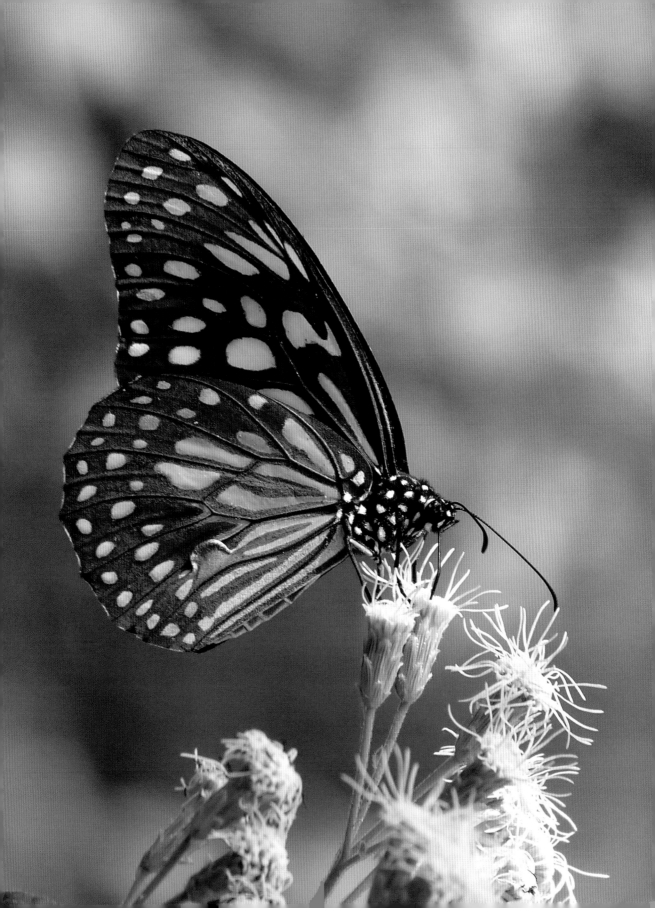

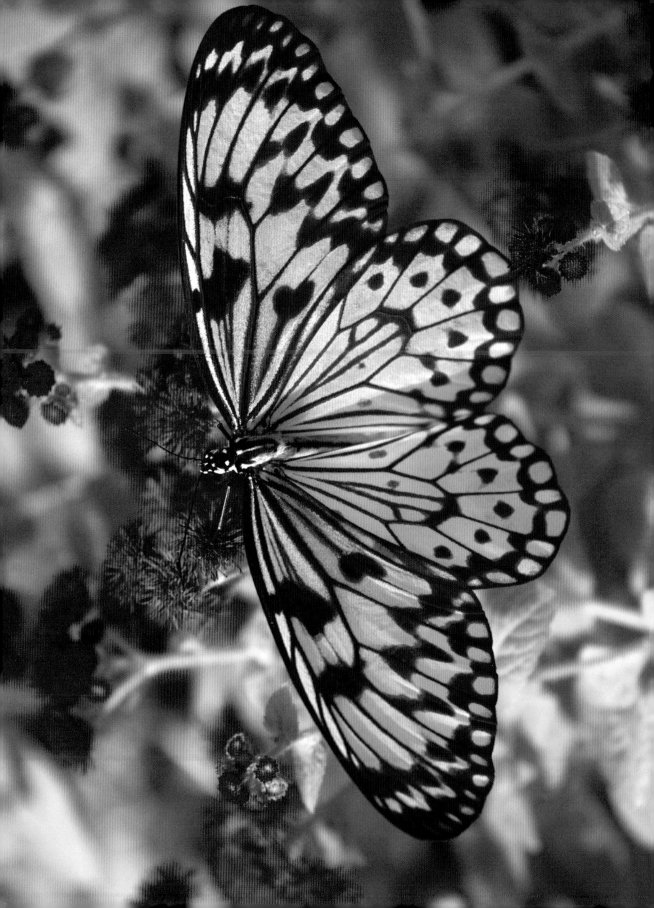

The monarch butterfly, in contrast, does not produce danaidone and appears to make little use of pheromones in mating. Eschewing the use of perfume, it more often just grabs the female unceremoniously in flight.

The danaid butterflies are thought by some to have earned their name from Danae, a princess from ancient Greek mythology. Although she was imprisoned by her father, the god Zeus came to her in the form of a shower of golden rain, as a result of which she give birth to Perseus. One wonders whether Linnaeus, who in 1758 used the name *Danai* for a group of butterflies including the monarchs, may have had reports about the courtship of these butterflies. However, the most likely explanation is more prosaic: Danaus was a minor deity of the ancient Greeks, who had fifty daughters known as the Danaidae, and the butterflies are named after his daughters and the fifty sons of his brother Aegyptus.

Danaid butterflies are found in South-East Asia, including the tree nymph (*Idea*) and crow butterflies (*Euploea* species), and a species very similar to the monarch, the striped tiger (*Danaus genutia*). The dark blue tiger butterfly undertakes north-south migrations in India and China, and contributes to the butterflies that fly in an ever-widening stream to over-winter in southern Taiwan and other coastal areas in South-East Asia.

At least some Asian species are toxic and are models for Batesian mimics. In Taiwan there are nine species that migrate to the south of the island in winter, escaping the cold weather fronts from mainland China.

The common, or striped tiger (*Danaus genutia*) is found in aggregations of tens of thousands in Taiwan every winter. Great efforts are made there to protect the clouds of migrating butterflies, including the closure of roads over which they fly. Hair pencils are also used in the courtship ritual and the pheromone includes danaidone garnered from heliotropes and other plants. The crow butterflies open their hair pencils when flying over the winter aggregations, and it has been suggested that the pheromone also helps to keep the swarms settled (the pheromone induces females to settle as part of the courtship ritual).

The *Idea* butterflies, known variously as paper kites (in reference to their very leisurely floating flight), tree nymphs or rice paper butterflies, are found in the southerly regions of South-East Asia. Like the monarchs, they feed as caterpillars on toxic dogbanes and milkweeds and sequester the toxins in their bodies through to adulthood. The adult males take in additional toxins, pyrrolizidine alkaloids, from plant sources and these compounds form part of the sexual pheromone in their hair pencils. These are then passed to the females in mating, so sharing the toxin, some of which the females donate to the eggs.

Idea butterflies have very large bright wings, *"like shining from shook foil"* to use the imagery of the poet Gerard Manley Hopkins. They are ornamented with black lines and hieroglyphic-like markings that obscure the wing edges and the body.[3] Viewed in the head-down position, the open wings resemble white petals with black anthers, and the black line down the body turns it into a style. In flight, birds are presented with a translucent, papery membrane floating in the air, which is too large to swallow and appears not to have a body, and if it is pecked it will have a repulsive odour and taste: a brilliantly contrived defensive strategy.

The paper kite or large tree nymph butterfly (*Idea leuconoe*)

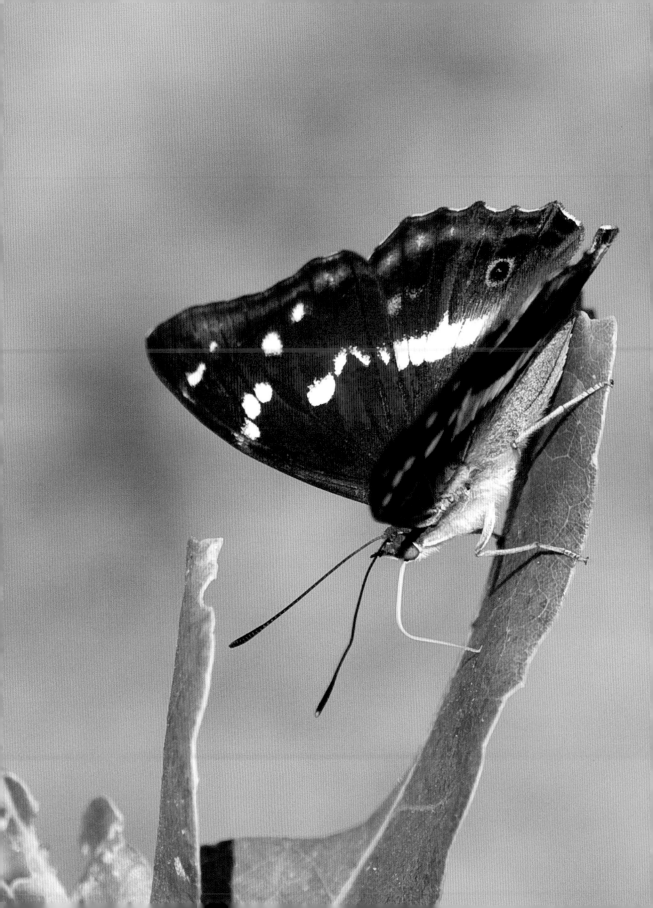

BLUE MORPHOS
& THE PURPLE EMPEROR

Take a thousand kingfishers, boil them down and distil them all into a single ray of light.... It was a blue that makes all the blue things in the world look grey ... a blue Morpho.

— Simon Barnes

The dazzling blue iridescent wing colours of the large male morpho butterflies of South America are not due to pigments, but are known as *structural colours*: a result of the way in which light is reflected back from an extremely thin layer of scale cuticle. The name "morpho" comes from an ancient Greek epithet for Aphrodite, the goddess of beauty. In *The Golden Bough*,[1] Sir James Frazer records that certain Amazon Indian tribes perform a masked dance in honour of the dead: "*there is a large azure-blue butterfly which delights the eye with the splendour of its colour, like a fallen fragment of the sky; and in the butterfly dance two men represent the play of these brilliant insects in the sunshine, fluttering on the wing and settling on sandbanks and rocks.*" The purpose of the dance is to imbue the dancers, through the masks, with spiritual power over demons.

opposite: Male purple emperor (*Apatura iris*)

overleaf: A blue morpho butterfly (*Morpho peleides*) The wing borders have caterpillar-like images

I speculated in Chapter 3 that over 60 million years ago the cells containing the brown-black pigment, melanin, evolved in some early birds (and perhaps in dinosaurs also) into structures that were iridescent. This iridescence

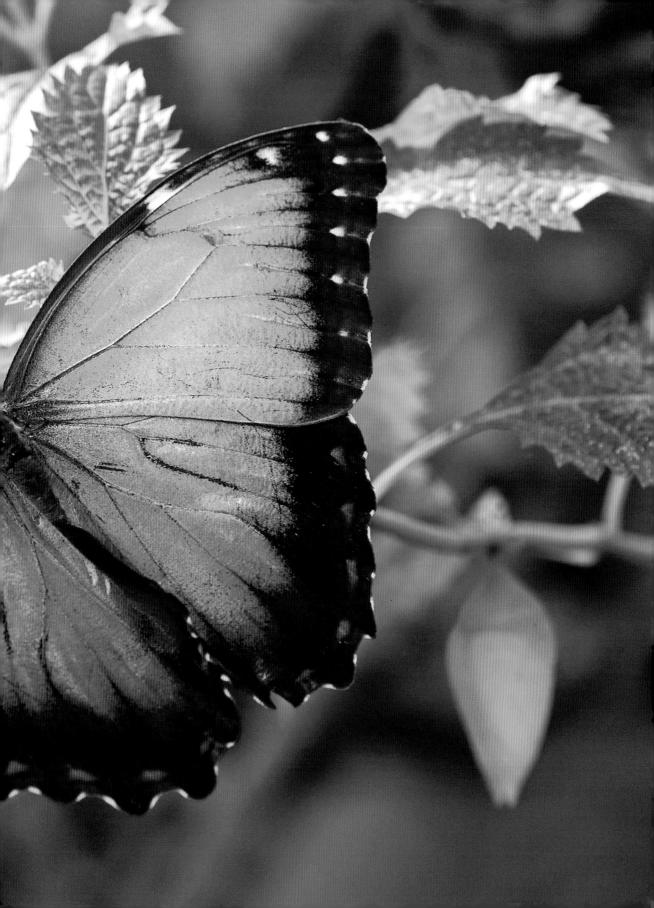

could have then been useful either as a warning colouration, or for putting the glitter and glamour into a courtship dance (as in peacock birds), or as a territorial "flag" used by rival males. Whichever may have been the case (possibly each to a greater or lesser extent), smaller insectivorous birds and lizards would have gained protection by adopting the colours symbolic of larger predators,[2] and day-flying butterflies and moths in turn would have been more likely to escape predation as a result of flying the colours of those insectivores. Iridescence is very often a feature of male birds and butterflies, while the females tend to be dull brown in colour. Males, though, are usually more expendable once they have finished mating. Camouflage, or cryptic colouration, generally increases the chance of survival, and so selection will tend to water down iridescence in females, leading to sexes of differing colours (a phenomenon known as sexual dimorphism).

The transparent wing membranes of the Lepidoptera are covered with microscopic pocket-like scales that overlap like tiles on a roof. Each scale of a morpho butterfly has slits in it, which can be seen only by an electron microscope. They are about 200 nanometres apart, which is half the wavelength of blue light (400-480nm). One light wave will hit the first slit where it is reflected back, and at the same time another wave hits the slit behind, and will be reflected back also, but will have travelled 2 x 200nm when it joins the first wave so that it is exactly in phase (peaks and troughs of the wave coincide) with the first wave. This process is repeated over the whole width of each scale, which contains thousands of slits so that the whole of each scale appears pure blue when viewed from a particular angle. Light of much longer or shorter wavelengths will not be reflected back because the light from successive slits will be out of phase: peaks of one wave will coincide with troughs of another and cancel each other out. Light rays striking the wing surface beyond a certain angle will pass between the slits and be absorbed by the brown pigments underneath.

Let us remember, however, that only a minor part of the wonder of morpho butterfly wings rests on an enlightening explanation of the physics of iridescence, but the glory is in the diamantine, dancing colour patterns that touch our souls, like great music and poetry. Marcel Proust captured this when writing about a church window with a panel of blue glass tiles (not unlike a gargantuan man-made morpho wing):

"...*whose colours died away and were rekindled by turns, a rare and flickering fire – the next instant it had taken on the shimmering brilliance of a peacock's*

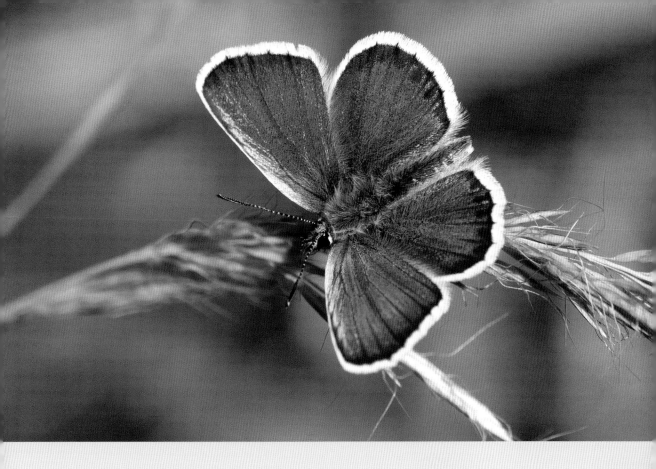

tail, then quivered and rippled in a flaming and fantastic shower. ... A moment later the little lozenge panes had taken on the deep transparency of sapphires clustered on some enormous breast plate...."[3]

Pete Vukusic and his colleagues at Exeter University found that roughly 75 per cent of light falling on the wings of a male morpho is reflected back. This compares with about 95 per cent from a silver mirror – but this is the case only for visible and infrared wavelengths. Below 400nm (in the ultraviolet, which we cannot see) the reflectivity from a mirror drops to very low levels. The morpho wing, on the other hand, has a large peak of ultraviolet reflectance between 300 and 470nm[4] a range to which the bird eye is sensitive. Because of this sensitivity, birds will see roughly twice the amount of light reflected from a morpho at the blue end of the spectrum as we do. Bearing in mind that the sun reflected from a mirror is capable of destroying retinal cells by virtue of the high UV content, a morpho wing could be shockingly bright to a bird.

The American naturalist William Beebe described the reflection of sunlight from morphos as like an electric light suddenly flashed in one's eyes, and

top: Silver-studded blue (*Plebejus argus*), male. The wings reflect various blue and violet hues according to the angle at which light is reflected

above: Flash photograph of a morpho. Because the light strikes the wings at different angles, scales on some areas of the wings do not reflect back short wavelength light but appear transparent, so you can see the brown underlying pigments which absorb light in the human visible spectrum, while those in line with the flash give a strong blue reflection

suggested that this gave the insect a good chance of escape from any predator. Henry Bates, in *The Naturalist on the River Amazons*, noted that the most dazzling butterfly he saw, *Morpho rhetenor*, flies high along the forest roads, "*sailing along, it occasionally flaps its wings, and then the blue surface flashes in the sunlight, so it is visible a quarter of a mile off.*"

Because the blue colour depends on the angle at which light strikes the scales, the brilliant wing colour alternates with a dull brown[5] during the wing beat, and this may make it difficult for birds to follow the butterfly in flight. Morphos feed with their wings closed, but if something disturbs them even slightly they will flick open their wings delivering a flash like blue lightning. However, the bright colours may be as important in territorial behaviour and courtship as in evading predators. In what would be known as parallel evolution, were it solely biological, the flashing blue light that draws attention to the males has been unwittingly copied for similar purposes by police forces and ambulances all over the world.

above: Cornflower. The black anthers against the blue petals are possibly mimicked by the wing colours of the large blue butterfly

opposite: The large blue (*Maculinea arion*)

Morphos are the Olympians of the insect world, the butterflies of paradise, but the lesser mortals in the form of the family of blues and

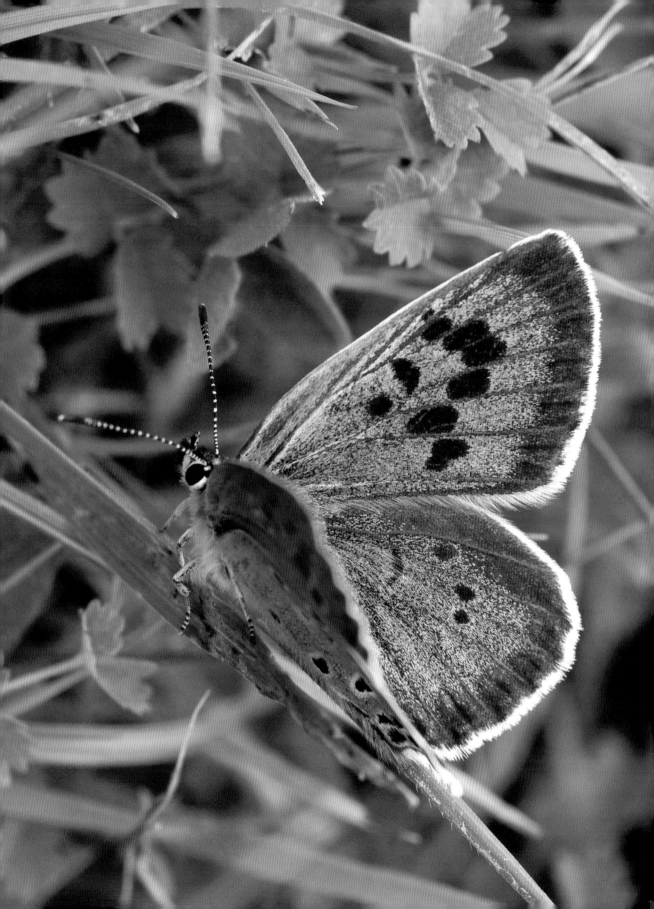

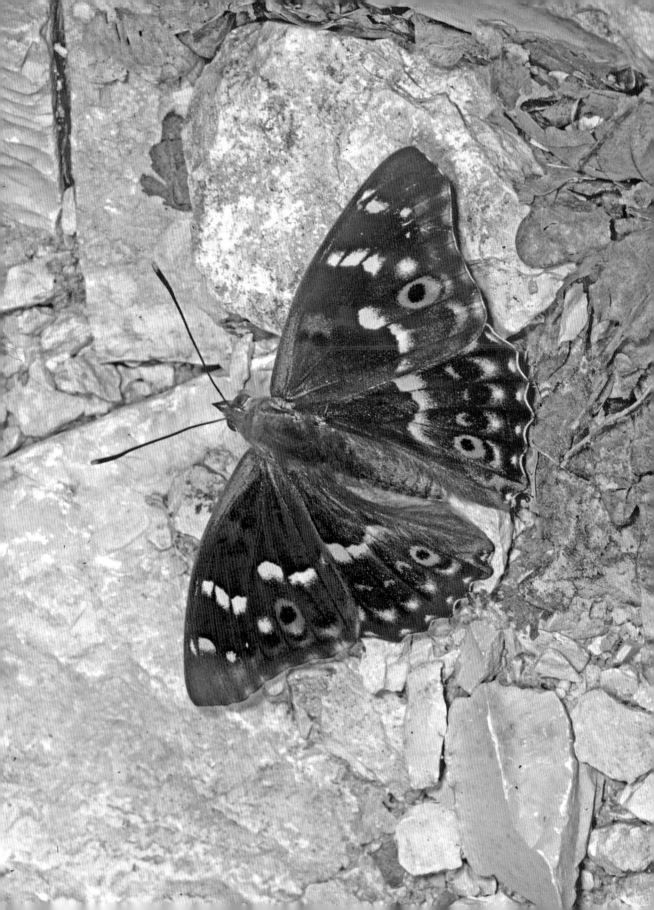

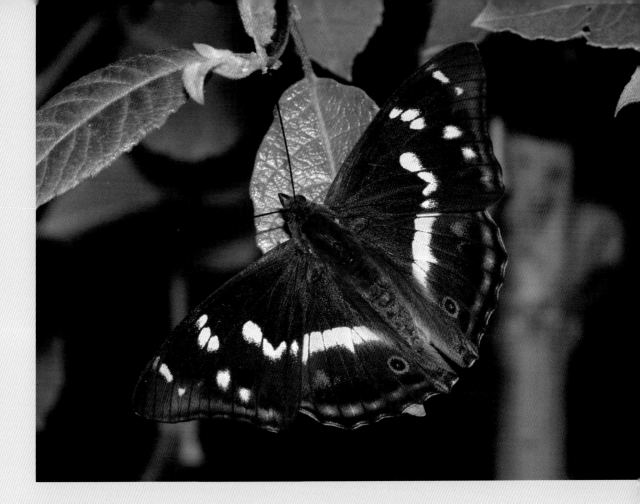

coppers (Lycaenidae) also have beautiful iridescence. In June many blue
butterflies appear, ornamenting the countryside like blue petals dancing in
the wind. Put aside your identification guide when you have worked out
whether you are seeing a common blue or the rarer Adonis blue of chalk
downland, and examine the iridescent blue colours that no painting or
photograph can fully capture. The large blue (*Maculinea arion*) has fore-
wings that carry images of the interior of a cornflower, or chicory, with
black stamens (see page 113).

Colours other than blue can be generated, including green, copper and purple,
especially in the Lycaenidae which include the hairstreaks and coppers.

The name "purple emperor" awakes many symbolic associations, some of
which go back over two thousand years. For the ancient Romans, dress, a
little like military uniform today, showed the status and power of the person
wearing it. Senior magistrates were allowed to wear a toga with a purple
border, and the early kings and many emperors wore togas that were

opposite: The lesser purple emperor (*Apatura
ilia*) with lizard-like crested heads

above: Male purple emperor (*Apatura iris*)

completely purple. Even today purple dress is worn by senior clerics, judges and, fittingly for its ancient origins, was a colour component of the uniform chosen for officials of the 2012 Olympic Games.

When the town of Pompeii was buried by the massive eruption of Vesuvius in AD 79, many works of art were preserved under the ash. Among these was a wonderful mosaic which has a purple butterfly in the centre, almost certainly the lesser purple emperor (*Apatura ilia*) sitting on the wheel of time. The butterfly represents man's soul.[6] By using a purple emperor the artist was intimating that the soul was connected with the gods. Interestingly, according to St Mark, Jesus was clad in a purple robe at his crucifixion.

The purple of the purple emperor butterflies is nothing to do with dyes of the kind the Romans used, but is again a slice of the rainbow, a structural colour like that of the morpho butterflies. A male purple emperor can quickly detect another male that flies into its territory, and birds will experience the shock of sudden flashes of light when the butterflies fly or open their wings.

Now focus on the upper surfaces of the hind-wings. A little re-orientation of the page will make it easier for you to detect, on each wing, a bird's head with a partly opened beak. If you have never noticed this before, now you will see it every time you look. Each fore-wing, on the other hand, has another allusion to a bird embroidered on it: a barred feather.

Equally intriguing is a similar image discernible on the wings of the lesser purple emperor. This figure resembles more the head of a lizard with open jaws and teeth than a bird head, perhaps reflecting the greater abundance of lizards in southern Europe, North Africa and Asia where this insect flies. One possible model is the Asian blue crested lizard (*Calotes*) which, in addition to having a crest similar to that represented on the wings of the butterfly, is an iridescent blue colour.

When the purple emperor is at rest with its wings closed it resembles a dead leaf with a split in it. When it is alert the fore-wing slides forwards to show the bird-like "eye", which then brings it to life. (The purple emperor was once called the "purple eye"). Viewed with the brown "nose" on the wing tip, the eye seems to belong to a fallow deer. For your own amusement, look for the image of a shrew.

opposite: The small copper butterfly (*Lycaena phlaeas*) which has iridescent orange wings marked with black "stamens" and under-wings that reflect light at certain angles

overleaf: A green hairstreak butterfly (*Callophrys rubi*). The iridescent green on the underside provides excellent camouflage

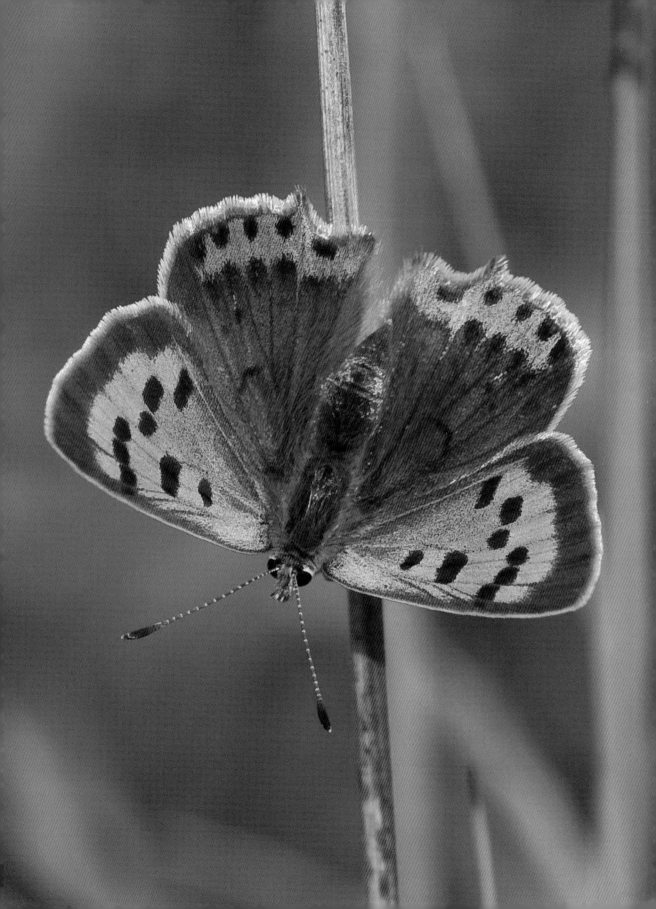

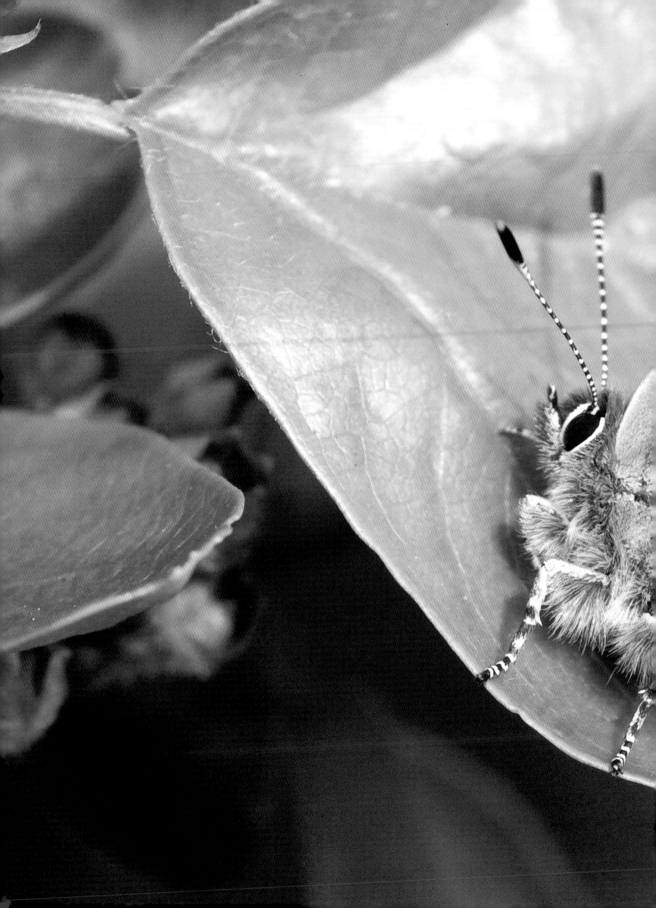

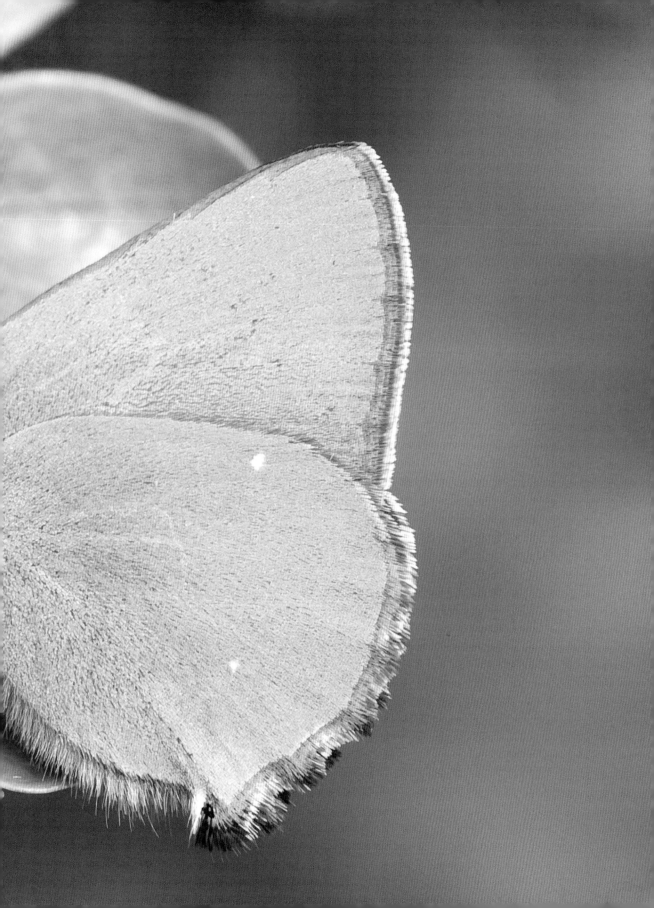

WHITES & YELLOWS

"Crawling at your feet," said the Gnat, "you may observe a Bread-and-butter-fly. Its wings are thin slices of bread-and-butter, its body is a crust, and its head is a lump of sugar."
"And what does it live on?
"Weak tea with cream in it"
– Lewis Carroll, *Through the Looking Glass*

It is commonly believed that the word "butterfly" came from a medieval English expression referring to a "butter-coloured fly". Lewis Carroll makes an amusing play on this by comparing the insect with bread-and-butter pudding: some old recipes for this traditional English dish include tea and cream (which Carroll seems to have thought were essential ingredients) along with the bread, butter and sugar.

Most white and yellow (sulphur) butterflies – the Pieridae – make use of pigments known as pteridines. These are actually breakdown products of protein metabolism. About three-quarters of the pteridines in the large white butterfly are channelled into the wing scales, which, during development, serve as microscopic translucent bin-liners. This is part of a recycling system that turns unwanted nitrogenous compounds into wing paint.

The brightness of the wing colours of pierid butterflies is largely due to the light reflected from the pteridines in the scales and from the surface of the scales themselves. Compounds known as biopterins are also found

The clouded yellow (*Colias croceus*)

in the scales. They occur in the wings of morpho butterflies too and reflect ultraviolet strongly. The Japanese cabbage butterfly (*Pieris rapae crucivora*) also has uric acid – the same white excretory product found in bird droppings – in some of the wing scales, and these reflect very little UV, the result being that the males and females of this (and many other) pierids look the same colour to us, but other butterflies and birds see UV patterns on their wings against a duller white background. In his book *Pale Fire*, Vladimir Nabokov seems to have detected a change in colour in white butterflies as they fly into the shade:

"The setting sun
Bronzed the black bark, around which, like undone
Garlands, the shadows of the foliage fell.....
White butterflies turn lavender as they
Pass through its shade"

Strangely, ultraviolet reflections become more important when the butterflies are in the shade. Some male pierids search for females in the shade and often carry out their courtship there. The reason appears to be that, although the intensity of UV is only ten per cent of that in direct sunlight, it accounts for a much higher proportion of light in the shade because it is reflected around more than visible light, and therefore white butterflies stand out more clearly to other butterflies against the background.

The brightness of the wings may make pierids conspicuous targets for predators, but they have two countermeasures: firstly, pteridines and uric acid are toxic to varying extents, and, secondly, try to catch a cabbage white. In his poem about the cabbage white Robert Graves conceded that *"Even the acrobatic swift / Has not his flying-crooked gift."* The highly unpredictable changes in the flight pattern of butterflies such as the large white make it very difficult to catch, whether you are a bird or a human with a net. It is not that the butterfly has not learned to fly properly, as it seemed to Graves, but that the apparent randomness is part of a neural programme that produces a bizarre flight pattern with apparent random and frequent changes of direction that confuse the would-be captor.

In books on African butterflies we invariably read that the male yellow African migrant (or emigrant) butterfly (*Catopsilia florella*) is sulphur-yellow in colour and can be distinguished easily from the female, which is much paler. But it is very likely that other butterflies and birds would

Female (*top*) and male (*centre*) of the African migrant (*Catopsilia florella*) in daylight *above*: male illuminated additionally with a near-ultraviolet source which produces fluorescence

opposite: A male brimstone butterfly (*Gonepteryx rhamni*) showing the bright reflectance of sunlight from the wings, while the shaded part reflects the green vegetation

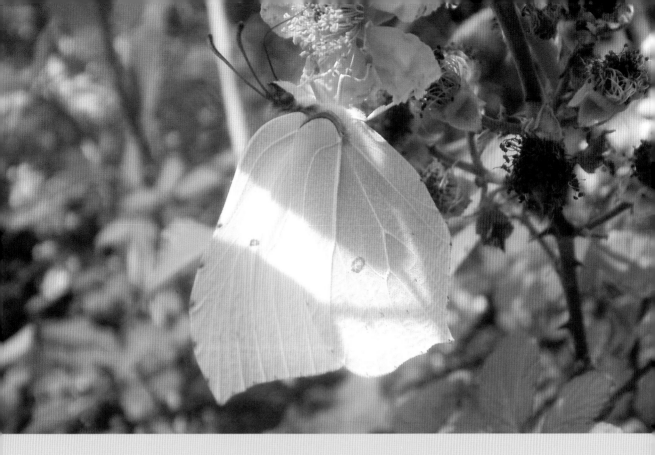

see much clearer differences than we can. When light from a source emitting some near ultraviolet – that is, light of a wavelength on the border between violet and the invisible ultraviolet – is shone on the male, a ghostly fluorescent bluish-white pattern appears which demarcates the main UV-reflecting zone. This bright pattern creates, with the body, an image rather like a large insect with spread wings. This pattern is not present in the white female, which appears to lack pigment that fluoresces in ultraviolet. These differences, which are normally invisible to us, may stand out to a bird or to another butterfly like graffiti on a blank wall. Similar UV patterns have been found on the wings of clouded yellow butterflies. Mystery still surrounds the significance of these patterns: it has been found that the UV reflectance patterns of male clouded yellow (*Colias* species) and brimstones (*Gonepteryx* species) in Europe are more diverse within the species than between species.[1] This has led various researchers to conclude

that the patterns are involved in female choice of mates, but an alternative hypothesis is that the reflectance is a factor in camouflage in which the exact form of the reflective areas is largely irrelevant. Pierids have their wings folded when feeding and at rest, and significantly the undersides of the wings of both males and females are very reflective.

The brimstone butterfly (*Gonepteryx rhamni*) is thought by some to be the original *"butter-coloured fly"*. Like its near relative the Cleopatra butterfly of southern Europe, it is beautifully camouflaged amongst vegetation, resembling a yellowing leaf. However, look more closely at these insects when you see them alive. In sunlight they are a vibrant yellow, lost amongst the spring flowers. But when they rest amongst leaves the wing colour appears to change, reflecting the colours of the leaves around them. This is no doubt because the wing scales have slightly reflective surfaces, but this change

Asian yellow orange-tip butterflies (*Ixias pyrene*) "puddling" for salts in a river bed

cannot be seen in specimens in collections, which are inevitably viewed under artificial light. Light from tungsten and halogen bulbs contains less than one per cent UV with the peak emission in the yellow/red range.

The yellow or white wings of many butterflies render them almost invisible among the flowers of meadows and downland. The clouded yellow is a migratory butterfly that appears in huge numbers in northern Europe and Britain in certain years – the so-called "clouded yellow years" – at intervals that have been lengthening since the advent of synthetic insecticides. These butterflies breed mainly in southern Europe and North Africa where in the spring they merge into the carpets of yellow spring flowers that cover

meadows and coasts. The clouded yellows rest with their wings closed, concealing the body, but when feeding the small white and the large white usually have their wings slightly open and the body on the axis of the sun's rays. This may be a means of shielding the body (which is black) from view as much as possible while the butterfly is keeping warm in the sun.

Some tropical pierid species migrate in clouds, sometimes described as resembling snowstorms. They can also be found in vast numbers on river beaches taking in minerals from the sand. Bates[2] mentions species of *Callidryas*, "… *in densely packed masses… so that the beach looked as though variegated with beds of crocuses.*"

The marbled white, actually a member of the family of brown butterflies (Satyridae), is similarly difficult to trace on chalk grassland. Its under-wings are harlequin-patterned like the flowerheads of white clover, while the upper surfaces resemble a white flowerhead when viewed head down. There are also possible caterpillar images on the edges of the hind-wings.

Two butterflies camouflaged as meadow flowers: (*above*) the marbled white (*Melanargia galathea*) and (*opposite*) the clouded yellow (*Colias croceus*)

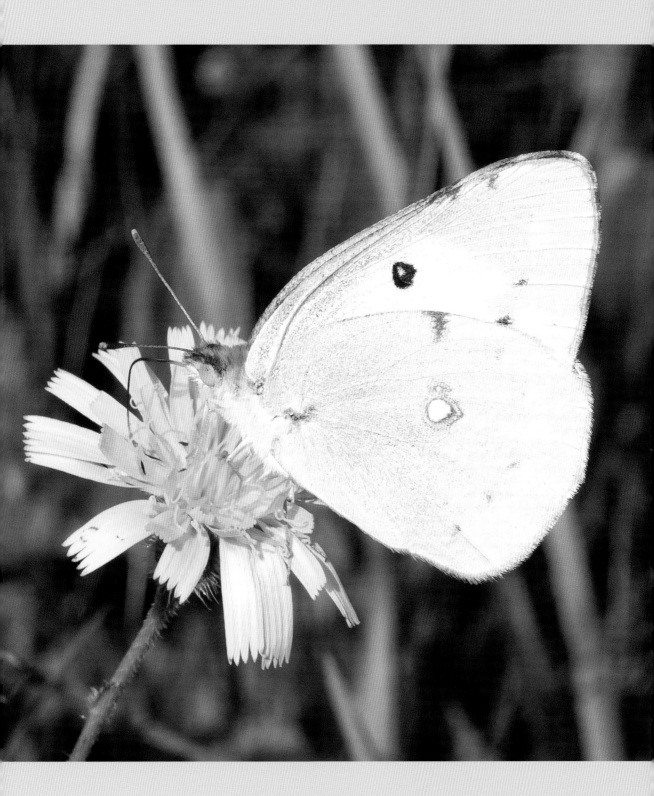

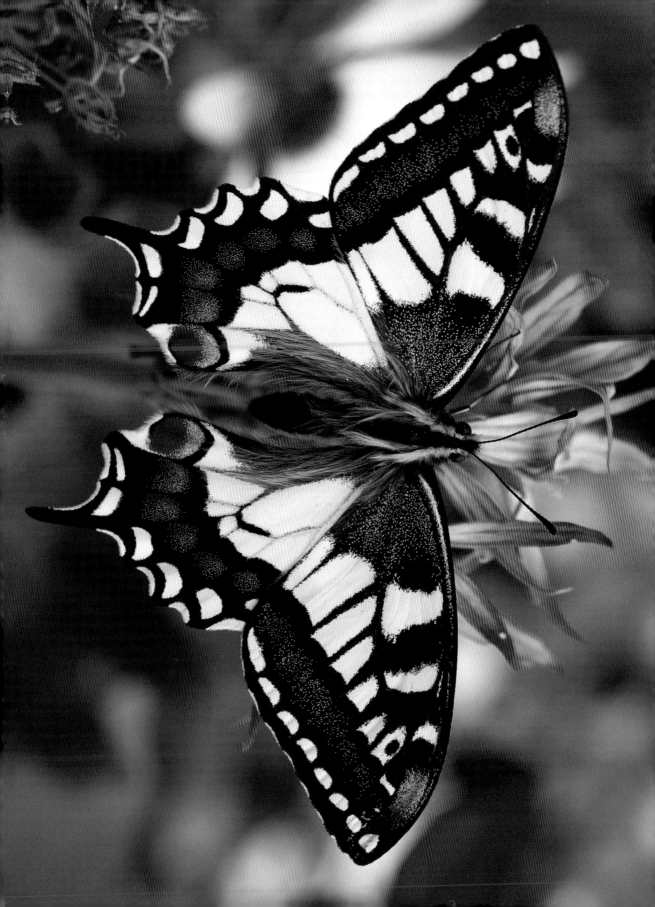

THE SWALLOWTAIL & BIRDWING BUTTERFLIES

"… my guiding angel … pointed out to me a rare visitor; a splendid pale-yellow creature with black blotches, blue crenels, and a cinnabar eyespot above each chrome-rimmed black tail. As it probed the inclined flower from which it hung, its powdery body slightly bent, it kept restlessly jerking its great wings, and my desire for it was the most intense I have ever experienced."
— Vladimir Nabokov, *Speak, Memory*

The European swallowtail (*Papilio machaon*) is Britain's largest butterfly. The British sub-species was once found in many parts of southern England and as far north as Yorkshire, but is now found only in very few localities, principally the Norfolk fens. Elsewhere in the world sub-species are found throughout Europe and sub-Arctic North America and extend eastwards to Kashmir in the Himalayas and Japan. Some of their food plants are poisonous, including Artemisia[1] (in North America, it is also known as the artemisia butterfly) and marsh parsley (*Ciclospermum leptophyllum*) in Britain, which may explain why this butterfly is so brightly coloured, advertising its toxic nature. In older publications it is referred to as the "Royal William" apparently as a tribute to King William III, as it was present around London during his reign in the seventeenth century.

At first sight you might think there is no reason to connect the common swallowtail (*Papilio machaon*) with anything else. Can this be anything more than a beautiful butterfly resplendent enough to deserve a regal epithet?

The European swallowtail butterfly
(*Papilio machaon*)

129

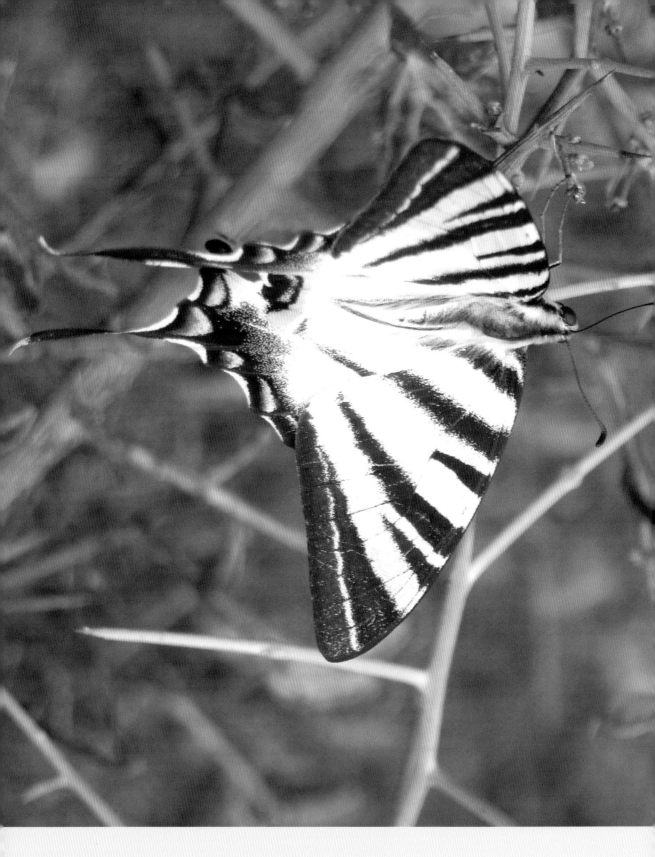

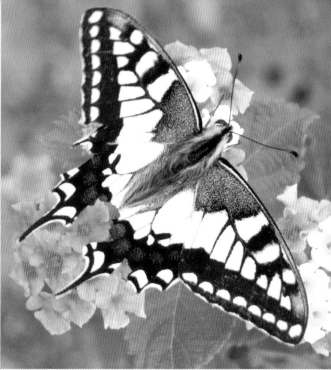

above: European swallowtail hovering while feeding. Note the caterpillar image on the hind-wing and the yellow and black wasp-like stripes of the fore-wing

above: Papilio machaon (Crete) with hind-wing eye-spots pecked out

opposite: The scarce swallowtail (*Iphiclides podalirius*)

But look again, and, more importantly, if you get the opportunity, watch the live insect feeding and you will see wasp features. The edge of the bright yellow fore-wing is marked with black bars. As it hovers taking nectar, the fore-wings are a blur. There are two wasps hovering there, their bright abdomens are the give-away, materialising like bright spectres in the air above a flower. Most of the time the butterfly keeps its wings moving, even when settled on a flower. What is more difficult to see is that the hind-wings move relatively little, and only the fore-wings are in rapid motion painting the air black and yellow.

The colours that contrast most strongly to the human eye, whichever one forms the background, are yellow and black, and also red and black. Significantly, these are colour combinations that we find among swallowtails and many other aposematic insects.

As in many Lepidoptera, one unexpected image can obscure others. As you refocus on the hind-wings,

two eyes and an open sharp beak are pointing up at you. Only a few individuals of the eponymous scarce swallowtail (*Iphiclides podalirius*) have ever been found in Britain, having wandered in from the Continent. The false head of this butterfly is so convincing that it has been said that it appears to fly backwards: as the two hind-wings are brought together when the insect takes off, the pointed false beak seems to open and close. The movement is too fast for the human eye to resolve but bird eyes have a higher flicker fusion frequency (see Chapter 1) and birds would be able to see this.

It is usually said that the eye-spots are part of a butterfly's false head – a sacrificial mock offering that enables the insect to avoid being caught and eaten. But a bird might perceive this as a direct threat from another dimly-seen bird and must then face the need to make an instant decision to withdraw or fend off possible attack by pecking at the "eyes". These two hypothetical interpretations

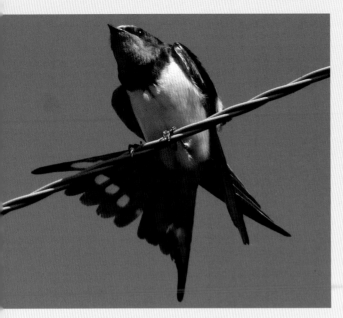

above: European barn swallow with white-marked tail fan

opposite: Common mormons (*Papilio polytes*) in flight resembling small swallows

them the name "tiger" swallowtails. These tiger stripes have at least two possible advantages. Firstly, they amplify the wasp pattern, especially in flight. Secondly, each stripe usually ends in a point, and so resembles a cactus spine. Interestingly, striped swallowtails are found mainly in the Americas where plants with dangerous spines, such as the agaves, are common (they were introduced into Europe only after the Spanish Conquest).

Despite the name, no one seems to have thought that swallowtail butterflies might sometimes be swallow mimics. When we look at a swallowtail butterfly at rest with its wings spread, it has many of the features of a bird like a swallow. These bird-like features can be seen in the many colourful swallowtail butterflies from the tropics and sub-tropics, and also in the appropriately named birdwings of South-East Asia, which are tail-less members of the swallowtail family.

Swallows, swifts and martins are extremely common in South-East Asia and throughout the rest of the world. Consult a bird identification book and you will find that we use the following features to identify the European swallow and similar birds (*Hirundinidae*):

Narrow wings, with curved leading edges
Glossy blue-black wing colour
Red-marked throat and forehead
Forked tail
White-marked primary wing feathers
Tail fan with band of white marks

Most of these features typical of swallows can be seen in common Asian swallowtails, such as the common mormon (*Papilio polytes*) (see opposite).

When a bird is hovering or about to land, it spreads its tail fan, with the fore-wings beating fast but the tail fan staying relatively still and slightly bent down so that it acts as an air-brake like the flaps on an aircraft's wings.

are, of course, by no means exclusive. However, there is anecdotal support for the latter view (see Chapter 1). Pecking at eyes is more common among birds than we imagine, because it is only the cases where someone comes into very close contact with a bird and loses an eye that get reported.[2]

There is yet more subterfuge: false caterpillars are there too, creating more confusion. As with many butterflies, the hind border of the swallowtail hind-wing has a caterpillar design with scallop designs portraying the legs, the eye-spots becoming the head (all caterpillars have large false eyes which metamorphose into compound eyes in the adult) and the short tails resemble large pointed spines. The illusion is completed by the dark wing veins breaking the "caterpillar body" into segments.

There are also many South American species that have striking stripe patterns on their wings, earning some of

The hind-wings of many swallowtail species resemble this spread tail fan, with the black edging sketching out the false feather tips. If a bird makes a mistake and what it sees is indeed another bird, it may be immediately attacked and could have only a fraction of a second more to live. Correspondingly, if the predator is confused for only a small fraction of a second the butterfly will be gone.

The first time I saw live tropical swallowtails in Africa the blur of hind-wings, such as you also see in a hovering small bird, was a surprise, the live insects offering a different spectre from that for which I had been primed by looking at guide books and museum specimens: it is the fore-wings that are beating while the hind-wings stay more or less still. In some Asian species there is an even greater resemblance to a bird about to land with its tail fan spread. There are some supreme examples of Batesian mimicry amongst swallowtails, which are often sex-linked, as in the extraordinary African mocker swallowtail in which the females mimic toxic danaid butterflies (see Chapter 2), and there are palatable species that mimic unpalatable swallowtails.

The common mormon (*Papilio polytes*) and the great mormon (*P. memnon*) from Asia have three and more than twenty-five female forms respectively, but only one male form each (hence the reference to the polygamous Mormon sect). The females are mimics of the red-bodied swallowtails including the crimson rose (*Atrophaneura hector*) and the common rose (*A. aristolochiae*) butterflies marked with bright red

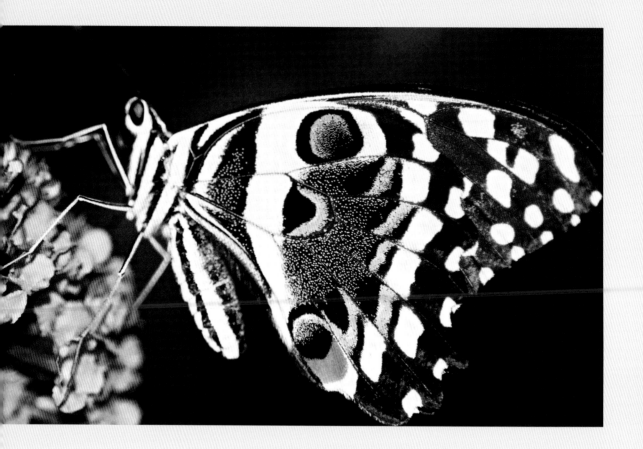

spots on a black background, like a pattern on the skirt of a flamenco dancer. The caterpillars of these butterflies feed on Aristolochia vines containing powerful toxins that are ingested and taken through to the adult butterfly, which can also produce repellent odours when attacked. The mormons are among other swallowtails that are Batesian mimics of the red-bodied swallowtails including the red admirals (see Chapter 5).

One of the most common African butterflies is also a tail-less swallowtail: the citrus swallowtail (*Papilio demodocus*). A very similar species is found in some parts of central Africa, where it is called the "snake butterfly".

Its mimicry does not stop at snakes: this butterfly may be a mimic of a buffalo or antelope: what appear to be eye-spots may represent nostrils (the giant silkmoth *Eacles barnesi* has similar nostril features).[3] The "nostrils" are surmounted by two "eyes" and whitish hairs mark the edge of the muzzle. This becomes an animal's face, the shade flecked with yellow spots of sunlight coming through the foliage.

above: The African citrus swallowtail (*Papilio demodocus*). The snake head image becomes clear on rotating the page anticlockwise

opposite: Citrus swallowtail showing the mask of a buffalo in the upper wing surface

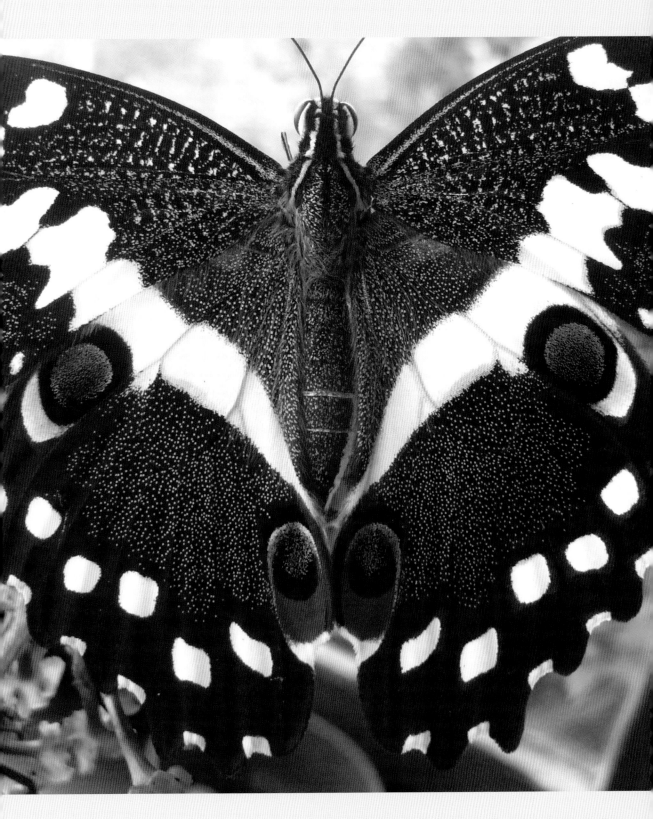

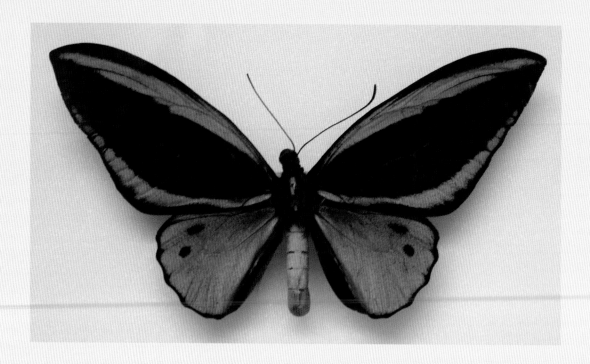

Birdwing butterflies

The magnificent birdwing butterflies of South-East Asia and Australia are appropriately named because they are the size of small birds. The exoticism of their environment is captured by Rudyard Kipling:

"Do you know the pile-built village where the sago-dealers trade –
Do you know the reek of fish and wet bamboo?
Do you know the steaming stillness of the orchid-scented glade
When the blazoned, bird-winged butterflies flap through?"

The first entomologists to collect birdwings in Papua New Guinea employed tribesmen to shoot the largest birdwing butterfly with bows and arrows. Queen Alexandra's birdwing, the largest butterfly in the world was brought down with a small shot-gun by one of Lord (Walter) Rothschild's collectors.[1]

Some of the birdwings of South-East Asia and Australasia

have the brilliant opalescence and iridescence distilled into their wings making them part of the same paradise as the eponymous birds of that region of the world. Some, such as *Ornithoptera priamus* from Queensland, even have feather markings on their fore-wings that suggest the iridescent tail feathers of birds of paradise. Alfred Russel Wallace was overcome with the beauty of the birdwings when he visited Sarawak in the mid-nineteenth century. On one of the most striking, which he named "Rajah Brooke's birdwing" he noticed that the iridescent green markings on the wings were like the tips of the feathers on a Mexican trogon (see Chapter 1, page 10). The trogons have brilliant iridescence – like the famed Quetzal bird which had great sacred significance for the ancient Aztecs. There are, of course, birds with similar plumage in South-East Asia, including members of the crow family (Corvidae) and the birds of paradise, which appear to have undergone a rapid phase of evolution in the Orient during the Cretaceous period. In his book on the Malay Archipelago, Wallace, in a much-quoted passage, described his ecstasy on capturing a specimen of Priam's

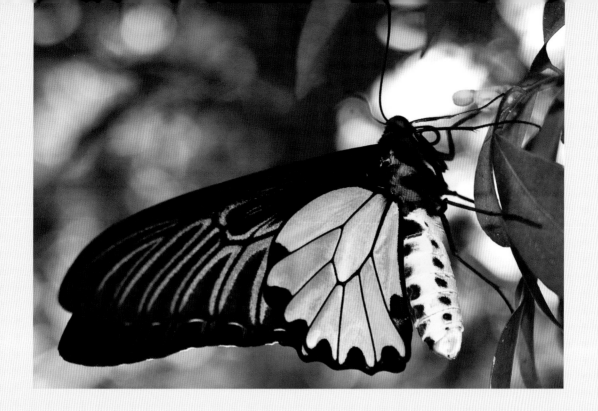

opposite: Priam's birdwing (*Ornithoptera priamus*) (male) an epiphany for Alfred Russel Wallace

The golden birdwing (*Troides aeacus*); *above:* showing the wasp-like abdomen; *below:* the fore-wings resemble wings of a bird and the abdomen is obscured by a false (lizard?) head seen more easily on inverting the page

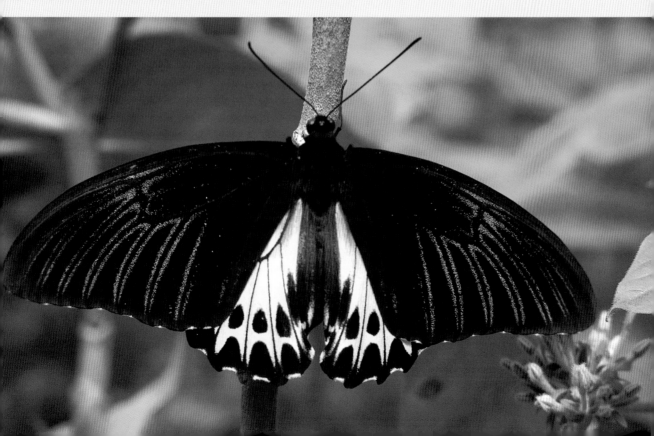

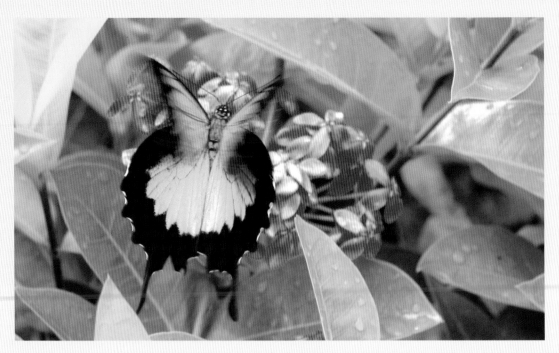

above and opposite: The blue mountain swallowtail butterfly (*Papilio ulysses*) with iridescent wing feather markings that have the appearance of a blue bird in flight

birdwing. It was a profound emotional experience for him: "...*my heart began to beat violently, the blood rushed to my head, and I felt much more like fainting than I have ever done when in apprehension of immediate death.*"

The blue mountain swallowtail (*Papilio ulysses*), found in tropical forest in Queensland, Australia, and throughout Australasia is one of the world's most beautiful butterflies, and this, too, uses the same deception as the Rajah Brooke's. It has iridescent blue feather tips emblazoned on its wings and the rest of the wings appear as if in darkness. The feather pattern on the wings and their colouring match perfectly the plumage of the Indian roller (*Coracias benghalensis*) a most beautiful bird, very conspicuous in flight, that feeds on large invertebrates including butterflies. We can suppose that prey that mimics the predator has a good chance of being avoided.

The birdwings and the swallowtails are considered to be closest to the root stock of the evolutionary tree

of butterflies. I have argued in Chapter 3 that the red admirals and others are Batesian mimics of the red-bodied swallowtails. It is then tempting to conclude that the European swallowtail (*Papilio machaon*), which today has a very wide distribution throughout Eurasia, evolved a wing pattern based on the abdomen colours of the yellow-bodied birdwings (*Troides* and *Ornithoptera* species) of South-East Asia. The yellow hind-wings of the golden birdwing are so lustrous – the wing scales are partially iridescent – that the finest burnished gold seems dull by comparison. But the birdwings, like the red-bodied swallowtails, feed on Aristolochia vines and as a result are equally toxic to predators.

The bold yellow markings on the *P. machaon* wings are a closer match to these colours than to those of oriental hornet species, which are predominantly orange. However, *Troides aeacus* will curl its body downwards when it is molested, as if to sting, so possibly yellow wasps, many birdwings and *P. machaon* are co-mimics.

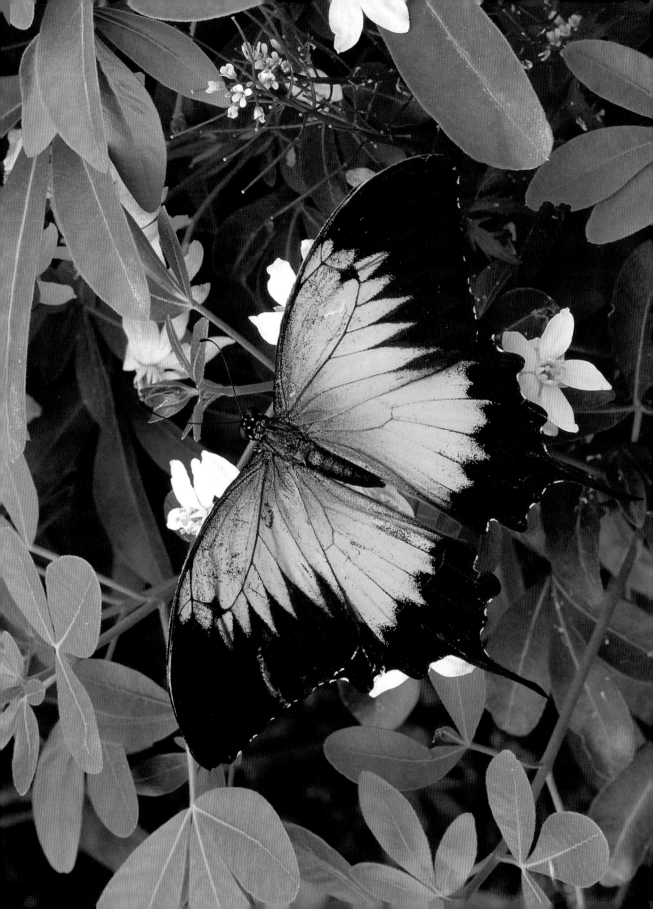

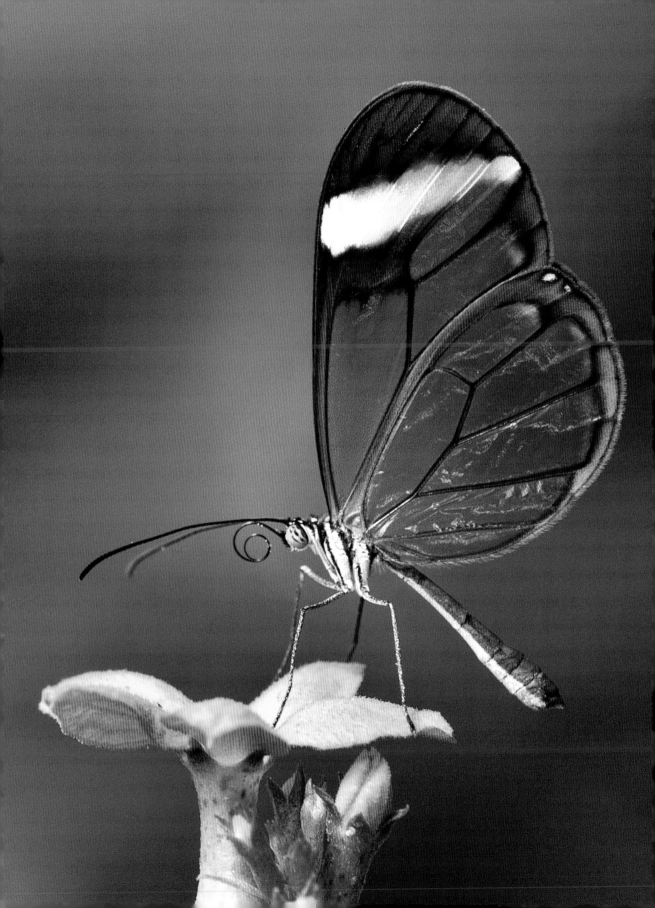

THE TROPICAL VINE
& CLEARWING
BUTTERFLIES

It is hardly an exaggeration to say that whilst reading and reflecting on the various facts given in this Memoir, we feel to be as near witnesses, as we can ever hope to be, of the creation of a new species on this earth.
— Charles Darwin's comments on H.W. Bates' seminal 1861 paper on mimicry in Heliconidae of the Amazon

Around 180 million years ago, the continental masses began to separate, and about 65 million years ago Asia, Australasia, Africa, North and South America were all disconnected with the consequence that the flora and fauna began to evolve separately. At this time in prehistory there was a period of violent geological upheaval, now thought to have been caused by the impact of a gigantic meteorite. Intense volcanic activity at the same period led to dust clouds blotting out the sun. This near-Armageddon resulted in the extinction of the dinosaurs and over 45 per cent of all plant and animal genera in the world.

The area of the meteorite strike causing the so-called K-T event is believed to be where the Yucatán peninsula of Mexico and Guatemala now lies. This event must have suppressed any expansion of the range of surviving butterflies for many millions of years. Ultimately, reconnection between the Americas, Eurasia and Africa about 20 million years ago allowed butterfly families to extend their range intermittently during the

The glasswing butterfly (*Greta oto*)

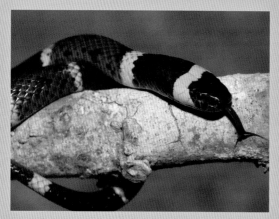

above: A Texas coral snake (*Micurus tener*) with the red, black and yellow patterns that are assumed by many South American Butterflies

opposite: A passion vine butterfly (*Heliconius melpomene*)

the vines on low-growing vegetation on which they depend. They are generally distasteful or poisonous to other animals, and many different species fly together in what are known as "mimicry rings" all bearing similar patterns of yellow, white, red, or orange on black. Quite unrelated species can be found in these mimicry rings, including members of the white and swallowtail families, even some beetle and moth species that have evolved the same colour patterns – all protected by the same distinctive wing costume and all members of the same insect community. Species that fly at higher levels in the forest tend to be blue and white – colours that reflect UV and are more easily seen against a dark background.

course of several ice ages, the last of which ended about ten thousand years ago.

Butterflies belonging to the family Nymphalidae, such as the tortoiseshells and painted ladies, and moths similar to the common silkworm were around at the time of the great extinction. How they managed to survive this and the ice ages that followed defies imagination, because it is believed that a high percentage of all the flowering plants on which the caterpillars could feed were also killed off. But in the South American tropics and sub-tropics new families of nymphalid butterflies arose, phoenix-like from the scorched planet, and came to populate the Amazon basin in huge numbers. The longwing or passion vine butterflies (heliconids) and the clearwings or glasswings (ithomiids) are among the most fascinating of all butterflies in terms of their behaviour, life cycles, and relationships with their (usually) poisonous food plants. They form a bewildering constellation of mimetic species that will keep evolutionary geneticists intrigued for generations to come.

Clouds of these butterflies can often be seen in forest clearings and on riverbanks. They have long wings that are ideal for slow, hovering flight, allowing them to manoeuvre easily like miniature helicopters through

The yellow-red-black patterns, of course, stand out and make very good warning colouration, but could also be copies of the uniform of one of the most feared animals of the tropical and sub-tropical Americas: the coral snake. Coral snakes are also banded in bright red/orange, yellow and black. They are very venomous as the following medical report on a case in Ecuador shows:

"A man bitten by a large coral snake (Micrurus lemniscatus helleri) … developed persistent excruciating pain in the bitten arm. Despite treatment with specific antivenom 50h after the bite, he required oxygen for respiratory failure 60h, and 6h of mechanical ventilation 72h after the bite. Over the next 38h, he required two further intubations and periods of assisted ventilation before being airlifted to a tertiary referral hospital."

Without an antiserum, about one in ten people die after a bite from a coral snake, so not surprisingly Amazonian Indians do everything to protect themselves against these snakes, which they fear as much as jaguars. Daniel Everett's fascinating account of life with a remote Amazonian tribe carries the warning title, *Don't sleep there are snakes*, which was the advice given to him by his new neighbours when he first arrived.[1]

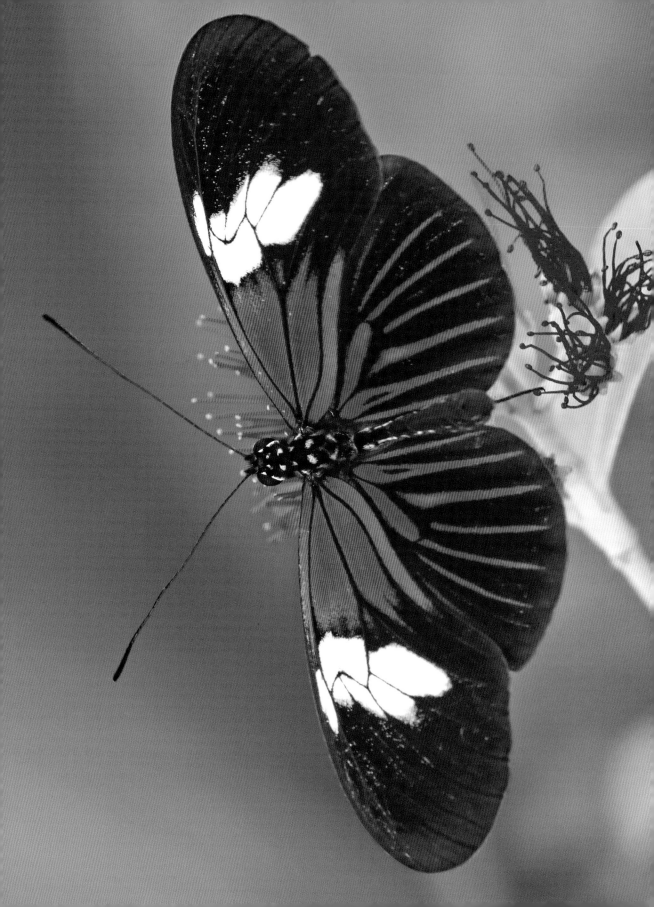

Coral snakes feed on animals that are predators of butterflies, such as lizards, frogs, toads and small birds, so these predators need to be very alert to anything with the coral snake colours. It has been found that a wide variety of bird species in Costa Rican forests avoid snake models with coral snake colours (red, black and yellow) or even just red and black.[2] This includes young birds that would not have had time to learn of the dangers of these snakes by experience. An exception to this colour patterning occurs in the brilliant orange butterfly (*Dryas iulia*), known as the flame in the southern United States.

Researchers in Brazil and Costa Rica have discovered many fascinating details of the lives of heliconid butterflies. Not only can the caterpillars feed on and tolerate the cyanide-producing chemicals in the passion vine leaves, but they can also manufacture more cyanide in their own bodies. The caterpillars do not need to eat much compared with other species, and that is because the adult butterflies are able to feed on pollen as well as imbibe nectar. Pollen sticks to the proboscis and then is sucked up to the mouth, chewed up with tiny jaws (found only in these butterflies) and mixed with saliva with digestive enzymes. Pollen is rich in protein and this is put into the eggs, so that there is already a store there for the caterpillars to draw on (a hen's egg is similarly packed with protein). An astonishing 90 per cent of the body of a newly-emerged butterfly comes from the protein in the egg.

above and opposite left: Heliconius caterpillar and egg mimics on a passion vine

opposite right: Extra-floral nectaries on a passion vine leaf stem that attract ants

Feeding on proteins makes it possible for the butterflies to use these building blocks to repair their tissues. Largely as a result of this and unlike most butterflies, which survive only on the sugars in nectar, living for only two or

three weeks, heliconids can survive for many months. Along with this they have large brains and very good memory. They are able to learn where the main sources of their favourite pollen-producing plants are (cucurbit vines) and visit them in sequence day after day. Not only that, but they return to the same roosting spot each night.

With butterflies that are so successful and such good survivalists, you may wonder how the passion vines survive. In fact, the plants fight back in a host of different ways. It is often said that there has been an evolutionary arms race between them and the butterflies: as each partner has evolved a new defence strategy the other appears to have evolved a new way around it, and so it goes on.

To add to its chemical defences, the passion vine is also able to recruit a mercenary army to protect it. The troops are small but vicious *Azteca* ants, which come to the plant for the sweet nectar that is secreted, not from the flowers, but from extra-floral nectaries on the stems of the plant. The ants then keep away or kill any caterpillars or other bugs that they encounter on the plant.

The butterfly empire strikes back against the ants by laying eggs on the tendrils of the vines, away from the stems and

ants, but the plants have an answer for that too. Some of their tendrils simply drop off after a time, taking the eggs with them. As a further line of defence, some passion vines have egg mimics on their tendrils – small yellow growths that look like butterfly eggs. Female heliconids usually lay one egg on a tendril. The caterpillars are cannibals, so if there are two that hatch on a tendril only one will survive. The innate tendency of the butterflies is to avoid tendrils that appear to have an egg already. The tendrils pose a threat even to the butterfly chrysalids on the plant: they curl around them and strangle them. Some vines even have short curled caterpillar-like growths on the stems giving the impression that the food resource is already compromised.

Hooked spines on the leaves of some passion vines impale the unfortunate caterpillars. The evolutionary biologist Larry Gilbert even suggested that the butterflies had won the arms race when he found that zebra butterfly (*Heliconius charitonius*) caterpillars could protect themselves by spinning a silk web over the leaves and then biting off the tips of the spines and eating them before attacking the leaf. In this case the ball appears to be in the plant's court, but natural selection will no doubt correct the balance some time in the future, if it has not already done so. Scent plays a very important part in the lives of

heliconids; a trapped butterfly everts scent glands from the tip of the abdomen, releasing a pungent odour. They also use scents (sex pheromones) which are produced even in the chrysalids: males of some species find the chrysalids of females and stay close to them until the butterfly starts to emerge. Mating then takes place before the female has emerged properly and dried her wings. This brutish behaviour is compounded by the male leaving a scent mark on his chosen partner that makes her repellent to any other prospective suitors that may come along.

The Clearwing or Glasswing Butterflies (Ithomiidae)

Many species of ithomiid butterflies look very similar to the heliconids and are also distasteful. The caterpillars feed on plants belonging to the Solanaceae, a family that includes the nightshades with their poisonous berries. Some of these butterflies have yellow, orange and black wing designs and are common in mimicry rings. Other species have wings that are mostly without scales and transparent (hence the common names). The wing membrane sometimes creates a subtle iridescence in sunlight, like the light reflected from a soap bubble.

With their transparent wings and thin delicate bodies the clearwings are difficult to spot in the dappled light of the forest. The adult butterflies have an addiction to plants of the borage family, such as heliotrope. If you take a dried heliotrope plant and hang it in a small clearing where ithomiids occur, the insects arrive out of nowhere within a few minutes and sit feeding on the damp parts of the plant. They do this because the plants contain certain poisonous alkaloidal compounds that the male butterflies take up and transform into a scent (pheromone) that is attractive to females and is used in courtship. The same scent also has other purposes: it keeps other males away, and the alkaloids are also poisonous to spiders, frogs and others that might prey on the butterflies. Small day-flying moths of the tiger moth family (Arctiidae) are also attracted to heliotrope at dusk: their bright iridescent colours turn them into jewelled pendants in the forest shade.

On the front margin of the hind-wings of male clearwings, you can usually see a white or black band, which is where the scent is produced, and long hairs, called "hair pencils", which dispense the scent, nature's exquisite equivalent of the cotton wick of an air freshener (see overleaf, right). The monarch butterflies and their allies also have hair pencils that are used by males in courtship as part of the seduction process.[3] Many butterflies use such aphrodisiac pheromones, and when you see a male repeatedly hovering over a female the likelihood is that the male is perfuming the female in some way.

The flame or flambeau butterfly (*Dryas iulia*) on a passion vine.

overleaf: Glasswing butterflies (*Greta oto*)

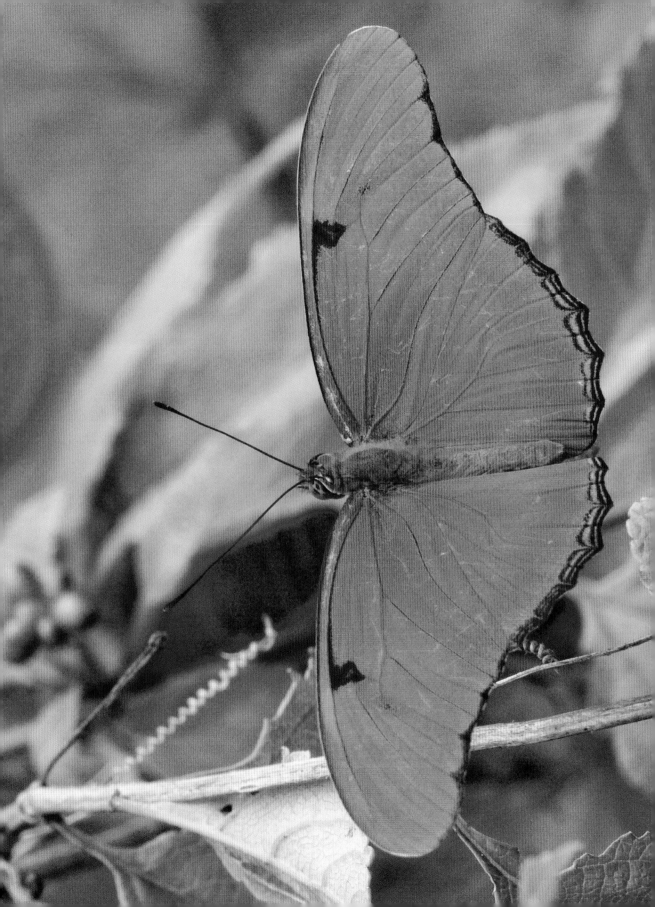

THE HAWK MOTHS

"They can't be bees — nobody ever saw bees a mile off, you know" and for some time she stood silent, watching one of them that was bustling about among the flowers, poking its proboscis into them. However, this was anything but a regular bee: in fact, it was an elephant."

— Lewis Carroll, *Looking-Glass Insects*

Lewis Carroll was amused by the thought that an insect probing flowers with its proboscis could also be an elephant, but the name "elephant" for a hawk moth is believed to come from the caterpillar, which when full grown, has the grey-brown wrinkled appearance of an elephant's trunk and has what were once called "terrifying marks" — eye-spots on the front segments of the body (see page 51). These segments can be inflated, upon which the insect rears its head, sometimes lashing it from side to side. Every entomologist must have been given a description of this diminutive monster found crawling across a garden path and asked, "Is it a snake?"

The Latin name for the hawk moth family is Sphingidae, a name that comes from the eighteenth-century French polymath Réaumur, who described the caterpillar of the privet hawk in its defensive posture with its head raised and inflated as a "sphinx". The great Linnaeus, who originated the system of scientific nomenclature for all living organisms, kept the epithet for his system of classification.

Small elephant hawk moth
(*Deilephila porcellus*)

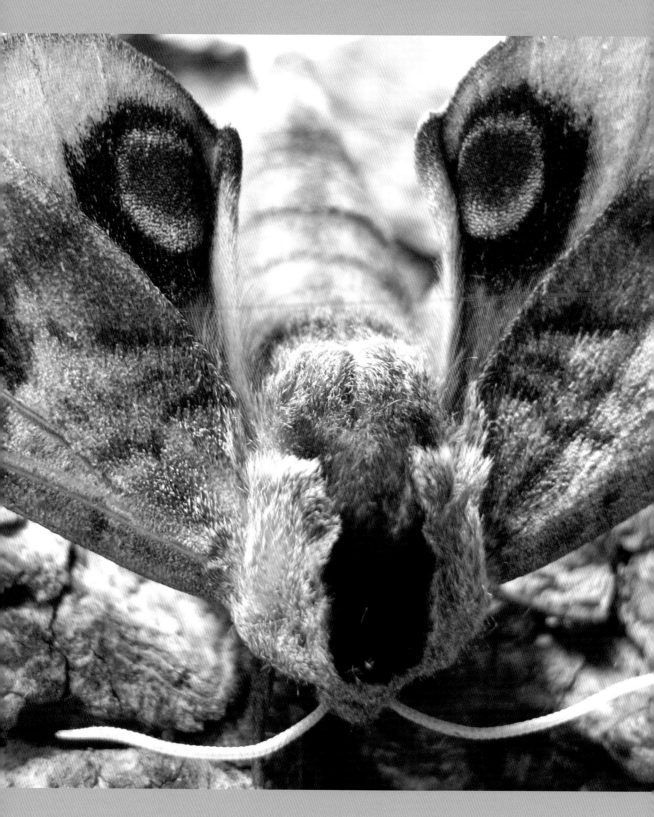

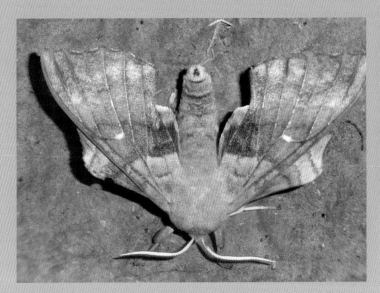

above: The poplar hawk moth (*Laothoe populi*) with a raccoon mask

opposite: A bird's eye view of a displaying eye hawk moth from the anterior

above: Eyed hawk moth (*Smerinthus ocellatus*) at rest, the wings resembling a bracket fungus

Hawk moths are very powerful fliers. Their wings, like those of falcons and fighter aircraft, are broad blades that enable them to move quickly, cutting through the air, rather than sailing and gliding like many butterflies, which have broader wings. By changing the angle of their wings in flight to fan the air downwards, some hawk moths can hover, like a helicopter, and carry out mid-air refuelling from flowers. This means that they are less vulnerable to predators because they do not have to land to feed and they can keep their body temperature high all the time. At rest, of course, they face the greatest danger because of the time they may have to spend shivering to warm up, and we find that they are generally very well camouflaged, the elephant hawk moth beautifully so against willowherb, when its white antennae and legs resemble the long anthers of the flowers and the wispy white seeds.

The eyed hawk moth (*Smerinthus ocellatus*) is a great impersonator. Close observation can reveal a bracket fungus, a bunch of dead leaves and a fox-like animal. Some of the illusions are seen with the insect at rest with its wings folded. Then, this moth hides its eye-spots beneath the beautifully camouflaged fore-wings that

make it look like a piece of bark. When disturbed it suddenly opens its wings and flashes its "eyes". This is usually enough to frighten any inquisitive, hungry bird. In his book *Curious Naturalists* Niko Tinbergen describes a simple experiment with chaffinches. When eyed hawk moths displayed their eye-spots to the birds they leapt back as if they had been stung and left the moths alone, but when he rubbed the "eyes" off the wings the birds just went ahead and ate them.

Even more unexpectedly, if you see the moth directly from above with the head down, the head of another animal appears: it could be a fox, wolf, coyote or some other caniid. Look carefully and you can see the eyes, which are blue as in many young canines, the dark line on the fur on the inside of each eye, the characteristic black nose, the snout, white cheeks, and the ears. Caniids of course have very sharp pointed teeth, and the white antennae are pushed forwards and suggest canine teeth or even a snake's forked tongue. When provoked, this moth makes a brusque rocking movement, and when you see this with the head towards you, it gives an eerie and frightening impression of a miniature fox, snapping.

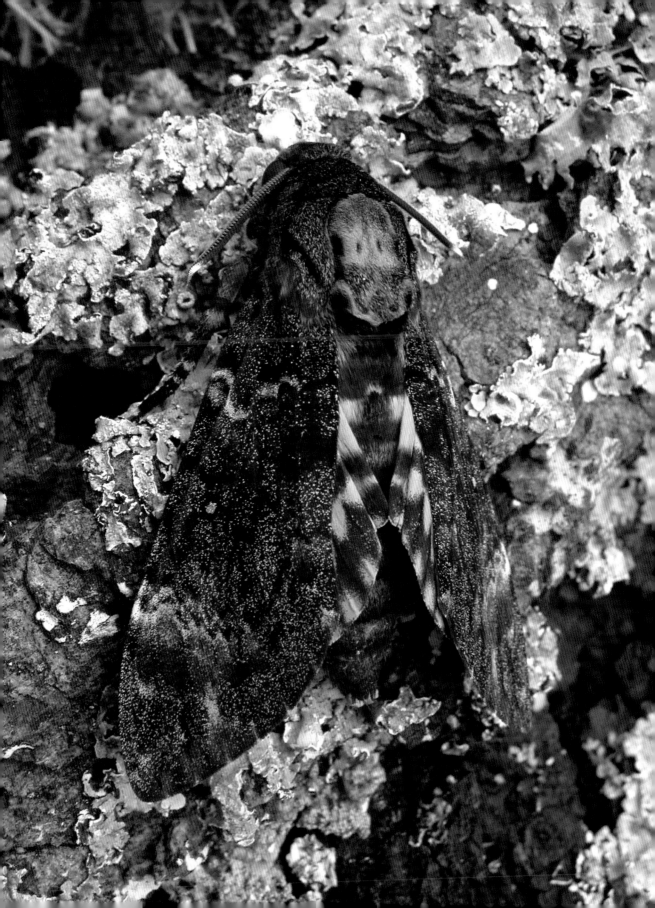

The poplar hawk moth (*Laothoe populi*) also resembles dead leaves or fungal growths when at rest, but when viewed upside-down has a mask that greatly resembles the face of a raccoon. Raccoons evolved in the tropics and subtropics and extended northwards about 28 million years ago moving into northern Europe before dying out. It seems certain that raccoons and poplar hawk moths overlapped in the same habitats for substantial periods of their evolutionary history.

The death's head, or skull symbol of the eponymous moth has always alarmed superstitious people who have seen it as a bad omen. The moth features in *The Silence of the Lambs*, both the book and the film, as a gruesome calling card that the murderer leaves in the mouth of his victims. On the book cover and posters for the film the "skull" marking is a fake: it has been replaced by a miniature of a painting by the surrealist artist Salvador Dalí of naked women in a fixed choreographed pose.[1] The skull symbol, frequently used in art, is a stepping stone from what is real to what can be imagined: in this case death by murder.

It simply does not make sense to suggest that this moth has evolved the skull mark as a protection from superstitious people or animals, nor that God created it that way to entertain us. The black and yellow bands on the hind-wings and the abdomen suggest that it is flying the flag of a huge wasp, which is a vital clue. We can find the answer to this enigma by observing the live moth from the perspective of a bird. When alarmed, the insect will tip its body forwards and open its wings slightly. The "skull" is thus displayed, with the yellow and black striped abdomen behind it. This suggests a large hornet with a white or yellowish face. The Japanese giant hornet fits the bill particularly well. It has a powerful sting and is the *Tyrannosaurus* of the insect world, known in some places as the "Yak killer".

Now carefully compare the hornet's head with the markings on the thorax of the moth. Perhaps what you

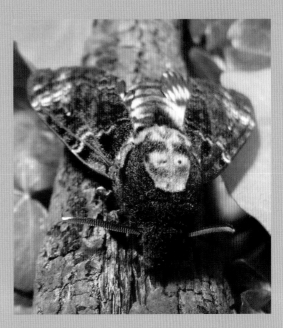

above: Bird's eye view of the hornet masquerade of the death's head hawk moth

opposite: The death's head hawk moth (*Acherontia atropos*)

thought were eye sockets in the "skull" are not that at all, but the tips of the sharp jaws pointing towards you threateningly. Now find following from the hornet:

 the first coloured segments of the antennae (feelers)
 the black segments of the antennae
 the big oval compound eyes
 the small triangle of simple eyes
 two pairs of pale brown legs
 folded wings alongside the body.

This astonishing hornet mimicry is further elaborated when the insect takes flight. It emits a grasshopper-like cry which is not unlike the whirring of the wings of a large bee or wasp. Some other hawk moths are hornet-like. The moth is notorious for robbing bee hives to feed on honey. The fine white wax particles on the wings and body are infused with the scent (the colony odour) of honeybees which allow the moth to go unmolested. The convolvulus hawk moth (*Agrius convolvuli*), for example, has a very pointed abdomen,

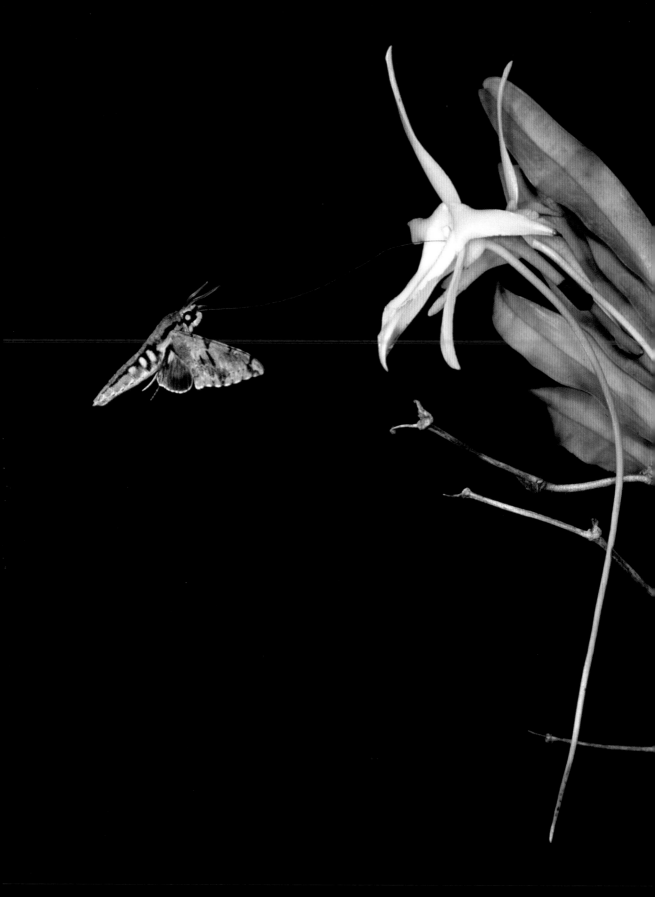

striped in red and black, with a projecting tip that can be curled downwards as if to sting.

Darwin's moth

Feeding in mid-air needs a very long tongue. Alfred Russel Wallace proposed that many of the flowers with long corolla tubes would eventually prove to be pollinated by hawk moths, and during his studies on orchids, Charles Darwin was intrigued by the comet orchid from Madagascar, which has a very long flower tube, 24-35cm long. He predicted that it could be pollinated only by a hawk moth with a tongue the same length. He was right! Morgan's sphinx moth was identified as the pollinator years after Darwin died. While hovering it inserts its tongue into the flower to reach the nectar at the base. When the tongue is fully extended the moth's head meets the pollen sacs (pollinia) at the entrance to the flower tube; they stick to it and are carried to the next flower. The plant needs the moth for survival, and if the moth became extinct so would the orchid.

Their long tongue means that hawk moths do not have to compete with other nectar-feeders like bees, or even, in some cases, hummingbirds, like the eponymous hawk moth that migrates from North Africa and the Mediterranean every year and sometimes reaches as far north as Scotland. Bates relates that the Amazon Indians firmly believed that hummingbird hawk moths (*Macroglossum titan* in this case) and hummingbirds are one and the same species, so great is the resemblance, and that one can metamorphose into the other.

The European hummingbird hawk moth (*Macroglossum stellatarum*) has a body suffused with orange; it mimics bumblebees as a protection, like the similar bee hawk moths, and is a mimic of its namesake by evolutionary design. Like the birds, it refuels in hovering flight through its proboscis, with wings beating at about 85 times per second – and so fast in movement that it flicks to another position in space faster than the eye can follow (a challenge for amateur photographers). The tongue is long enough to reach and extract the nectar of flowers in less than a second while the body remains perfectly fixed in space. I once saw one of the moths deceived by the reflections from the unlit candle-bulbs of a chandelier in a hotel foyer, docking before each in turn; it must have seen them as part of a gargantuan inflorescence – a moth's Stately Pleasure Dome, potentially harbouring lakes of golden nectar.

opposite: The long-tongued Morgan's sphinx moth (*Xanthopan morganii*) from Madagascar
below: Broad-bordered bee hawk moth (*Hemaris fuciformis*)

overleaf: The oleander hawk moth (*Daphnis nerii*). Invert the page and you will see the head and thorax are marked like an open-mouthed lizard. (Its green caterpillar has formidable blue eye-spots)

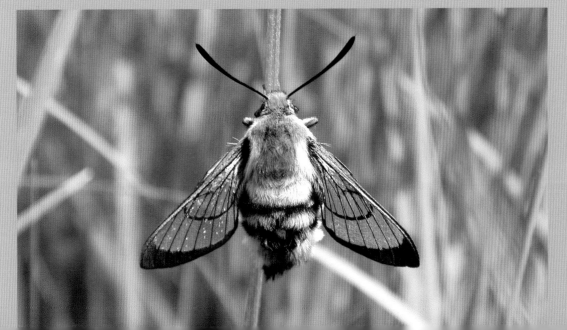

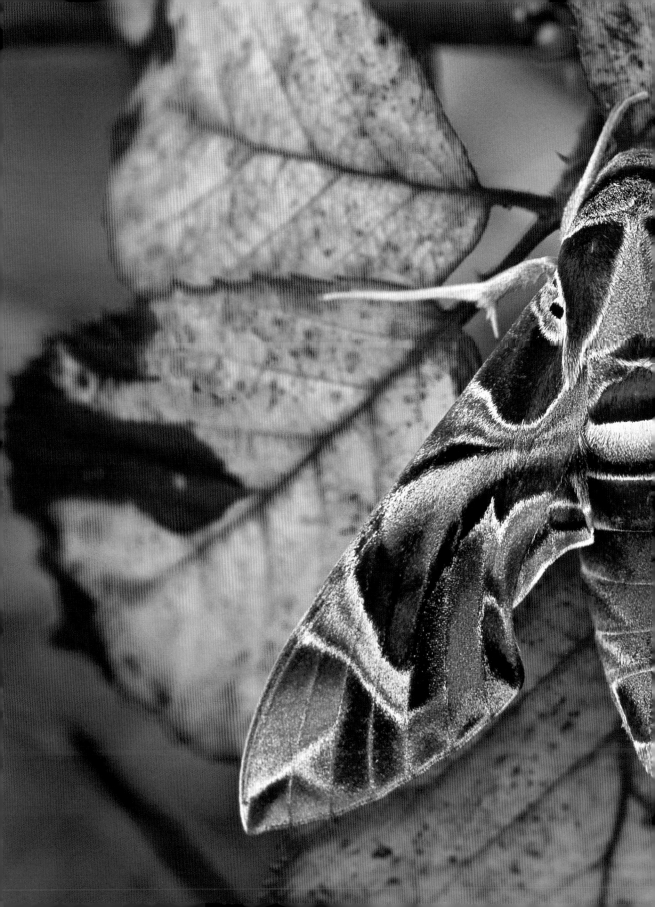

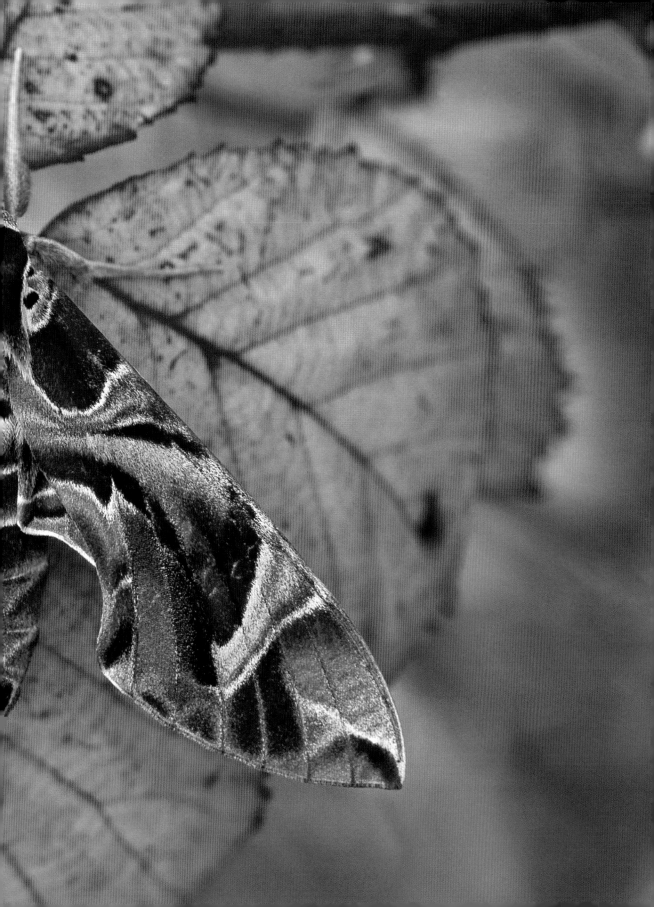

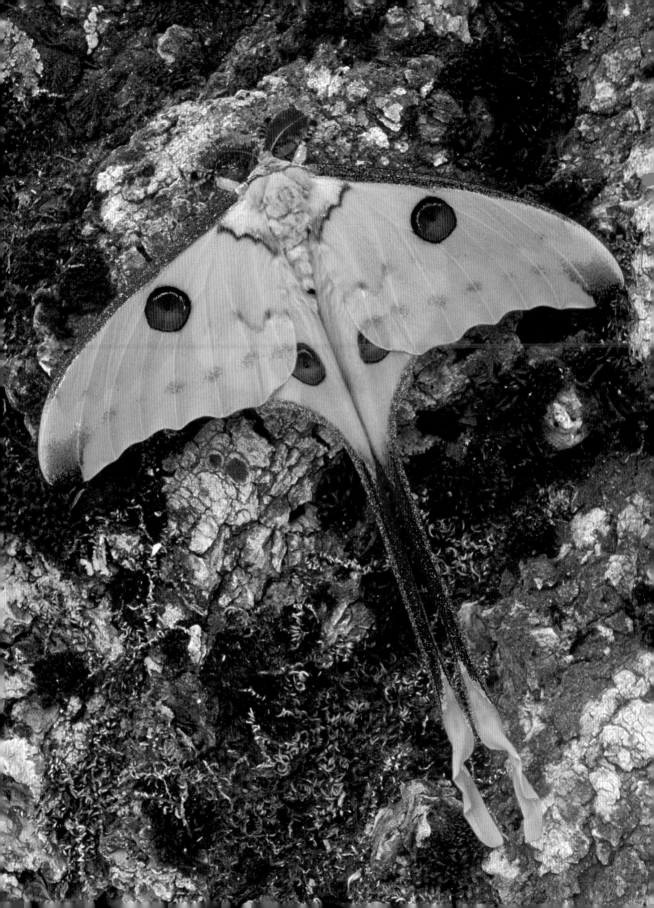

THE GIANT SILKMOTHS

The eyes of nocturnal animals such as cats glow and shine in the dark so that one cannot look at them, those of wild goats and wolves gleam and radiate light.

– Pliny the Elder, *Natural History* (AD 77-79)

The common silkworm has been domesticated for thousands of years, selectively bred for silk production. A side-effect of this is that it can't even fly because its wing muscles are not powerful enough. Its relatives, though, include the largest moths in the world, the size of small bats, many with designs on their wings that outshine the richest man-wrought tapestry. Many of these species have huge eye-spots on their wings, centred with large black pupils with white marks that give the impression of moonlight reflecting back from the surface of a cornea. The Latin name for the family to which these moths belong is the Saturniidae, meaning "belonging to Saturn". The circular rings of the eye-spots provide the explanation for this name.

These large-bodied moths take longer than slimmer versions to become airborne. To generate the necessary muscle power they must first raise their body temperature to over 30°C by vibrating their wing muscles. This can take several minutes, which can become literally a fatal delay if one has

The Madagascan moon moth
(*Argema mittrei*), male

161

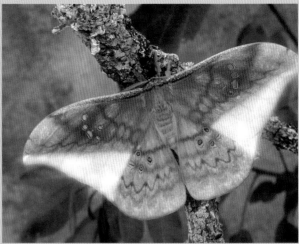

been discovered at rest by a predator. They therefore rely on mimicry and deception to avoid being captured.

The American luna moth and the Indian and Chinese moon moths have delicate colours, mixing turquoise, jade and opal with innumerable other hues, giving them a refined beauty that is matched only by the elegance and texture of the wings that enrobe them. The swallow tails, usually longer in the males, help the moths to remain airborne in the strong winds of the mountainous areas where many of the species live. Kite-flyers will know that butterfly kites will sail steadily in gale force winds because of the drag that the tails create. The stiff, darkened leading edges to the wings stand out twig-like against the palette of camouflage greens on the wings, and in some these edges have side branches ending in imitation buds to complete the illusion.

The elegant Madagascan moon moth (*Argema mittrei*) has a medium-sized eye-spot on each wing. The eyes may have semblances of heavy eyelids, making them appear more like the eyes of mammals.

There are many species that live on the forest floor and are, at first sight, virtual leaves, festooned with apparent holes in the wings that give the overall impression of a decaying leaf attacked by small invertebrates or fungi. Lines running across from one wing tip to the other mimic a mid-rib and alter the axis of symmetry that we expect to see in a moth. But, surprisingly, most of these leaf mimics have bird images embedded

above: Copaxa mazaorum, right image brightened to reveal a hovering bird of prey

opposite: Indian moon moth (*Actias selene*)

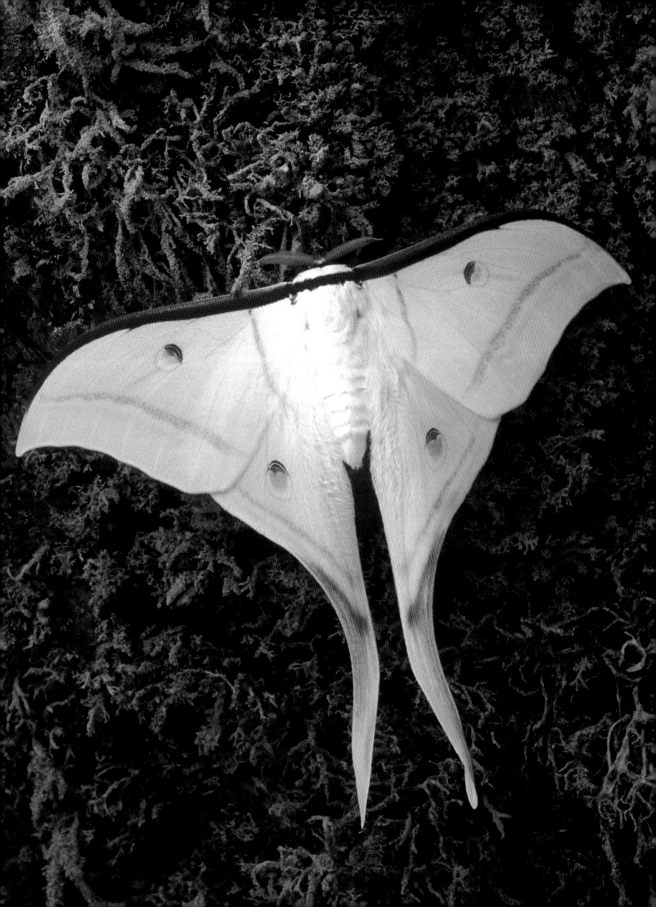

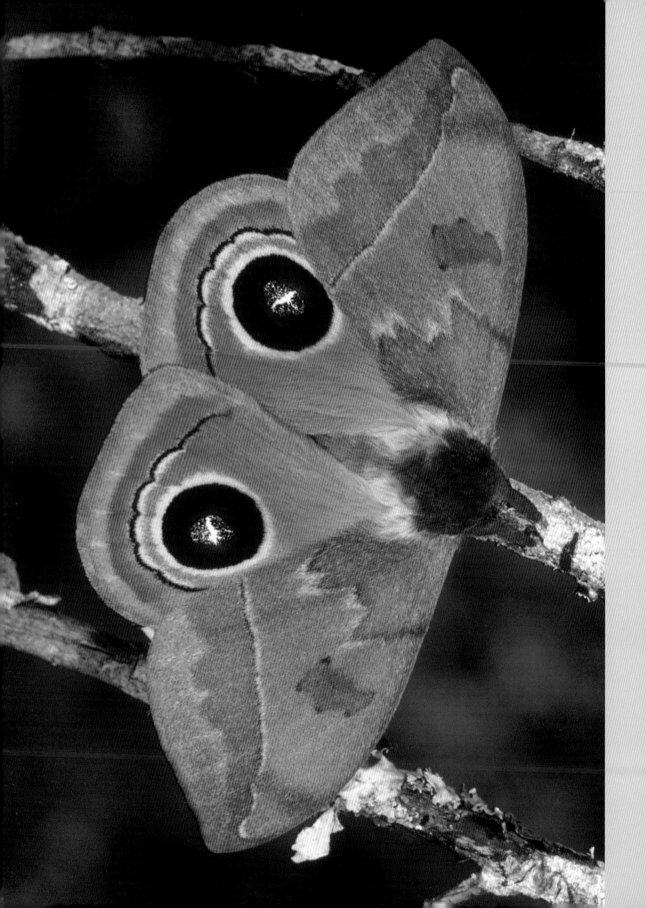

in their wings. These images are almost invisible to us, partly because we do not expect to see them and partly because they are outlined by blue-violet and ultraviolet reflecting scales (most birds, of course, are sensitive to this large band of the spectrum) leaving a silhouette of a bird with outstretched wings and spread tail fan as if about to land. In the photographs on page 162 you can see the hidden image appear when the blue end of the spectrum is artificially enhanced. The same effect is achieved if the colours are filtered out leaving the "black and white" image seen by nocturnal animals without colour vision.

Many saturniid moths have markings that mimic feather tips (as in Rajah Brooke's birdwing butterfly) that again suggest a small bird with spread wings amongst fallen leaves.

In yet other species which are among the most spectacular and arresting of all insects, only the fore-wings are leaf-like and the hind-wings carry huge eye-spots, which can be suddenly displayed.

Eye-spots are very conspicuous in the bull's eye moths from North and Central America. These moths keep their eye-spots concealed most of the time by covering them with their fore-wings, which have a bark-like camouflage. The staring "eyes" with large pupils are good copies of those of nocturnal predators – owls, small monkeys, etc. Forward-facing eyes give such predators good binocular vision and the large pupils help to collect the meagre amount of light in forests at night (see Chapter 1).

Some saturniid moths have fore-wings that bear relatively smaller eye-spots, and then the fore-wing can metamorphose as you look at it into the head of a bird. The most striking examples of this illusion are the *Polythysana* moths from Chile.

Different types of "eyes" are found in moths from South-East Asia, such as the tussore[1] and oak silkmoths (*Antheraea* species). They are small, round and see-through, without "eyelids" or simulated black pupils and are usually called "windows" for that reason. It is important to note that these windows are transparent only when you look at them from a 90° angle, and then the centres appear black if the insect is resting on a dark surface such as bark. Turn your head a little and look at them from the side and they reflect light back, like the eye of a cat caught in a beam of light. In cats and many other nocturnal mammals the eyeshine is produced by a layer at the back of the retina – the tapetum – which

A "bull's eye" moth (*Automeris oaxacensis*) from Mexico. Note the way a "beak" is outlined, and the "corneal" reflection

helps to harvest for the eyes the small amount of light that enters them at night. The wing surface is covered with microscopic hairs. When you look down at a grass lawn from directly above you can see the soil in between the grass blades, but get down to eye level and all you see is grass: it's the same principle, but the hairs reflect light.

Why do moths have these windows? When they are disturbed they start to rock from side to side. The effect of this is to change the colour of each eye from black to white, and then back again, making it seem as if all the eyes are opening and shutting and that the wings are part of a nocturnal predator. Birds will experience the same effect when inspecting one of these moths from different angles.

In many species of giant silkmoth the windows are neither circular nor eye-like, but claw- or tooth-shaped. The North American robin moth (*Hyalophora cecropia*) and its cousin the ceanothus moth have big canine teeth embroidered on their wings. Maybe they evolved these features when sabre-toothed tigers (*Smilodon*) roamed throughout America.[2] In some places in California large numbers of fossilised remains of *Smilodon* have been found, and it has been adopted as the "State Fossil". These fearsome cats were around for 2.5 million years, dying out only ten thousand years ago during the last ice age, and must have been one of the most feared predators, distinguished by their huge canine teeth. The fossil record shows that many large-fanged cats existed in most parts of the world, but most died out in the Pleistocene, only one or two million years ago.

The most spectacular of the giant silkmoths are the huge Atlas moths (see page 41), which have wingspans of up to 15cm (see pages 40-41). At the tips of their fore-wings there is an eye-spot, and most people will have little difficulty in recognising an embedded image of a snake's head. The body of the snake is outlined down the edge of each wing. When the moth is disturbed, it often falls to the ground, beating its wings slowly so that it tumbles over. This is a dance routine in which the "snake" appears to rear up as the fore-wings are extended, ready to strike – the same dance that an Indian snake-charmer provokes while playing a flute.

Snake images and images of the heads of other animals, such as alligators and birds, can be seen in quite a few members of this family of moths. The Atlas moths have windows on their wings that look more like claws (there were no sabre-toothed tigers in Asia for the last few million years,

Polythysana rubrescens from Chile. Each fore-wing viewed in isolation has a bird's head with finch-like beak, eyes and crest

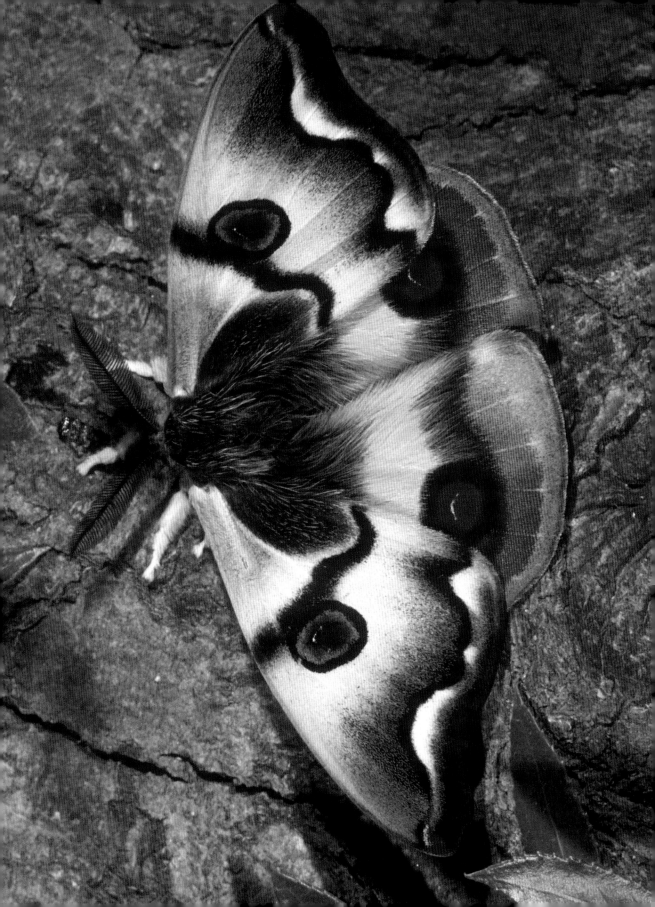

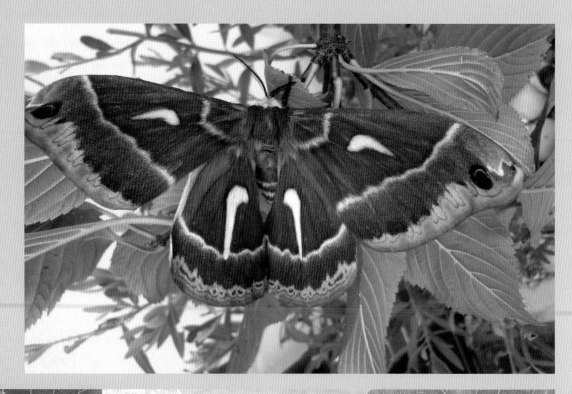

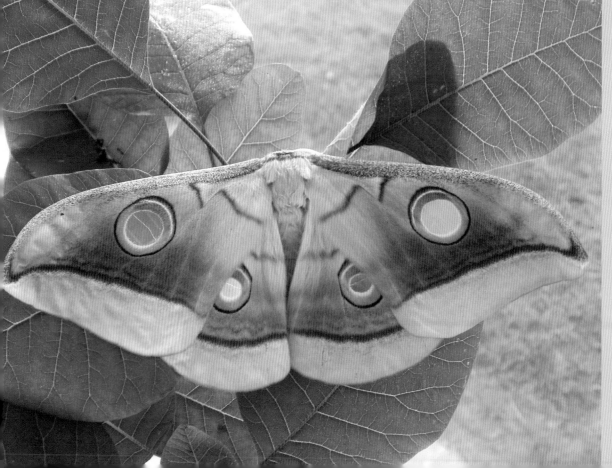

but plenty of tigers and other big cats). In addition, in darker colours, the outline of a bat or a raptor of some sort just about to land may be seen. Look carefully at the Atlas moth, and you may be able to recognise, in addition to snakes, a big, clawed foot, and a bat's wings.

Yet another type of iconic mimicry can be seen in the emperor moth (*Saturnia pavonia*), which is found on heathland in Britain and Europe where adders and other reptiles can be quite common. The caterpillar feeds on heather where there are few places to hide, but it is green with rings of purplish spots on its body, which provide excellent camouflage.

The emperor moth, which flies during the daytime, is obviously much more visible to predators and so some other sort of disguise is called for. The female is particularly vulnerable. When she is ready to mate she sits in an exposed position and exudes a sex attractant pheromone from her abdomen. Male moths can detect just a few molecules, and whenever they do they fly against the wind towards its source.

The adult moth appears to be a mimic of small animals that are most likely to be found in heathland. With its wings folded, at rest, the moth presents a pair of eyes on a seemingly furry head. If you turn the page so that you see the moth in the head-down position it is not difficult to discern a cat-like head. Closer inspection, however, shows that perhaps the nearest match is that of the European hare, which has eyes with a circular yellow ring around the iris, and a white ring of fur around the eye socket.

All things considered, the giant silkmoths are illusionists which far surpass in their beauty and subtlety of design anything produced by surrealist artists or magicians.

opposite above: The ceanothus moth of North America (*Hyalophora euryalus*)

opposite below: The oak silkmoth (*Antheraea mylitta*) with wing windows

overleaf: The emperor moth (*Saturnia pavonia*)

INDEX

A

Abraxas grossularia 52, 53
Acherontia atropos 154-155, 154, 155
Acraea sp. 36
Adonis blue butterfly 13, 115
Aegis 40
African eggfly 29, 30
African migrant butterfly 122, 122
African monarch butterfly 36, 102
Aglais sp. 15, 17, 79-82
Agrius convolvuli 52, 155
Alexander the Great 38
Amaxia apyga 34, 42
Ambiguity 42, 45-48
Antheraea sp. 165
Anthoptus epictetus 15
Apatura sp. 107, 112-116
Apocyanaceae 101
Arctiid moth 34, 42
Actias selene 162, 163
Arctia caja 25, 26
Arctic fritillary butterfly 57
Argema mittrei 160, 162
Argynnis lathonia 63, 65
Argynnis paphia 60, 62, 63
Artemisia plant 129
Aristolochia vine 64, 90, 92, 134, 138
Asclepiadaceae 50, 101
Amazon 35, 36, 73, 142
Antanartia sp. 86
Antheraea sp. 165, 169
Aposematic 24, 131
Attacus sp. 40-41, 166
Atlas moth 40-41, 166, 169
Atrophaneura sp. 89, 133-134
Automeris oaxacensis 164
Automimic 101
Azteca ant 145

B

Basilarchia archippus 90, 93, 102
Bates, Henry Walter 35-39, 112, 25, 141, 157
Batesian mimicry 36-39, 53, 58, 63, 87, 90, 91, 97, 102, 105, 133-134, 138
Battus philenor 90
Baucans 82
Bee hawk moth 157, 157
Beebe, William 111
Bering strait 57
Binocular vision 31-32, 165
Biopterins 121
Birdwing butterfly 9, 11, 36, 63-64, 136 et seq.
Biston betularia 44, 45
Blue tit 33, 43, 75
Blue jay 101
Blue mountain swallowtail 138, 138, 139
Blue tiger butterfly 103, 105
Bombyx sp. 58
Bordered patch butterfly 85, 87, 87
Bosch, Hieronymus 11
Bradley, Alan 28
Brimstone butterfly 2, 123, 123
Brown-tail moth 52
Buckeye 70
Budgerigar 15, 19, 70

C

Cabbage white butterfly 17, 122
Caligo eurilochus 72, 74
Callidryas sp. 125
Calotes 116
Calotropis plant 102
Calycopis cecrops 48, 49
Camberwell beauty 57-58, 58
Cane toad 70, 73, 73
Caniids 153
Cardenolides 97, 101
Cardiac glycosides 50, 97, 102
Carroll, Lewis 48, 121, 151
Catopsilia florella 122, 122, 123
Cézanne, Paul 18, 43
Charaxes jasius 94, 95
Cinnabar moth 82, 84
Citrus swallowtail 134, 134, 135
Cleopatra butterfly 46, 123
Clossiana chariclea 57
Clouded yellow butterfly 120, 123-125, 127
Chlosyne lacinia 85, 87
Colias croceus 120, 123-125, 127
Colour vision 22, 24, 165
Colour spectrum 28-29
Columba livia 33
Comet orchid 157
Comma butterfly 7, 47, 63, 64, 94
Common rose swallowtail 89, 133
Cones 24, 28, 30-31, 56
Confuciusornis 56
Convolvulus hawk moth 50, 52, 155
Copaxa mazaorum 162
Coral snake 142, 142, 144
Cosmopolitan 94
Crow 64, 75, 136
Crypsis 45, 53
Cuckoo 33, 50, 82
Cynthia sp. 78, 93-94

D

Dalí, Salvador 18, 38, 43, 155
Dalton, Stephen 17
Danaid, danaidae 36, 97-105, 133
Danaus sp. 36, 50, 102, 105
Daphnis nerii 158-159
Darwin, Charles 9, 35-36, 141, 157
Dazzle painting 21
Death's head hawk moth 154, 155, 155
de Mayerne, Sir Theodore 67
Deilephila sp. 50-51, 150
Diachrysia chrysitis 12
Diaphora mendica 48
Dione vanillae 58
Dryas iulia 144, 147

E

Eacles barnesi 134
Elephant hawk moth 48, 51, 150, 153
Emperor moth 169, 170-171
Ernst, Max 38
Eryphanis sp. 73
Euploea sp. 97, 105
Euproctis chrysorrhea 52

Evil Eye 67
Eye-spot 11, 14, 17, 18, 33, 42, 48, 59, 67-70, 74-76, 86, 94, 131, 132, 134, 151, 153, 161, 162, 165, 68-69, 74, 131, 161, 162, 165
Eyed hawk moth 43, 152, 153

F

Falco sparverius 61
Flame butterfly 144, 147
Flicker 21
Flicker fusion frequency 21, 131
Ford, E. B. 98
Forester moth 54, 55-57
Form constancy 43
Fox 43, 153
Frazer, Sir James 107
Fritillary butterfly 11, 57, 59, 61-63
Frog 11, 24, 40, 50, 70, 73, 144, 146
Freud, Sigmund 40

G

Gatekeeper butterfly 58
Gilbert, Larry 145
Giraffe 20, 62
Goldfinch 84-85, 85, 86, 90
Gonepteryx rhamni 2, 123, 123
Gorgon Medusa 38
Gorilla 33
Grandin, Temple 26
Graves, Robert 17, 122
Grayling butterfly 59, 59
Greta oto 140, 148-149
Grosbeak 101
Gulf fritillary 58

H

Hair pencil 102, 105, 146
Hairstreak butterfly 6, 48, 49, 115, 117-118
Harris, Moses 82
Heliconius sp. 38, 39, 58, 140 et seq.
Heliotrope 102, 105, 146
Hemaris fuciformis 157
Herring gull 22, 23, 33
Heterorhabditis 88
Hyalophora cecropia 13, 166
Hesperiidae 17
Hipparchia aristeus 59
Hooker, J. D. 36
Hopkins, Gerard Manly 74, 105
Hornet 11, 36, 80, 138, 155
Hornworm 50
Hoverfly 17
Hummingbird 22, 157
Hummingbird hawk-moth 22, 157
Hyalophora sp. 13, 166, 169
Hypolimnas misippus 29, 30

I

Icon, iconic 40
Idea sp. 21, 97, 105
Inachis io 14, 67
Indian leaf butterfly 29, 29
Iphiclides podalirius 130, 131
Iridescence 26, 30, 56-57, 68, 107, 110, 115, 136, 146,
Ithomia, ithomiidae 140 et seq.

J

Jackdaw 23

Junonia almana 70, 71

K
K-T boundary 64, 141
Kallima inachus 28, 29
Kestrel 61, 62, 62
Kipling, Rudyard 136

L
Lackey moth 80, 80, 82, 90
Ladoga camilla 30, 31, 90, 91
Laothoe populi 153, 155
Large blue butterfly 113, 115
Laciocampa quercus 43
Lasiommata megera 16, 17
Lehrer, Jonah 46
Leonardo da Vinci 9, 18, 20
Limenitis sp. 90, 92
Linnean Society 9, 36
Linnaeus, Carl 52, 105, 151
Lobster moth 50, 51
Lizard 40, 55, 56, 70, 73, 110, 116, 144
Lonomia sp. 52
Lopinga achine 74, 74
Lorenz, Konrad 23
Lysandra bellargus 13
Lunar hornet 36, 37
Lycaena phloeas 116, 117
Lycaenidae 30, 115

M
Macrurus – see Coral snake
Maculinea arion 113, 115
Macroglossum sp. 22, 157
Madder hawk moth 50
Madagascan moon moth 160, 162
Magpie 90
Magpie moth 52, 53
Malachite butterfly 8, 21
Malacosoma sp. 80, 80, 82
Malay archipelago 9, 136
Marbled white butterfly 125, 126
Meadow brown butterfly 11, 58, 59
Melanic form 46
Melanin 55, 56, 107
Melanargia galathea 124, 126
Melanophores 56
Milkweed 36, 50, 97, 100, 101, 105
Miró 18
Moa 86-87
Mocker swallowtail 36, 39, 133
Moffatt, Thomas 67
Monarch butterfly 50, 90, 96 et
 seq., 96, 99, 146
Monkey 15, 19, 40, 73, 165
Moon (Luna) moth 162, 163
Morgan's sphinx moth 156, 157
Mori, Masahiro 40
Mormon butterflies 132, 133, 134
Morpho 26, 29, 74, 77, 107 et seq.,
 108-109, 111, 122
Mother-of-pearl butterfly 94, 94
Müller, Fritz 36-38
Müllerian mimicry 36-38, 52-53, 102
Muslin moth 48
Myscelia cyaniris 17

N
Nabokov, Vladimir 45, 57, 82, 122, 129
Narcissus 12
Neitz, Jay 28

Nymphalidae 55, 58, 92
Nymphalis sp. 58, 58, 82

O
Oak eggar moth 43, 45
Oak silkmoth 165, 168, 169
Oleander hawk moth 158-159
Ornithoptera priamus 136, 137
Owl 32, 33, 42, 70, 165
Owl butterfly 70, 72, 73, 74

P
Pachliopta 89
Painted lady butterfly 57, 63, 78, 92-94
Papilio sp. 36-39, 90, 129 et seq.
Pararge aegeria 74, 75
Passion vine 144-155
Peacock butterfly 11, 14, 18, 33,
 66 et seq., 66, 69
Peacock pansy 70, 71
Peppered moth 45, 45
Pheromones 11, 29, 102, 105, 146, 169
Pieris sp. 122
Pigeon 23, 28, 33, 61
Plethodon sp. 98, 101-102
Polygonia c-album 46, 64
Polythysana 165, 167
Pompeii 116
Poplar hawk moth 153, 155
Post-impressionism 18, 20
Praepapilio 56
Precis atlites 74, 76
Precis lavinia 70
Priming 20, 21
Prodryas persephone 56
Proust, Marcel 79, 110-111
Pteridines 56, 121, 122
Purple emperor butterfly 55, 57, 106,
 107, 112-116, 115
Pyrrolizidines 102, 105
Pyronia tithonus 58

Q
Queen butterfly 101, 102

R
Raccoon 155
Rainbow 11, 28, 56, 116
Rajah Brooke 9, 10, 136, 138
Raphael 90
Reaction times 18
Réaumur, A.F. 151
Red admiral butterfly 52, 57, 76, 79,
 82-90, 83, 85, 134, 138
Releaser 23
Retina 24, 28, 30, 32, 56, 165
Riodinella 56
Robin moth 13, 166
Rothschild, Miriam 7, 24
Rothschild, Lord Walter 136

S
Sabre-toothed tiger 166
Sacks, Oliver 20, 23
Saint-Exupéry, Antoine de 19
Salamander 11, 50, 55, 98, 101-102
Salamis duprei 94, 94
Saturnia pavonia 169, 170-171
Saturniidae, saturnids 161 et seq.
Satyric mimicry 7, 19, 38-42, 53
Satyrids 18, 59, 125
Scales 29, 30, 56-57, 68, 69, 92,

 110-112, 121-123, 138, 165
Sesia bembeciformis 36, 37
Siproeta stelenes 8, 21
Shivering 13, 153
Sign stimuli 23
Silence of the Lambs 155
Silkworm 58, 142, 161
Silver-washed fritillary butterfly 21, 60,
 61, 61, 62, 63
Sinosauropteryx 56
Skipper 15, 17
Small copper butterfly 115, 117
Small tortoiseshell 17, 19, 57, 69,
 70, 79-82, 80
Smerinthus ocellatus 152, 153, 153
Smilodon 166
Sparrow 31, 33
Speckled wood butterfly 74, 75
Sphingidae 150 et seq.
Stauropus fagi 50, 51
Stendhal 88
Stradling, Dave 73
Stripes 21, 24, 26, 93, 132
Surrealists, surrealism 18, 19, 38, 48,
 155, 169
Swallow 90, 132, 132
Swallowtail 87, 89, 128 et seq.
Synaesthesia 22

T
Take-off 15, 17
Tapetum 165-166
Tenniel, Sir John 48, 50
Tiger butterflies 102, 103, 105
Tiger moth 24, 25, 26, 42, 48, 146
Tinbergen, Niko 23, 153
Tree nymph butterfly 21, 97, 105
Trogon 9, 136
Trogonoptera brookiana 11
Tussore (Tussah) silkmoth 165

U
Ultraviolet, UV 26, 28-31, 46, 56, 74-75,
 100, 111, 122-124, 165
Uganda 20
Uncanny valley 40, 42

V
Vanessa 82-90
Viceroy butterfly 90, 92, 102
Virgil 20
Visual agnosia 20
Vukusic, Pete 111
Vulcain 82

W
Woodpecker 17
Wallace, Alfred Russel 4, 9, 35, 38-39,
 136, 138, 157
Wall brown, Sardinian 16
Warhol, Andy 76
White admiral butterfly 30, 31, 57,
 90, 91, 92
Windows 165-166
Woodland brown butterfly 74,
 74, 75

X
Xanthopan morganii 156, 157

FOOTNOTES

CHAPTER 1

[1] The author Vladimir Nabokov, also well known as an entomologist, spent five years at Harvard Museum of Natural History separating blue butterflies on the basis of minor differences in their genitalia.

[2] Bartholomew, G.A & T.M. Casey "Effects of ambient temperature on warm-up in the moth *Hyalophora cecropia*", *Journal of Experimental Biology* 58: 503-507. 1973.

[3] Howse, P.E "Lepidopteran wing patterns and the evolution of satyric mimicry", *Biological Journal of the Linnean Society*, 109, 203-214. 2013.

[4] Sourakov, A "Extraordinarily quick visual startle reflexes of skipper butterflies (Lepidoptera: Hesperiidae) are among the fastest in the animal kingdom", *Florida Entomologist* 92(4), 653-655. 2009.

[5] Almbro, M & C. Kullberg "Season, sex and flight muscle investment affect take-off performance in the hibernating small tortoiseshell butterfly *Aglais urticae* (Lepidoptera: Nymphalidae)", *Journal of Research on the Lepidoptera* 44: 77–84. 2011.

[6] Hinde, R.A "Factors governing the changes in strength of a partially inborn response, as shown by the mobbing behaviour of the chaffinch (Fringilla coelebs). I. The nature of the response, and an examination of its course", *Proc. R. Soc. Lond.*, B, 142, 306-331. 1954.

[7] See Richard Gregory et al. *The Artful Eye* and references therein Oxford Univ. Press. 1995.

[8] Oliver Sacks *An Anthropologist on Mars*. New York, Alfred A. Knopf, Inc. 1996.

[9] Kerr J.G & M. Bellamy "John Graham Kerr and the Early Development of Ship Camouflage" in *The Northern Mariner* XIX No 2 (April 2009), p. 177 (www.cnrs-scrn.org/northern_mariner/vol91tnm_19_171-192.pdf).

See also Peter Forbes *Dazzled and Deceived: Mimicry and Camouflage*, Yale Univ. Press. 2011.

[10] Magnus, D.B.E "Beobachtungen zur Balz und Eiablage des Kaisermantels *Argynnis paphia* L. (Lep., Nymphalidae)", *Zeit. Tierpsych*, 7:435-449. 1950.

[11] Oliver Sacks' highly acclaimed book *Seeing Voices*, first published in 1989, does not mention the word synaesthesia.

[12] See Jamie Ward *The Frog who Croaked Blue*, Routledge. London & New York. 2008.

[13] Lettvin J et al. "What the frog's eye tells the frog's brain", *Proceedings of the IRE*, Vol. 47, No. 11, November 1959.

[14] See P.E. Howse & K. Wolfe, *Giant Silkmoths, Colour, Mimicry and Camouflage*, Papadakis. 2011.

[15] See Jay Neitz, Joseph Carroll and Maureen Neitz "Color vision, almost enough reason for having eyes", *Optics and Photonics News*, 1047-6938/01/. January 2001.

[16] People with an eye condition in which there is no lens present can see ultraviolet, which is said to greatly increase the brightness of images.

[17] http://money.cnn.com/magazines/fortune/fortune_archive/2005/04/04/8255929.

[18] Eaton, M.D "Human vision fails to distinguish widespread sexual dichromatism among sexually 'monochromatic' birds", *Proceedings of the National Academy of Sciences of the United States of America* 102 (31): 10942–10946. August 2005.

[19] Simon Barnes, writing in his column in *The Times*, was delighted that his Down's syndrome son, Eddie, began bird-watching although he saw cormorants as "blue". His son was probably quite correct; many members of the crow family have a blue sheen largely obscured by black pigment. I propose to call this the "Eddie Barnes effect".

[20] Rounsley, K.J, S.A McFaddenLimits of visual acuity in the frontal field of the rock pigeon (*Columba livia*)", *Perception* 34(8), 983-993. 2005.

[21] Martin, G.R "What is binocular vision for? A birds' eye view", *Journal of Vision* 9: article 14, 2009.

CHAPTER 2

[1] Meyer, A "Repeating Patterns of Mimicry", PLoS Biology, Vol. 4/10/2006, e341 doi: 10.1371/journal.pbio.0040341

[2] This can be seen in the famous Roman mosaic in Naples Archaeological museum depicting Alexander's battle with Darius of Persia.

[3] Howse, P.E & J.A Allen "Satyric mimicry: the evolution of apparent imperfection", *Proc. R.Soc.Lond. B*, 257, 111-114. 1963.

[4] See W. Dittrich et al. "Imperfect mimicry: a pigeon's perspective", *Proc. R.Soc Lond B*, 251-290. 1993.

[5] Note, however, that the satyric mimicry is only a hypothetical concept – as the theory of evolution was (and still is in many ways) – and although it is heuristic and provides an explanation for many observed facts, experimental work to validate it has scarcely begun.

[6] Takagi, S "An experimental study of the discrimination and constancy of form in the tomtit", *Japanese Journal of Psychology*, 8. 521-548. (1933).

[7] For a further discussion on this see Arthur Koestler, *The Act of Creation*.

[8] Maddock, S.A, S.C Church & I.C Cuthill "The effects of the light environment on prey choice by zebra finches", *J.Exp. Biology*, 204, 2909-16. 2001.

[9] Sourakov, A "Two heads are better than one: false head allows *Calycopis cecrops* (Lycaenidae) to escape predation by a jumping spider, *Phidippus pulcherrimus* (Salticidae)", *Journal of Natural History*. 2013. http://dx.doi.org/10.1080/00222933.2012.759288

[10] See P.E. Howse & K. Wolfe, *The Giant Silkmoths*, op.cit.

[11] Howse, P. E. 2013, op.cit.

CHAPTER 3

[1] Zhang, F, X Xu, M.J Benton, Stuart L Kearns, et al. "Fossilized melanosomes and the colour of Cretaceous dinosaurs and birds", *Nature*, 463: 1075–1078. 2010.

[2] McNamara, Maria E, Derek E.G Briggs, Patrick J Orr, Sonja Wedmann, Heeso Noh, Hui Cao, "Fossilized Biophotonic Nanostructures Reveal the Original Colors of 47-Million-Year-Old Moths", *PLoS Biology*, 15 November 2011.

[3] Martin, J.E, J.A Case, J.W.M Jagt, A.S Schulp & E.W.A Mulder "A new European marsupial indicates a Late Cretaceous high-latitude transatlantic dispersal route" *Journal of Mammalian Evolution* 12 (3-4): 495-511. 2005.

[4] Vila, R et al. "Phylogeny and palaeoecology of *Polyommatus* blue butterflies show Beringia was a climate-regulated gateway to the New World", *Proc. R. Soc. B*, 26 January 2011. doi: 10.1098/rspb.2010.2213

[5] Unpublished Report of the Scientific Exploration Society (London) Expedition to Southern Chile.

[6] For a detailed discussion of this and related issues see G. Vallortigara et al. "Are Animals Autistic Savants?", *PLoS Biology*, Vol. 6 (2) e42. 2008.

[7] Tvardíková, Kateřina & Roman Fuchs, "Tits use amodal completion in predator recognition: a field experiment", *Animal Cognition*, Vol.13, No.4, 609-615. 2010.

[8] Braby, M.F, J.W.H Trueman,, R Eastwood "When and where did troidine butterflies (Lepidoptera: Papilionidae) evolve? Phylogenetic and biogeographic evidence suggests an origin in remnant Gondwana in the Late Cretaceous", *Invertebrate Systematics* 19, 113–143. 2005.

[9] Williams, Paul, Ya Tang, Jian Yao & Sydney Cameron, "The bumblebees of Sichuan (Hymenoptera: Apidae, Bombini)", *Systematics and Biodiversity*: doi:10.1017/S1477200008002843 C

CHAPTER 4

[1] See *Butterflies, Messages from Psyche*, op.cit. for more comments about on this.

[2] See Chapter 1

[3] Stradling, D. "The nature of the mimetic patterns of the brassolid genera, Caligo and Eryphanis", *Ecological Entomology*, 1, 135-138. 1976.

[4] The argus butterflies are named after a monster of ancient Greek mythology that had a hundred eyes, at least one of which was always open.

[5] Olofsson et al "Marginal eye-spots on butterfly wings", *PlosOne*. 24 May 2010.

[6.] Berwick, the bird trainer for the film is quoted as saying, "Some of them were absolutely terrified of the birds and with good reason. They always talk about the danger to your eyes when birds are involved. The seagulls would deliberately go for your eyes. I got bitten in the eye region at least three times, and Tippi got a pretty nasty gash when one of the birds hit her right above the eye." At the beginning of the film the farmer is found with his eye pecked out.

CHAPTER 5

[1] From Peter Marren, co-author of *Bugs Britannica*, Chatto & Windus, London. 2010.

[2] See p.87

[3] A species found in the Canary Islands and Madeira, *Vanessa vulcania*, is barely distinguishable from *V. indica*.

[4] Fenton et al. "Parasite-induced warning coloration: a novel form of host manipulation" *Animal Behaviour* 81 (2011) 417-422. 2011.

[5] Stefanescu et al. "Multi-generational long distance migration of insects: studying the Painted Lady butterfly in the Western Palaearctic", *Ecography* 35: 001–014. 2012.

CHAPTER 6

[1] Quote from Simon Barnes.

[2] Reppert, Steven M., Robert J. Gegear, & Christine Merlin, "Navigational Mechanisms of Migrating Monarch Butterflies", *Trends in Neurosciences, 33(9): 399-406.* September 2010.

[3] See "dazzle painting" in Chapter 1.

CHAPTER 7

[1] 3rd edition, Vol. 9, p. 381.

[2] Iridescence is not found in mammals, with the exception of the golden mole. The melanin pigments are enclosed inside skin cells and are not contained in translucent structures such as feathers and scales, which can generate iridescence.

[3] Marcel Proust *Remembrance of Things Past*, trans. Scott-Moncrieff & Kilmartin)

[4] Zong Ding, Sheng Xu, & Zhong Lin Wang, "Structural colors from *Morpho peleides* butterfly wing scales", *Journal of Applied Physics*, 106, 074702. 2009.

[5] The "ground" scales, though, still reflect UV (see preceding ref.).

[6] See P.E. Howse *Butterflies, Messages from Psyche*, Papadakis. 2010.

CHAPTER 8

[1] Brunton, C & M. Magerus "Variation in ultraviolet wing patterns of Brimstone butterflies", *Proc. R. Soc. Lond. B*, vol. 260, no. 1358, 199-204. 1995.

[2] H.W. Bates, *A Naturalist on the River Amazons*, John Murray, London. 1892.

CHAPTER 9

[1] Artemisia extracts are toxic. Wormwood, an Artemisia species, is banned in France as an ingredient of absinthe because of this. A component of the oil, artemisinin, is toxic to the malarial parasite and is now being used medicinally.

[2] One of the greatest bird-photographers, Eric Hosking, lost an eye to an owl he was photographing.

[3] See *Giant Silkmoths*, op.cit.

[4] With the help of collectors worldwide, Lord Rothschild established the largest collection of butterflies in the world in the early twentieth century. It was housed in the museum at Tring.

CHAPTER 10

[1] Profile Books, London. 2008.

[2] Edmund D. Brodie III "Differential Avoidance of Coral Snake Banded Patterns by Free-Ranging Avian Predators in Costa Rica", *Evolution*, Vol. 47, No. 1, pp. 227-235. Feb. 1993.

[3] In monarchs the hair pencils look more like thistledown and open from glands near the tip of the abdomen (see Chapter 6).

CHAPTER 11

[1] For the full story see *Butterflies, Messages from Psyche*, op.cit.

[2] *The Naturalist on the River Amazons*, op.cit.

CHAPTER 12

[1] *Tussore* comes from the Hindustani word for "shuttle".

[2] Dogs also evolved on the North American continent.

FURTHER READING & INTERNET SOURCES

The following list of websites and books covers mainly Lepidoptera of Britain and Northern Europe. An internet search will reveal works on insects of other regions. The Royal Entomological Society has a comprehensive range of publications and keys to British insects.

A FEW WEBSITES

ukbutterflies, managed by Pete Eeles is a wonderful source of images of butterflies that can be used for identification. It includes many species that are common in continental Europe and a few from even further afield.

Butterfly Conservation (UK) has comprehensive photographs and information on British butterflies and moths.

BugGuide (USA) is a website featuring thousands of photographs of arthropods from the USA and Canada, and an excellent guide to identification of Lepidoptera.

www.learnaboutbutterflies.com has superb images of butterflies from all continents.

BOOKS

Butterflies – Messages from Psyche, P E Howse. Papadakis 2010

Giant Silkmoths – Colour, Mimicry and Camouflage, P E Howse and Kirby Wolfe. Papadakis 2012

The Butterflies of Britain and Ireland, Jeremy Thomas and Richard Lewington. British Wildlife Publishing, New edition, 2014

Philip's Guide to Butterflies of Britain and Ireland, Jeremy Thomas. Philip's, New edition, 2014

Butterfly – A Photographic Portrait, Thomas Marent. DK Reference, 2008

British Moths and Butterflies – A Photographic Guide, Chris Manley. A&C Black Publishers

PICTURE CREDITS

All images are © Philip Howse with the exception of the images listed below and those in the public domain.

Cover image © Bob Eade; pp2, 6, 31 (top & bottom), 58, 65, 106, 111 (top), 113, 115, 117, 118-119, 127, 128, 147 © Peter Eeles, www.ukbutterflies.co.uk; pp8, 108-109, 140, 143, 148-149 © Peter Farmer, Survivalphotos; pp10, 13 (left & right), 40-41, 47, 60, 61, 63 (top), 68, 71, 72, 75, 76, 77, 78, 83, 84, 91, 120, 137 (top & bottom), 139 © Stratford-upon-Avon Butterfly Farm Ltd. (K. Dolbear); pp15, 49 (top & bottom) © Andrei Sourakov; p26 used under the Creative Commons licence (cc) Ernst Vikne; p32 sculpture © Sue Lansbury/ butterfly art © Sally Davies; pp34, 160, 162 (left & right), 163, 164, 167, © Kirby Wolfe; p37 © Kevin DuRose; p39 (top) cc A. Meyer; (bottom) © Martin Thompson; pp51 (top), 53 (bottom) © Jeroen Voogd; pp53 (top), 54, 154, 170-171 © Chris Manley; p62 © Tony Bamford; p73 © William Quatman; p74 © Olofsson et al 2012; p80 (top) cc H. Krisp, (bottom) © Dave Goulson; pp86, 87 (top) © Thomas Neubau; p87 (bottom) © William Vann; p88 cc Alpsdake; pp89, 133 © Steen Heilesen; p92 cc Saxophlute; p93 cc D. Gordon E. Robertson; p95 © Stavros Marcopoulos; p96 © N. Suárez-Bosché; p98 © Troy Hibbitts; p101 "*Danaus chrysippus* male 2 by kadavoor" © 2010 Jeevan Jose, Kerala, India, Licence. CC BY-SA 3.0; p102 "Dark Blue Tiger *Tirumala septentrionis* by kadavoor" © 2010 Jeevan Jose, Kerala, India, Licence: CC BY-SA 3.0 or GFDL; p104 cc Greg Hume; p112 cc Loyna; p114 © B. Yates-Smith; p124-125 cc K. Mohan Raj; pp132, 157 © Tom Brereton; p136 cc Sterilgutassistentin; p138 cc Nonie; p142 © Solon Morse; p156 © Prof. Dr. Lutz Thilo Wasserthal, Institut für Zoologie, Friedrich-Alexander-Universität, Erlangen, Germany; pp158-159 © Thomas Marent

We gratefully acknowledge the permission granted to use these images. Every possible attempt has been made to identify and contact copyright holders. Any errors or omissions are inadvertent and will be corrected in subsequent editions.

ACKNOWLEDGMENTS

I wish to extend my gratitude to the Royal Entomological Society for their support and to all those who, in addition to Clive Farrell, have helped and encouraged me. Among others, I must mention in particular Mike Claridge, Bill Blakemore, Peter Smithers, and Simon Barnes. I am also grateful to those who have given generously of their superb photographic images, including especially Kirby Wolfe (my co-author in the award-winning *Giant Silkmoths*), Pete Eeles (of ukbutterflies), Chris Manley (UK), Steen Heilesen (Hong Kong), Peter Farmer (Survival Photos), and Andre Sourakov (Florida). I thank especially my wife Susan for her encouragement and constant support.

I am very pleased to be able to thank here my publisher Alexandra Papadakis, and Sheila de Vallée, Aldo Sampieri and Caroline Kuhtz who have all laboured valiantly and constructively on the editing and presentation of this book.